No Man's Land

No Man's Land

HENK VAN RENSBERGEN

DESMOND MORRIS | PETER VERHELST

LANNOO

FOREWORD

DESMOND MORRIS

This collection of extraordinary, haunting photographs is not only visually mesmerizing but also carries an important message. It acts as a sombre reminder that our incredibly successful species, Homo sapiens, is not immune to the forces of nature and may one day become extinct like thousands of other animals that were, in their day, also highly successful species. There are some people who seem to think that, unlike other animals, human beings are somehow protected from the laws of nature, but they are wrong. I have said elsewhere that we should see ourselves as risen apes and not as fallen angels. We should accept that we are just as vulnerable as any other species if our environment can no longer support us.

This is the crucially important lesson that is driven home, again and again, as you turn the pages of this book. The premise of Henk van Rensbergen's *No Man's Land* is that some catastrophic event has wiped humanity from the face of the Earth. What we see now are the tattered ruins of our civilizations, slowly decaying before our eyes, as other species, that have not been affected by the global disaster, wander through them in lonely isolation. It is a chilling re-run of the end of the dinosaurs. They too ruled the planet, but then some disaster struck them down, leaving the Earth to the other, less impressive species, from which our own ancestors eventually, and very slowly, emerged to replace them as the dominant force. In *No Man's Land*, we are the new dinosaurs. Somewhere our bones will lie, mouldering in the soil, with some of them eventually becoming fossilized as a distant reminder that, one day long ago, we were here. Before this imagined global wipe-out occurred, there is no question that we were the most successful animal species that had ever existed on this planet. There were 7,500 million of us swarming all over the land surface. There were vast cities everywhere, inside which the inhabitants felt snugly protected from

the dangers of the wild. Surrounded by concrete and steel, they felt detached from the natural world and increasingly chose to ignore its rumbling warnings. Human ingenuity always seemed to be able to find a clever solution to every new challenge that came along. But there were three threats that we seemed helpless to combat.

First, we failed to slow down the dramatic increase in our populations. Two thousand years ago, in the time of Christ, there were only 255 million people alive on the planet. Yet, despite wars, epidemics and famine, that figure started to climb year by year and never showed a downward trend at any time. In my own lifetime I have seen the population rise from 2,000 million to 7,500 million. I find it hard to believe that since I was born the number of people walking the Earth has increased by over 5,000 million, but that is the plain fact. So our first major threat is an unnatural degree of overcrowding. No other species could tolerate this condition. We know from careful experiments that, when another species has its population density artificially increased, its social organization quickly collapses and chaos rules. Somehow our human inventiveness and ingenuity, not to mention our remarkable flexibility, has managed to allow us to exist in vast, crowded populations that are in stark contrast to the small tribes in which we evolved over a period of a million years or more. We have achieved this, not by becoming like ants or termites, with a new form of social organization, but rather by contriving to retain our small tribal relationships within our huge urban communities. We still have the primeval figure of about 100 or 200 friends and acquaintances, and treat the rest of the city dwellers that we pass on the street as strangers with whom we make no attempt to set up any kind of personal connection. If we stopped everyone we met in a busy city centre, introduced ourselves and tried to make friends,

our societies would quickly grind to a halt. There were no strangers in our primeval tribes, but today we have come to accept strangers as a commonplace factor in our daily social lives. This has been the clever solution that we have applied all over the planet to what would otherwise have become an urban nightmare. It has enabled us to live in communities that far exceed the natural condition that we experienced in our evolutionary past. However, there is a limit to just how far we can take this manipulation of our overpopulation. There is a growing risk that we may become overcrowded to such a degree that we become overstressed to a point where our immune systems can no longer protect us efficiently. When we reach that stage we will face the second great threat to our species.

This second challenge concerns our health. Our overcrowding makes us vulnerable to pandemics in two ways. First, our stressed condition will make us more vulnerable to infection and, second, it will make it much easier to catch a new disease because of our close physical proximity to other city dwellers. Medical science is constantly doing battle with the bacteria and viruses that cause most of our serious ailments. Great advances have been made and some of the worst micro-organisms have been defeated, but viruses have a nasty habit of mutating and fighting back by rapidly changing their properties. Imagine what would happen if one particular strain of virus managed to become both lethal and also so easily transmitted that an infected human being could kill another simply by breathing on them. Before medical research could defeat this virus it would have killed all the medical research workers along with everyone else. This is one way that we could see the end of the human species.

Another great threat, caused by the growth of our populations, is that we will pollute the planet to a point where its ecosystems cannot recover. There are already signs that this is beginning to happen and it is heartening to know that world leaders are becoming increasingly aware of this problem and are doing their best to combat it. However, if we are overwhelmed by the tide of filth that we are spewing onto the surface of the Earth and into its oceans, then this too could herald the end of humanity. If, by applying our amazing ingenuity to these two major threats of epidemic and pollution, we managed to defeat them, there is still one final way in which we could see ourselves exterminated as a species. As part of modern warfare we have brazenly invented chemical, biological and nuclear weapons, each of which could destroy us if we allowed them to run riot. A major nuclear war could easily see a radioactive cloud spreading across the entire surface of the planet. This would mean that wherever there was rainfall, human populations would be destroyed. Only a few desert nomads would survive in the driest parts of the world.

So there we have the three ways in which our species could disappear suddenly from the surface of the Earth – epidemic, pollution or radiation. These are not scenarios taken from science-fiction. Sadly, they are all too real. What Henk van Rensbergen's *No Man's Land* tries to imagine is what the planet might look like in a post-human world. However, because, in his photographs, we see that other species have somehow managed to survive, this rules out the possibility that our destruction was caused by a radioactive cloud because that would have taken the other species with us. It seems most likely that his *No Man's Land* has resulted from a pandemic, with a lethal virus specific to Homo sapiens. Indeed, the virus was so species-specific that it did not even affect our closest relatives, the chimpanzees and orang-utans,

as we see these apes sitting forlornly in the ruins of our human world. When looking at these remarkable photographs it is important to remember that they represent a poetic vision and not an accurate scientific record. They are intensely evocative, creating in us the eerie feeling that we are wandering in a lost world – or at least, a world lost to us – but they have deliberately omitted one important feature of the planet following our destruction, namely the countless millions of rotting human carcasses. These are nowhere to be seen, but it is clear from the decayed state of the ruined buildings that the scenes we are witnessing are set some time after the great annihilation. Perhaps all those dead bodies have rotted away completely by now and vanished from the Earth except for a few bleached bones here and there.

It is interesting to consider what would have happened immediately after the great pandemic struck. There would have been an explosion of insect life, feeding on our remains. All over the planet the air would be full of a vast, black swarm of flying insects and this in turn would have provided a feast for their major predators, the bats. Bat colonies would not only have suddenly enjoyed a food supply beyond anything they had ever known, they would also have discovered millions of ruined buildings full of wonderful roosting sites where they could hang their tiny claws. Before long, the air would be full of another black swarm as the bat colonies multiplied as never before. Down on the ground, scavenging rodents would also experience a dramatic surge in numbers. The empty buildings would be alive with scampering rats. And those most resilient of insects – the cockroaches – would also enjoy a new level of infestation. These changes would in turn provide rich pickings for many different kinds of predators. In the absence of humanity, the wild world would flourish on a grand scale.

Eventually, when all our bones had been picked clean, these wild populations would gradually move into a new phase and would level out as a balanced post-human fauna. It would then be left to the great apes – the species that we had nearly brought to the brink of extinction – to start off along the slow path towards a new evolutionary stage of development, eventually arriving perhaps at the condition we know as Pierre Boulle's *Planet of the Apes*.

As we let our imaginations follow these global transformations, we must not forget one special category of animal life – the domestic livestock. All over the world there are millions and millions of pet animals and farm animals that, until we vanished, were relying upon us to feed and house them. What would happen to them now? Would they too vanish? How would they survive without us, when they had relied so heavily on our daily caring for them? Some would inevitably find themselves helplessly trapped inside their homes, farm buildings or enclosures, and would simply starve to death. Many others might be able to break free and wander the abandoned landscapes searching for food. Herbivores, like the horses, cattle, goats, sheep and pigs, would all find a plentiful supply of food in the now-overgrown vegetation. They would flourish and gradually become more and more wild, starting to revert towards their genetic ancestry. The carnivores, especially the millions of pet cats and dogs, might also do well because of the great increase of the rodent population. All the different dog breeds would start interbreeding and would soon revert to an animal much closer to their ancestral form – the wolf. Domestic cats have never varied as much as domestic dogs and they would soon lose their conspicuous coat-colours and revert to the camouflage markings of their feline forebears.

Out in the countryside, the carefully disciplined and partitioned farmlands would soon lose their geometric outlines and return to a wild raggedness. Domesticated crops would find themselves in strong competition with wild forms of vegetation. New grasslands would appear and forests would start to spread once more. This in turn would have a major impact on the weather, with an increasing annual rainfall and with the landmass slowly developing a greater fertility. The oceans, devoid of fishermen and with the eventual disappearance of human pollutants, would witness a surge in marine life. It is a hard truth for us to bear, but the fauna and flora of our planet would enjoy a richly replenished condition following our demise.

The photographs in this book show us a time before this renaissance of nature has taken place. The animals that wander the empty ruins are rather sad and lonely, as if bemused by the sudden absence of their old masters. It is as if they believe that we are still hiding round the corner, waiting to reimpose ourselves. But, as I said, these amazing photographic compositions are not scientific records; they offer instead a powerful poetic vision portraying the unthinkable – the end of humanity. Turning the pages of this book is a strangely humbling procedure and is one that should make us all think a little harder about the way in which our species must face the future.

Finally, there is the question of how on earth Henk van Rensbergen managed to capture these scenes with his camera. Where did he find those extraordinary derelict buildings and how did he persuade the elephants, hyenas and the rest of the animals to occupy them? Or did he perhaps employ some of the latest computer-generated trickery to create these scenes? Personally, I do not want to know the answer to these questions. If we know how a magician does his tricks, it destroys the magic of the moment. I would prefer to accept these astonishing photographs at face value, without trying to analyse their technology. Let us hope that, by encouraging us to contemplate the possibility of the destruction of our species, the author of this book helps us to become so aware of this disastrous possibility that we start to employ our human ingenuity to avoid it.

I am often asked whether, as a student of human behaviour, I am optimistic or pessimistic about our future. When I was younger, being forced to spend much of my childhood during World War II, I have to admit that I was something of a pessimist. To my child's brain it seemed as though all that adult humans wanted to do was to kill one another and in a school essay I described human beings as 'monkeys with diseased brains'. When peace came and I began to grow older, I started to change my views. I became more and more impressed by the ingenuity of the human brain. In my lifetime, for instance, I have seen the invention of such things as television and the internet. No Victorian scientist could possibly have imagined such wonders. In the same way, it is impossible for us today to imagine what astonishing inventions will be made in the century ahead. We can make wild guesses – perhaps an antigravity machine that will float in the air and carry us wherever we want to go, or some kind of fourth-dimensional travel. But the truth is we really have no idea where our fertile imaginations will take us next. So, instead of destroying ourselves miserably and ending as a wretched pile of corpses, we might instead move on to an entirely new plane of existence. Nobody knows, but the possibilities are there. And it is these possibilities that make me optimistic for the future. If I am wrong, then Henk van Rensbergen's *No Man's Land* will cease to be merely a poetic vision and become instead a terrible reality.

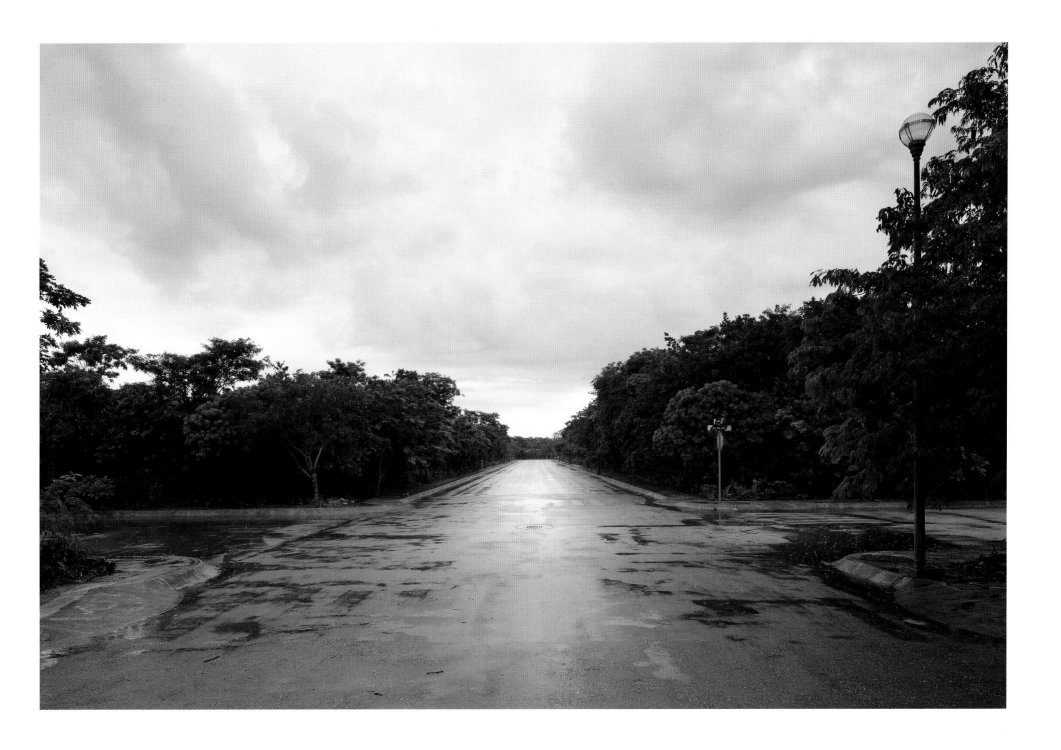

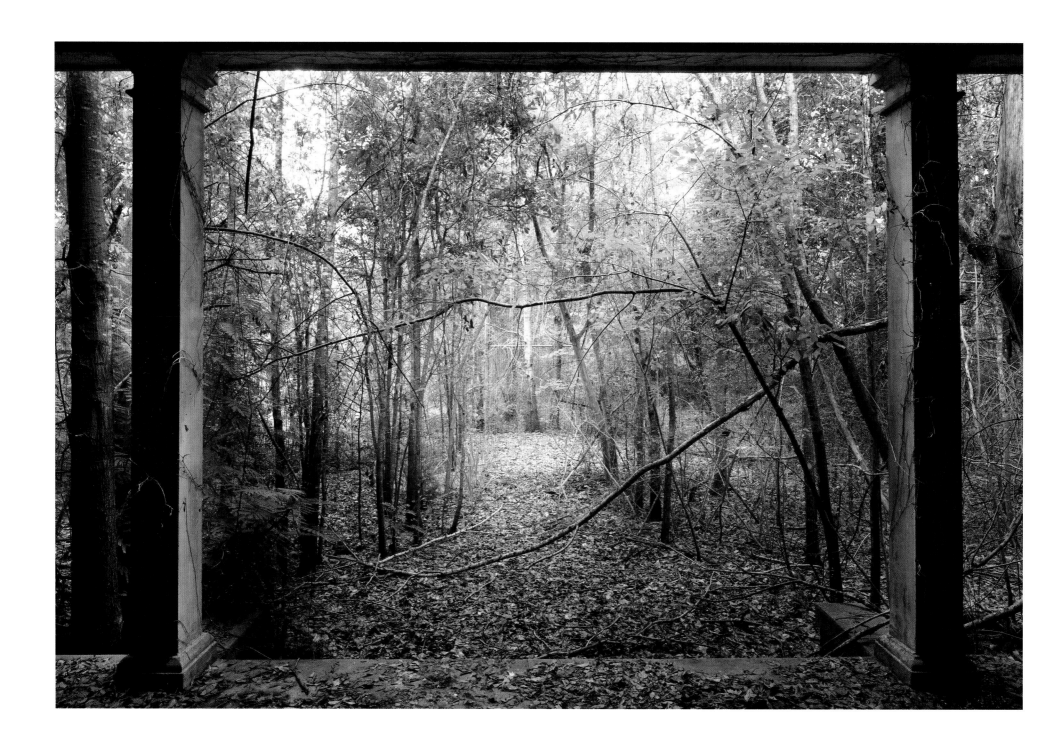

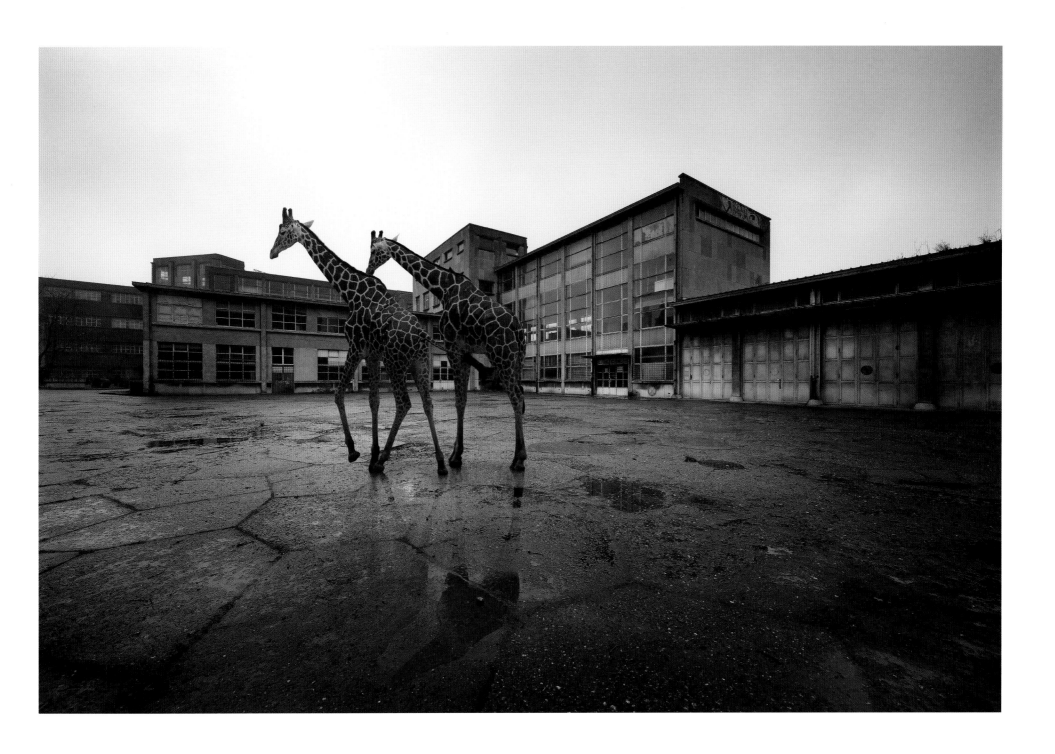

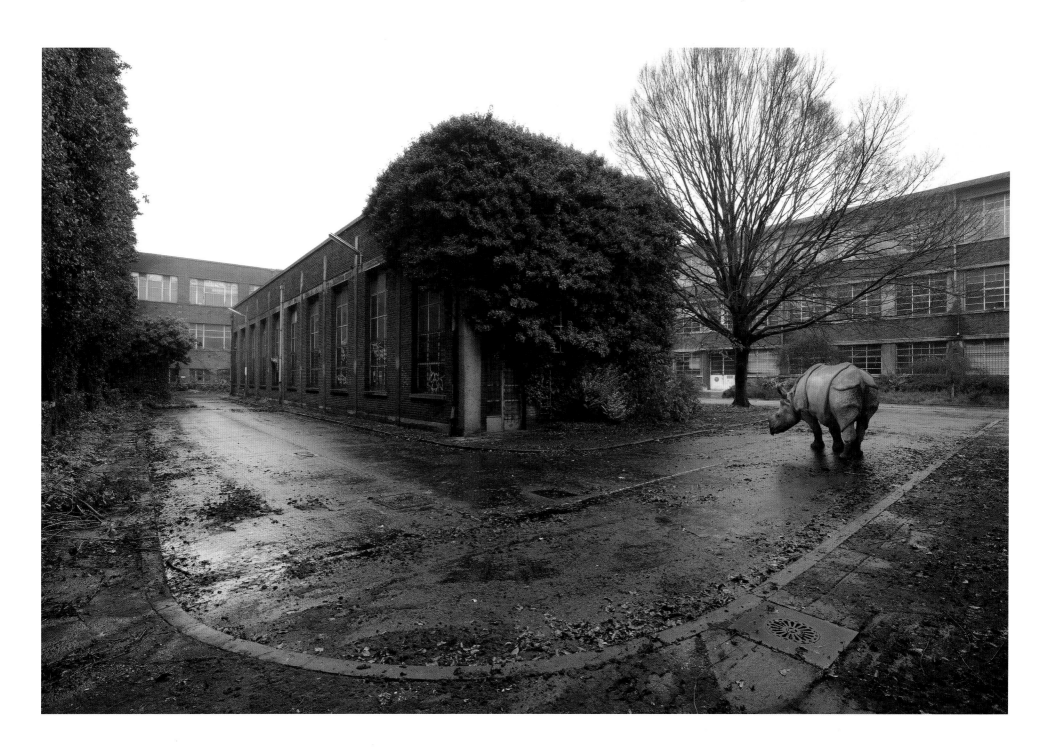

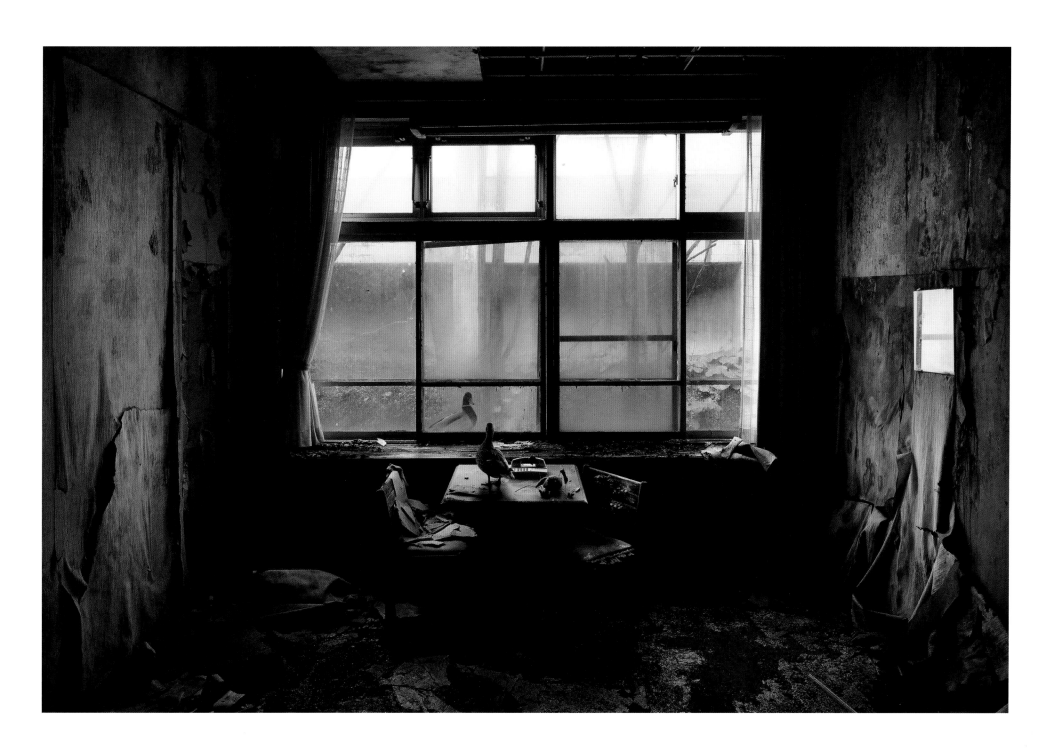

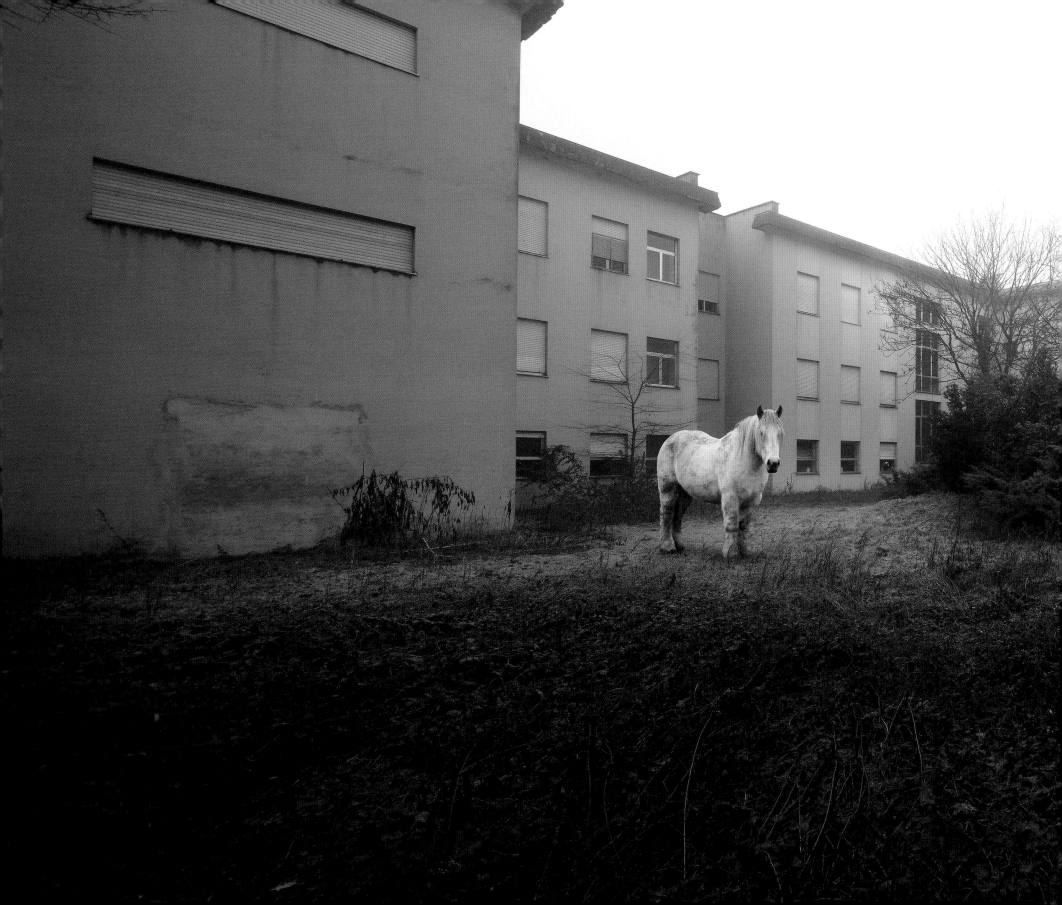

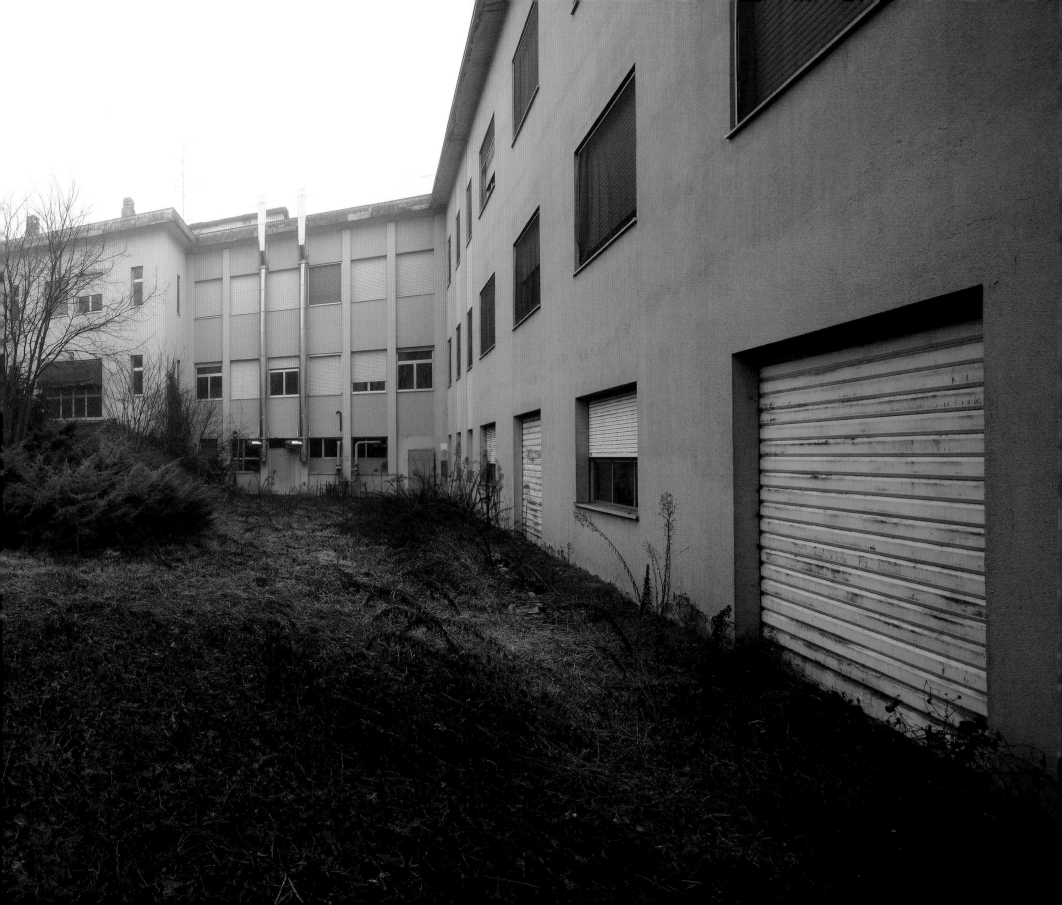

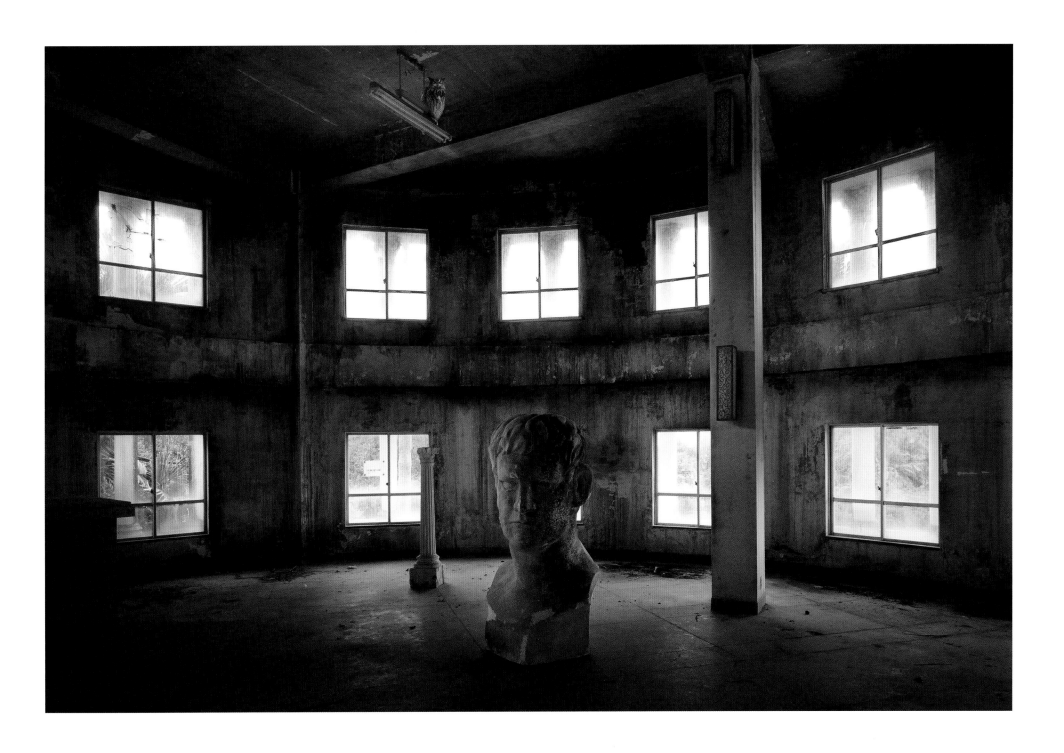

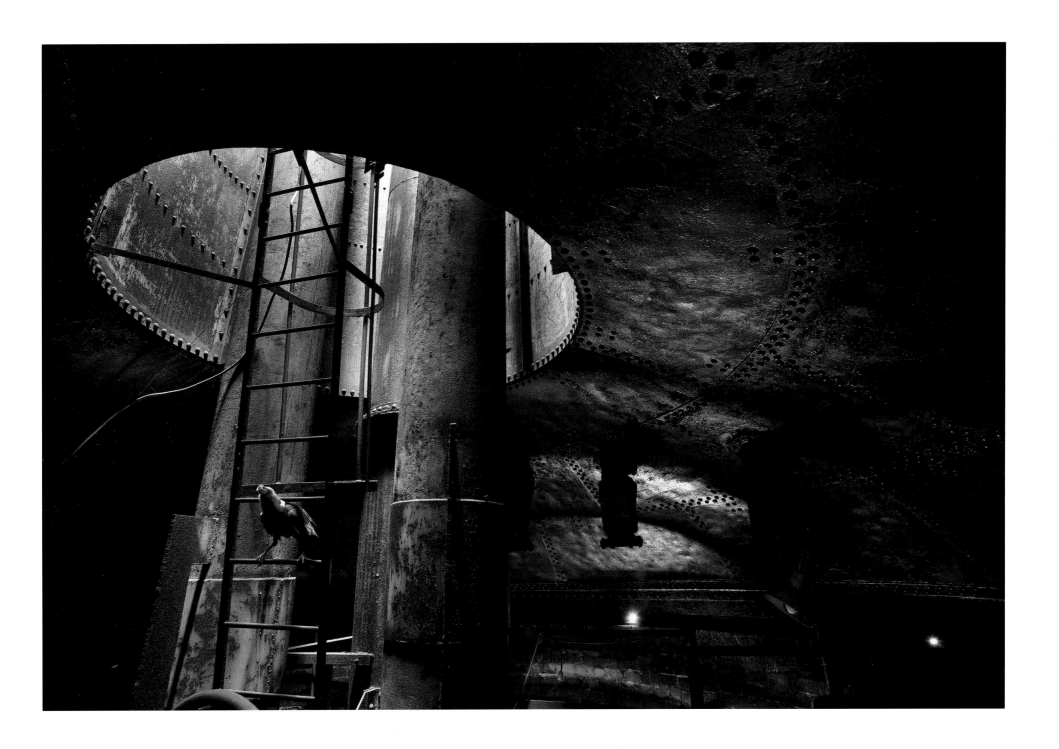

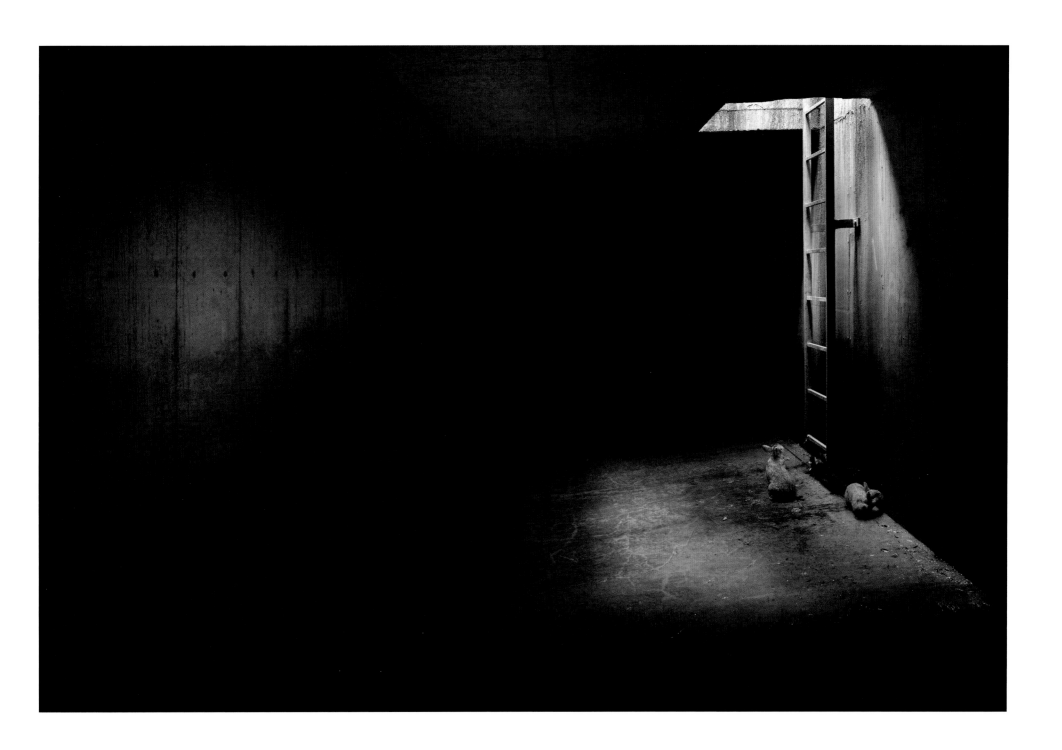

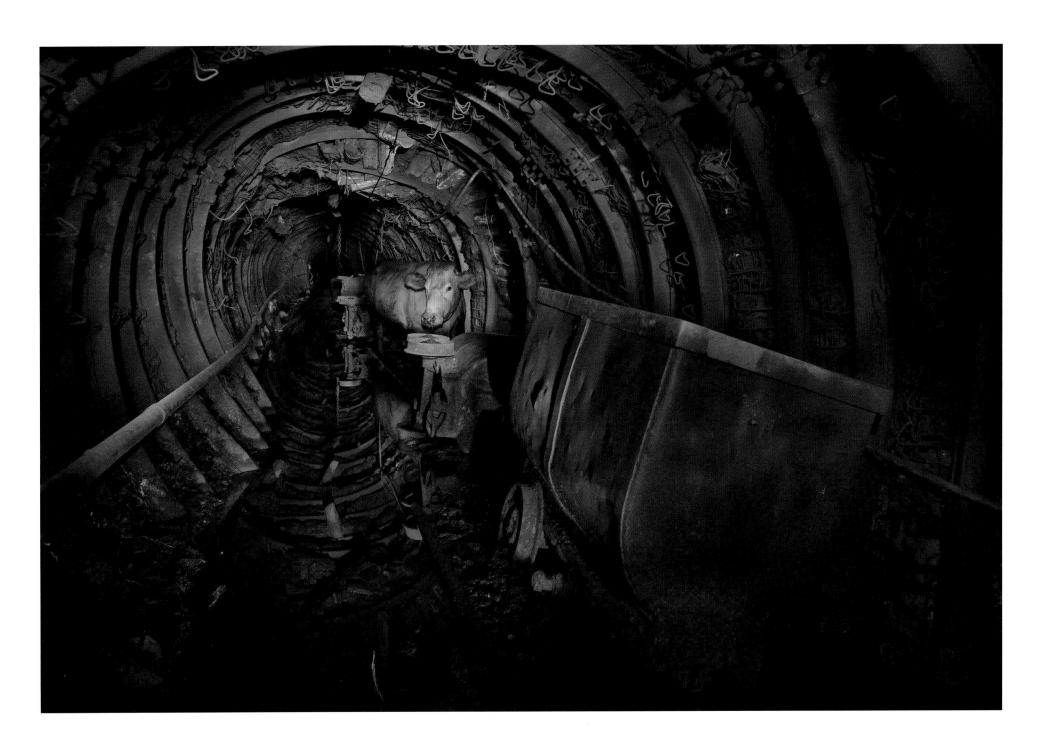

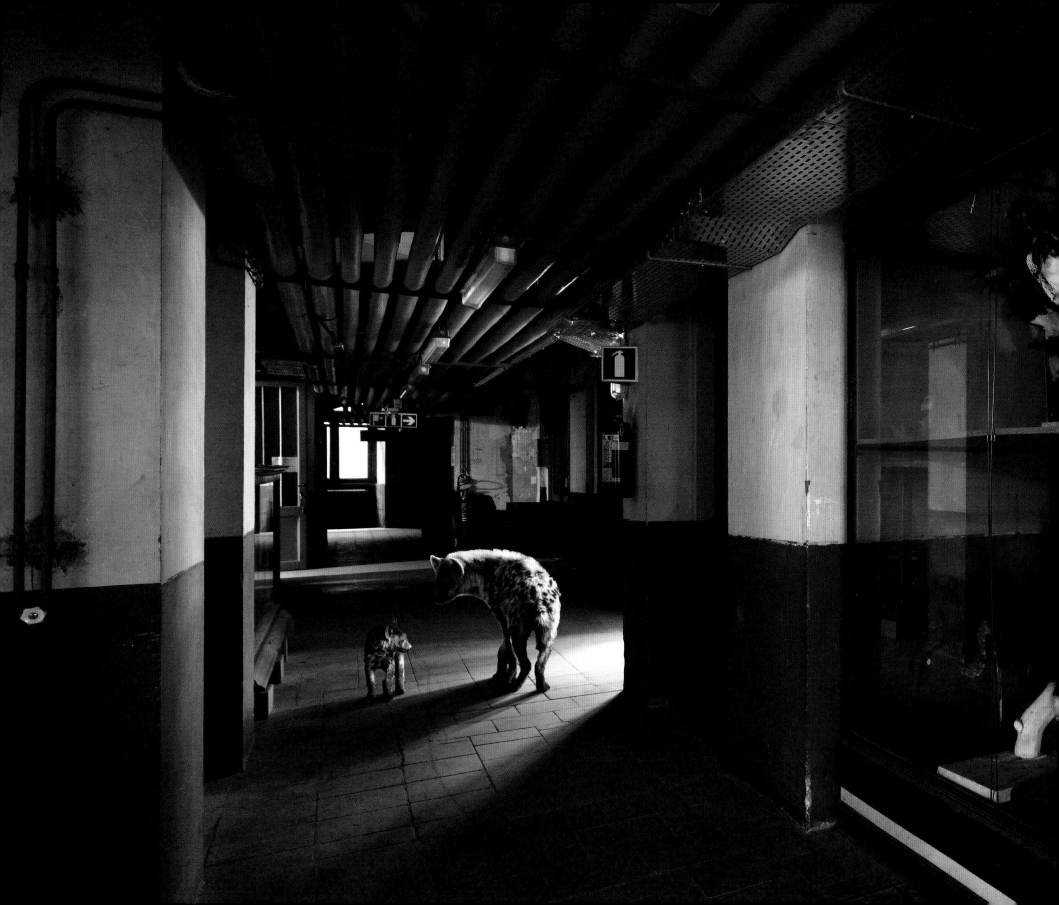

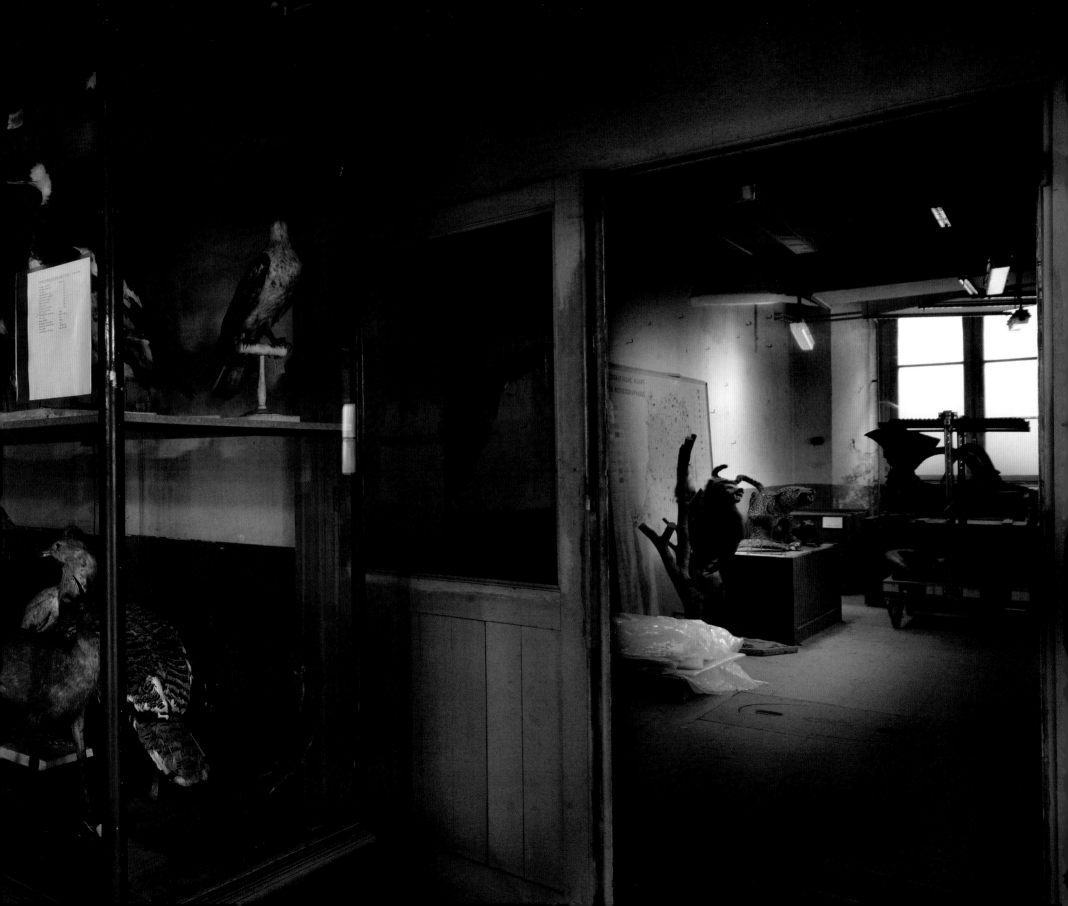

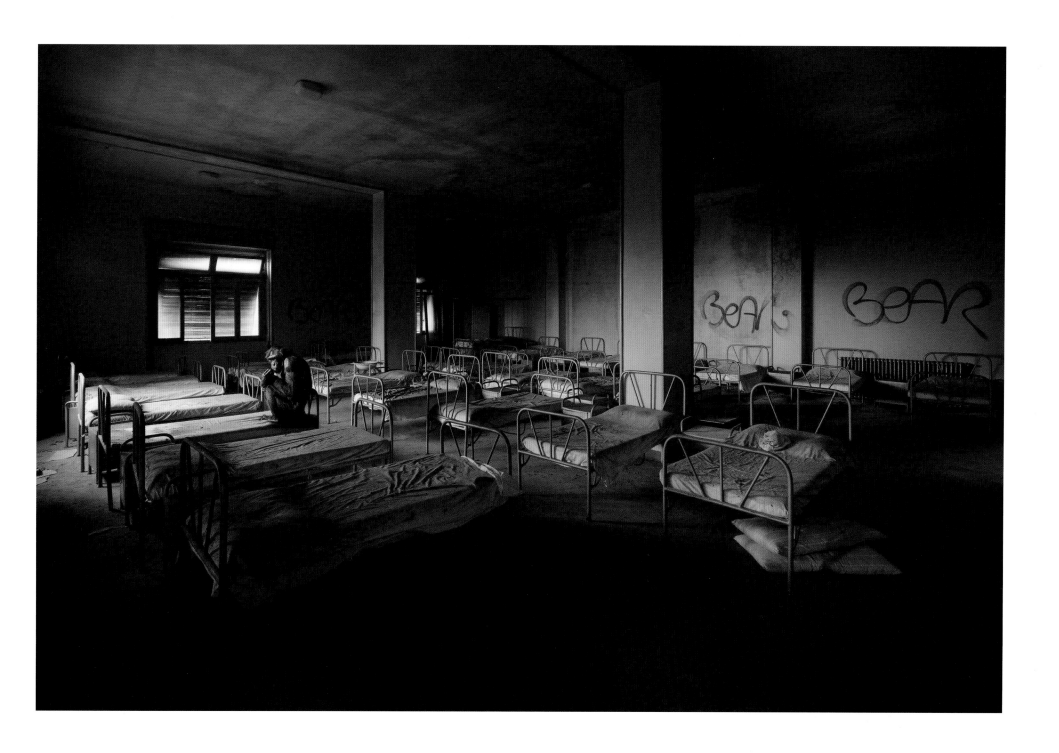

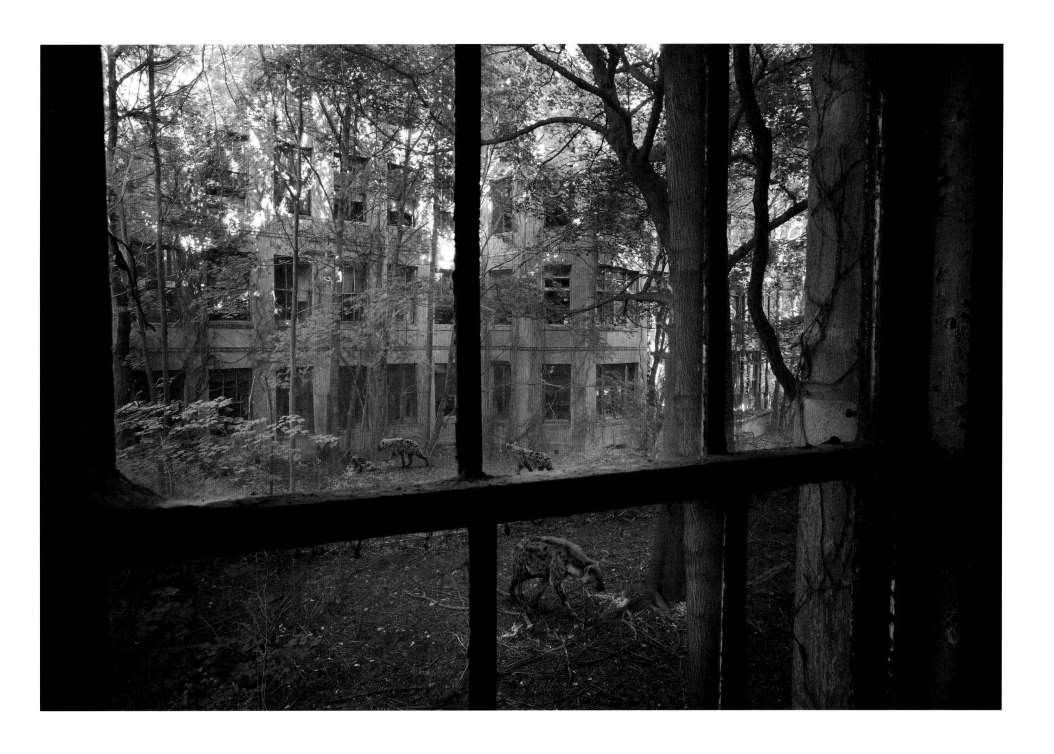

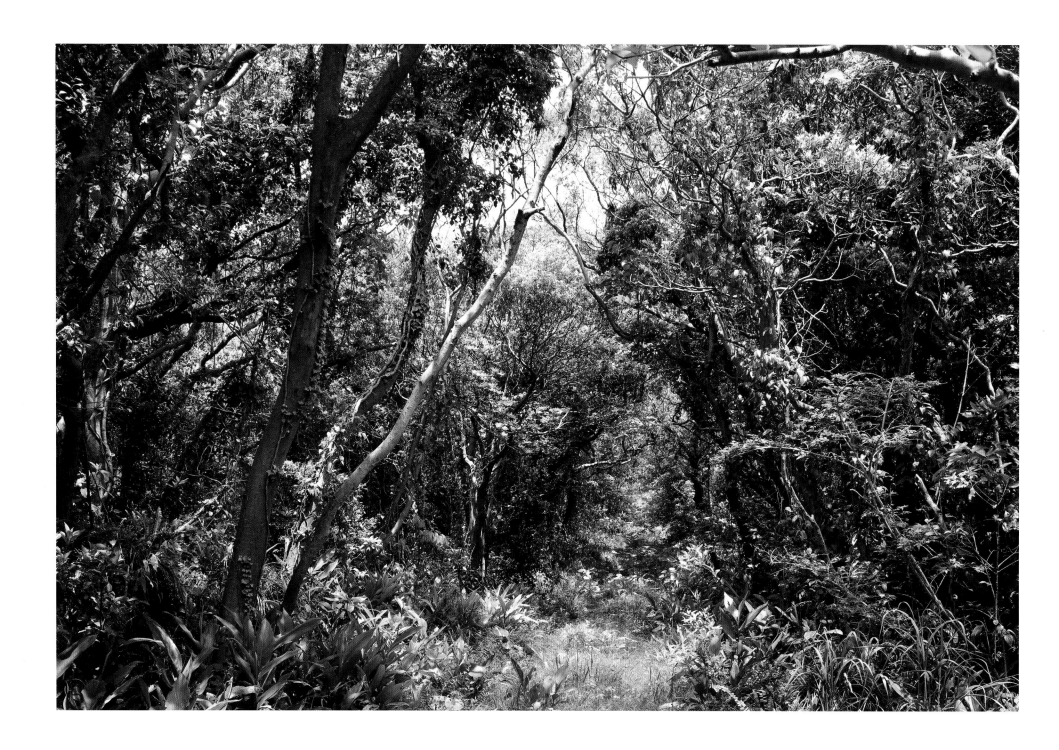

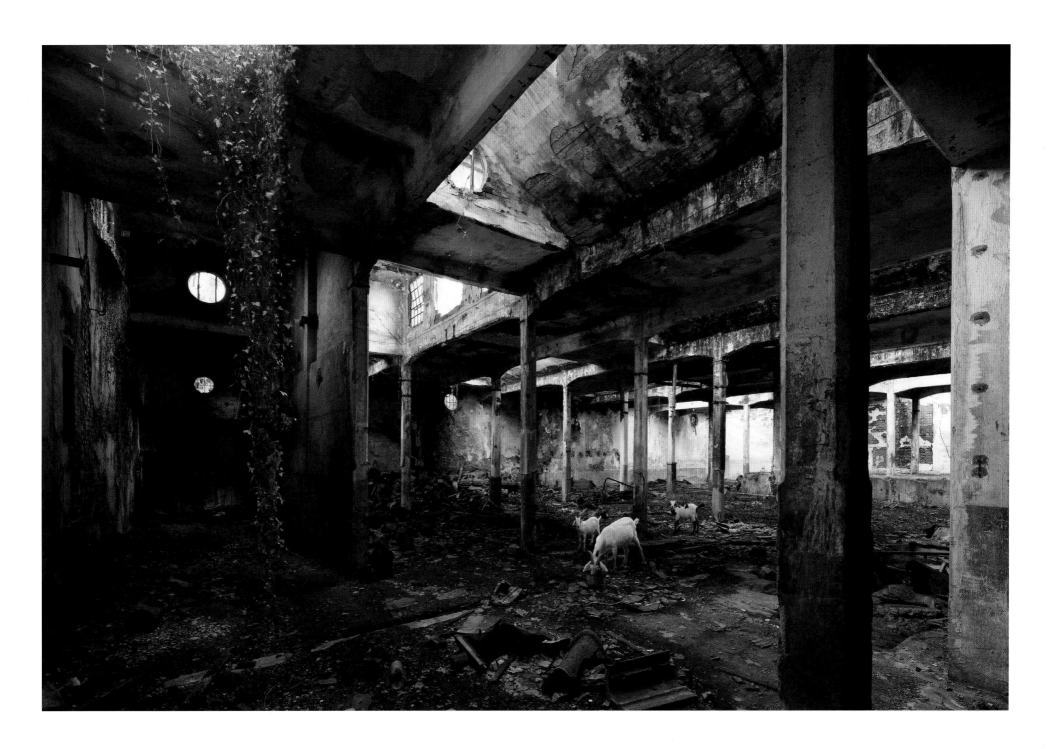

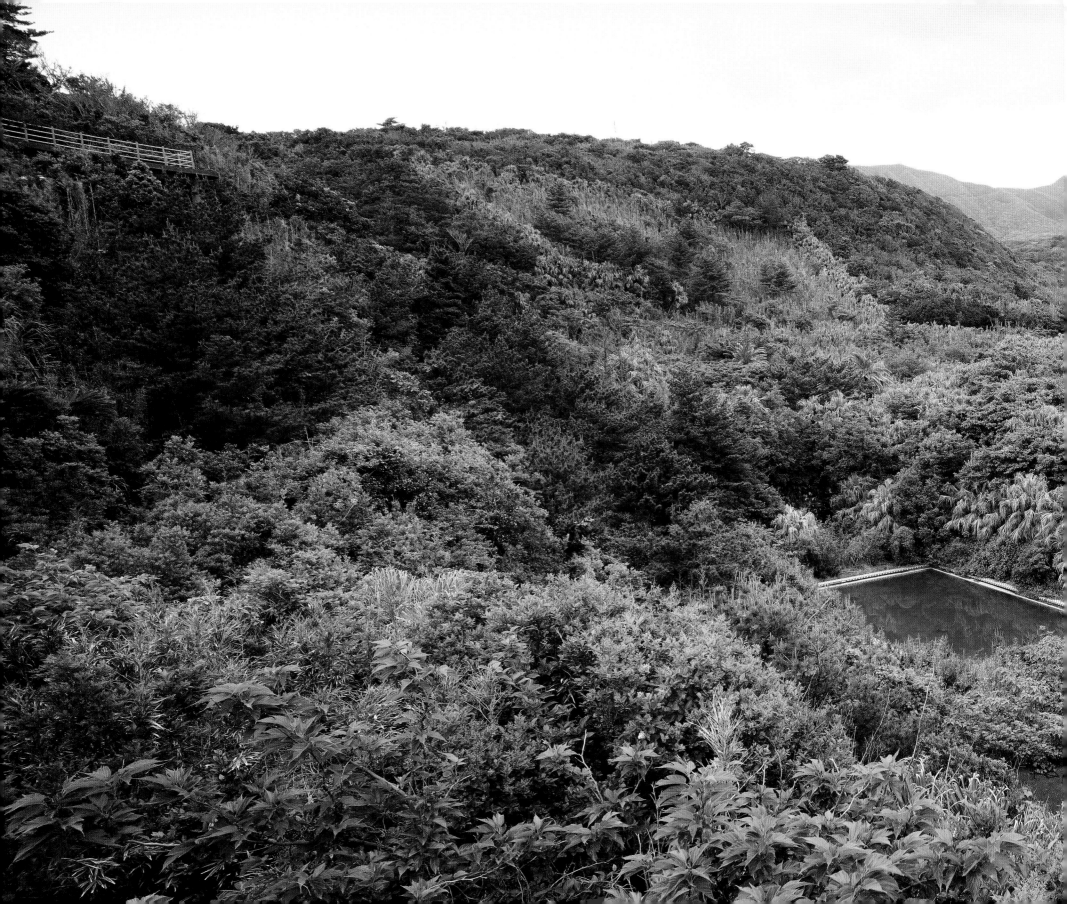

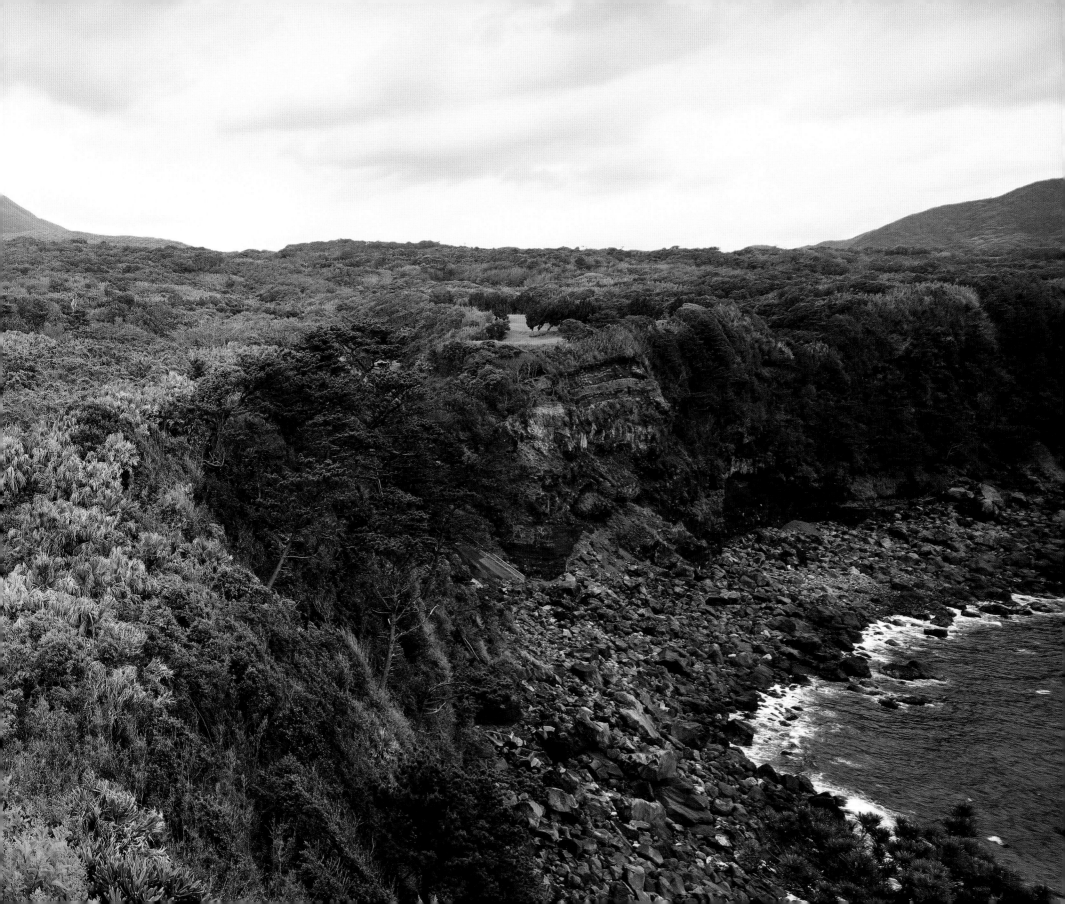

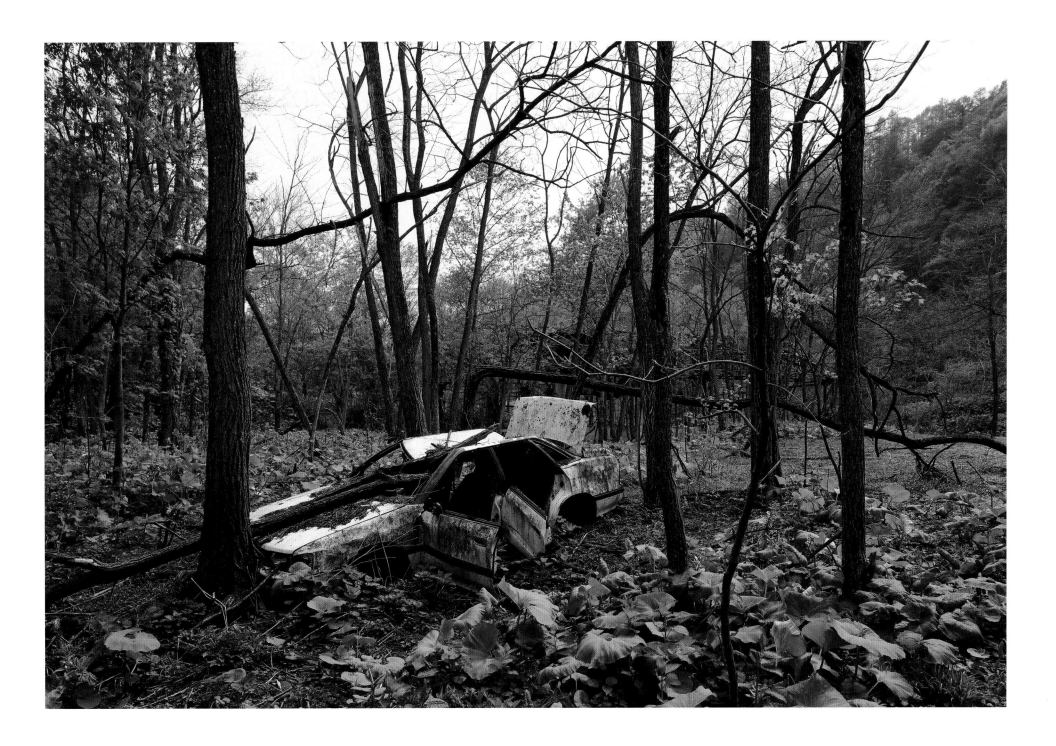

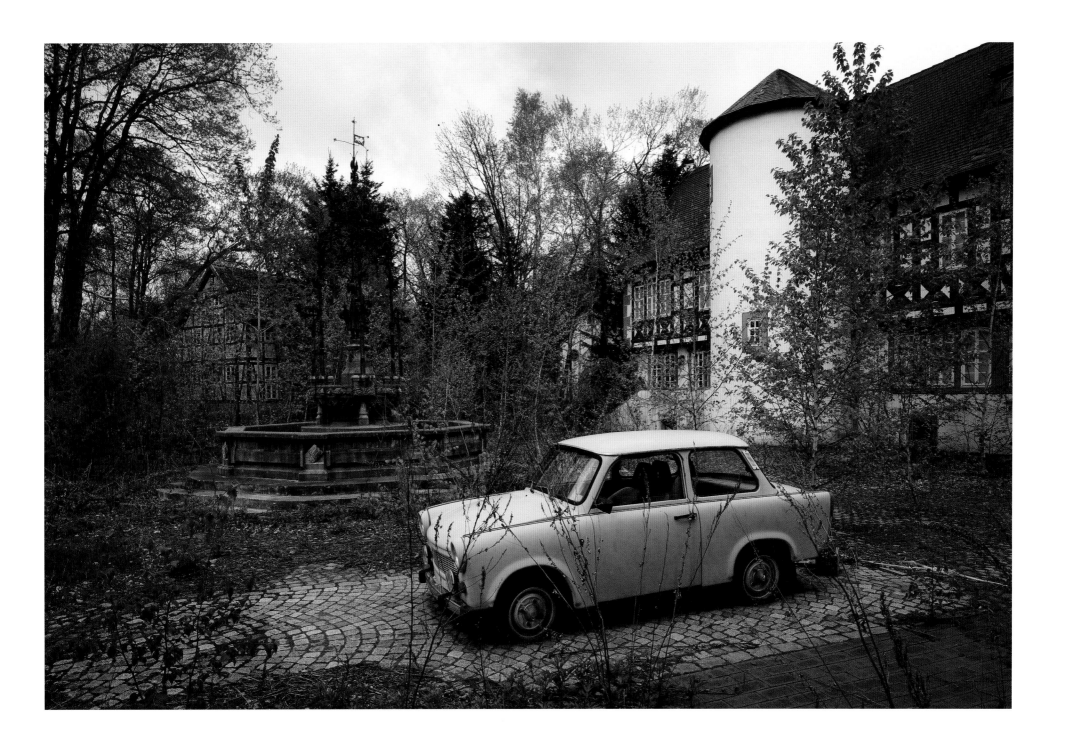

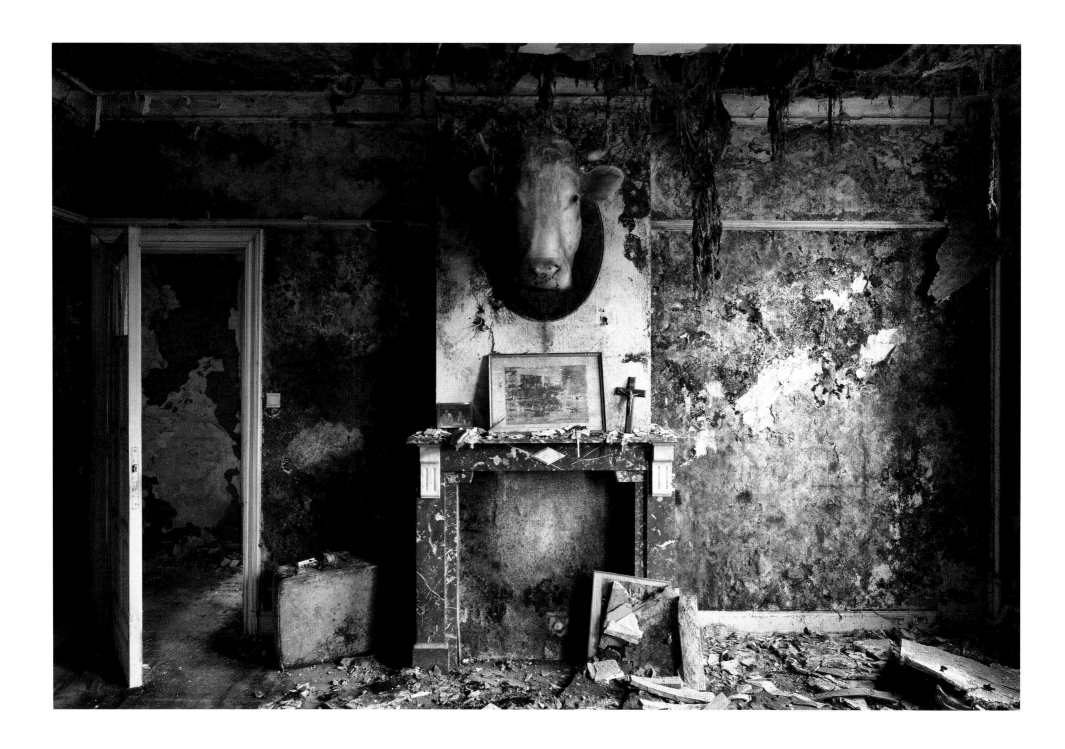

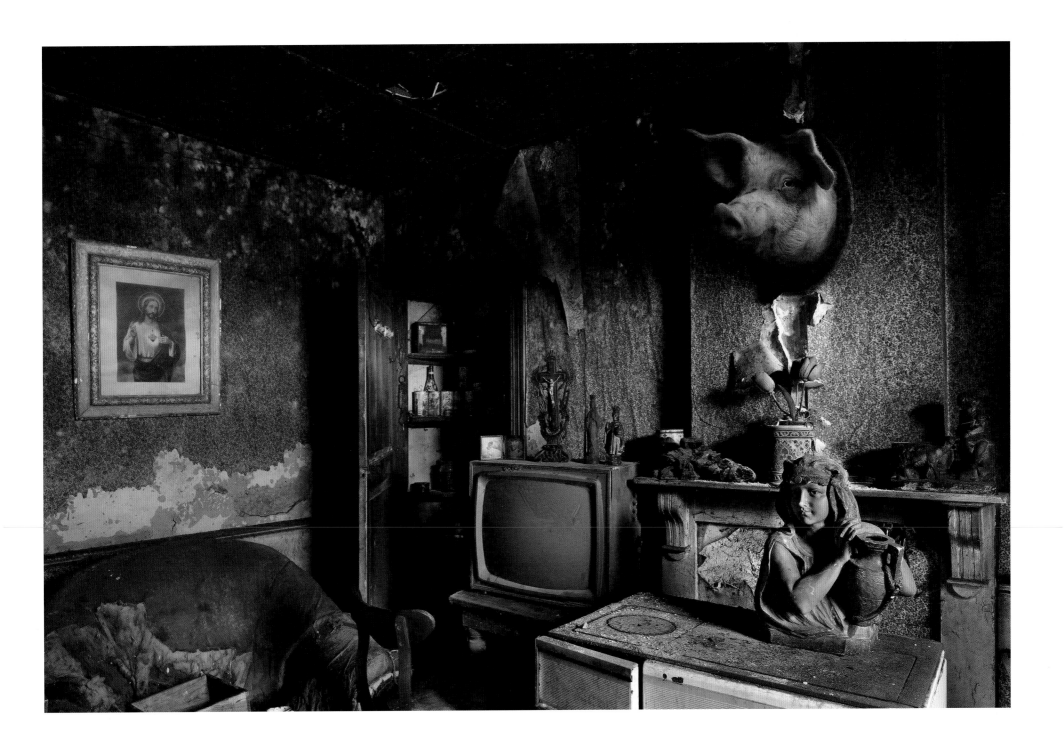

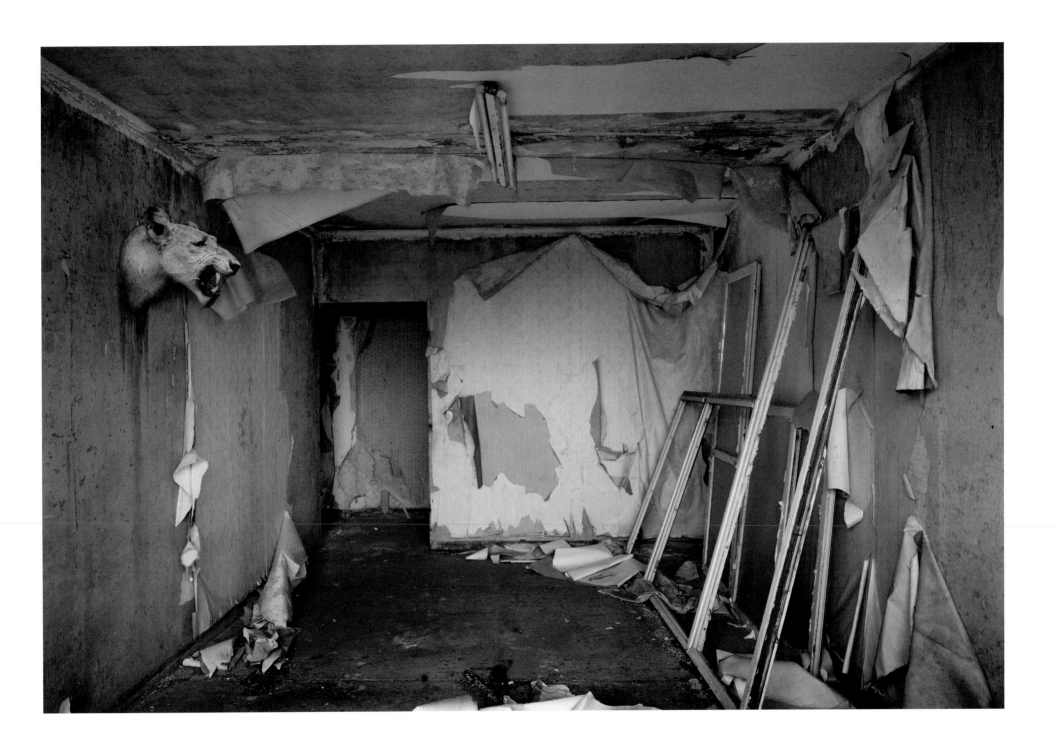

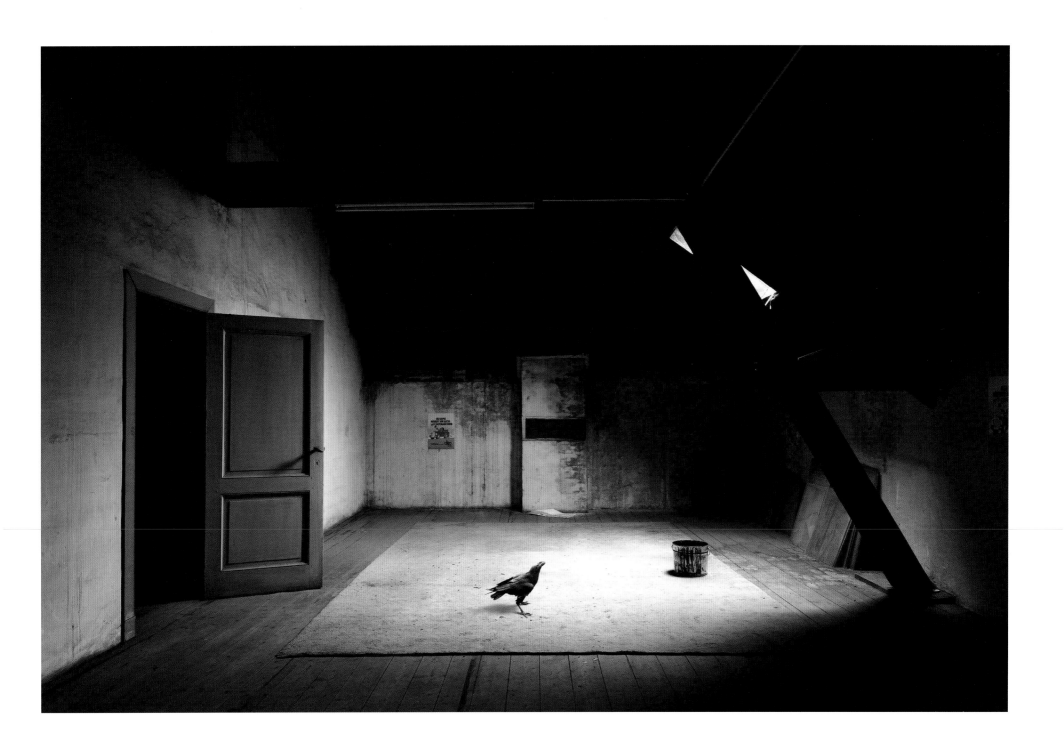

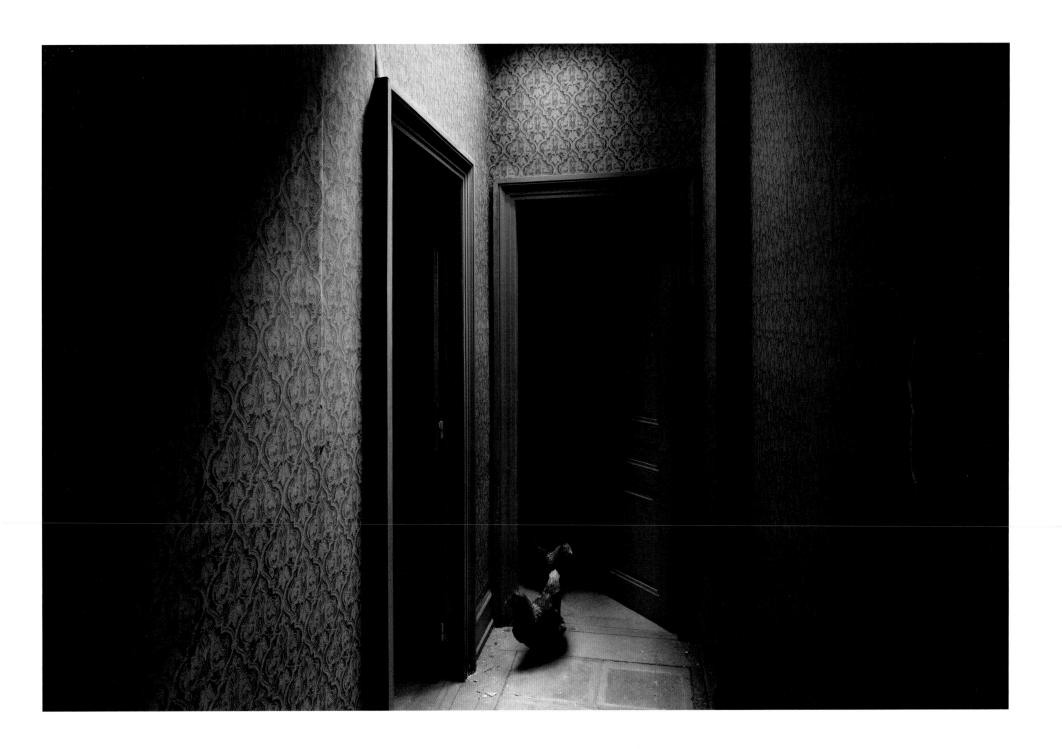

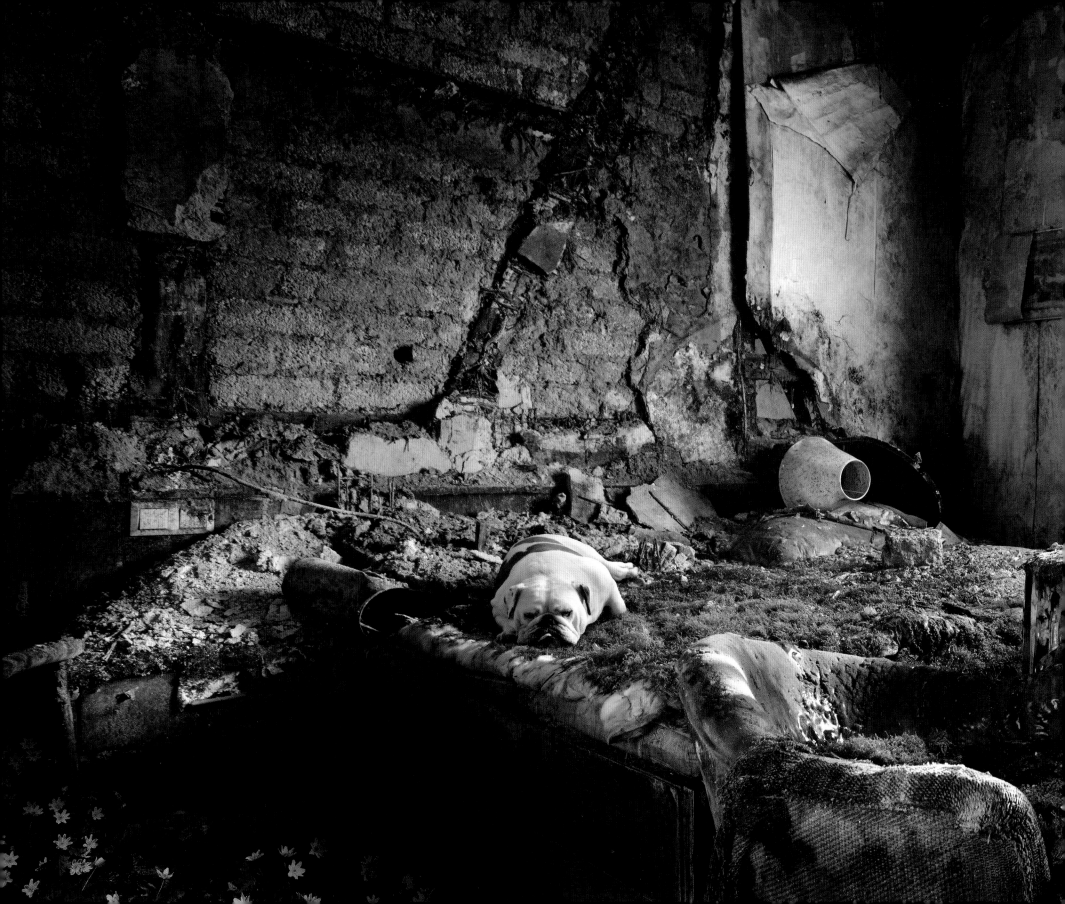

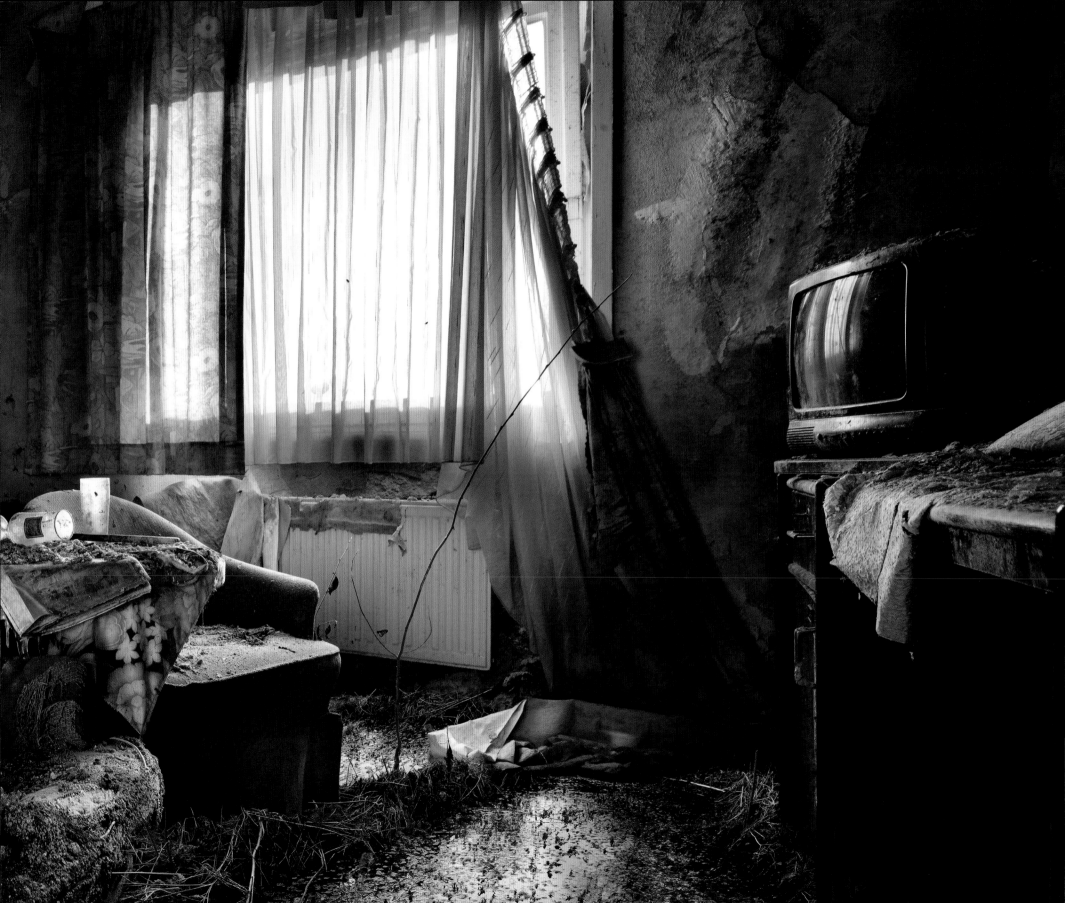

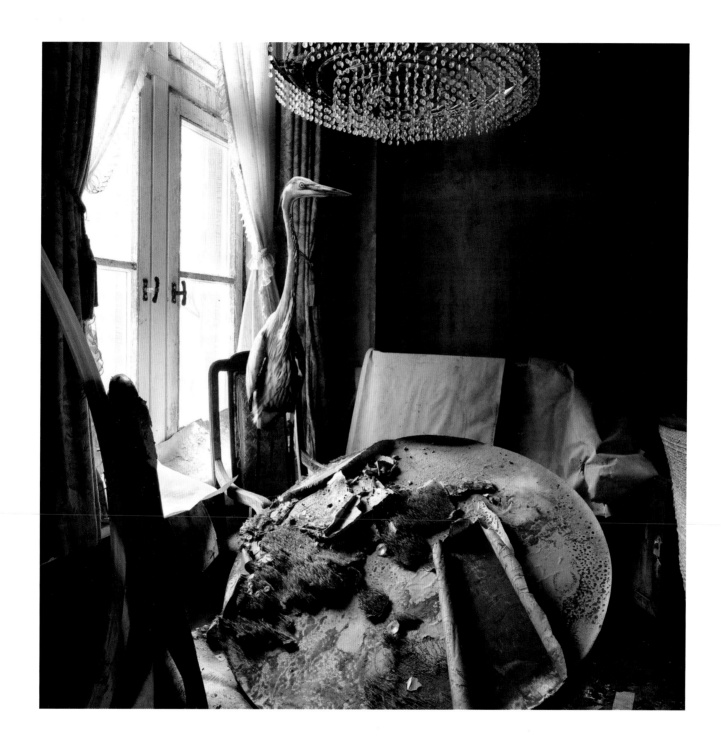

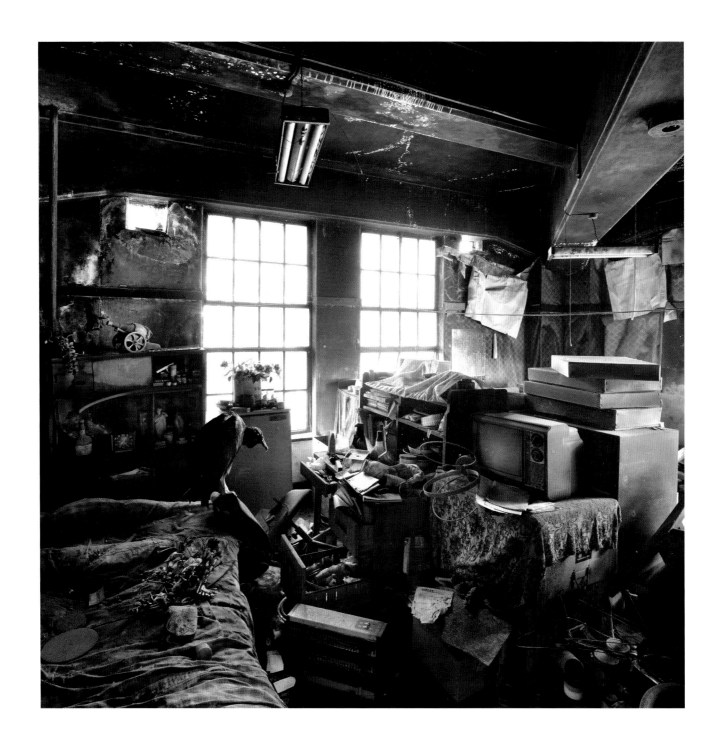

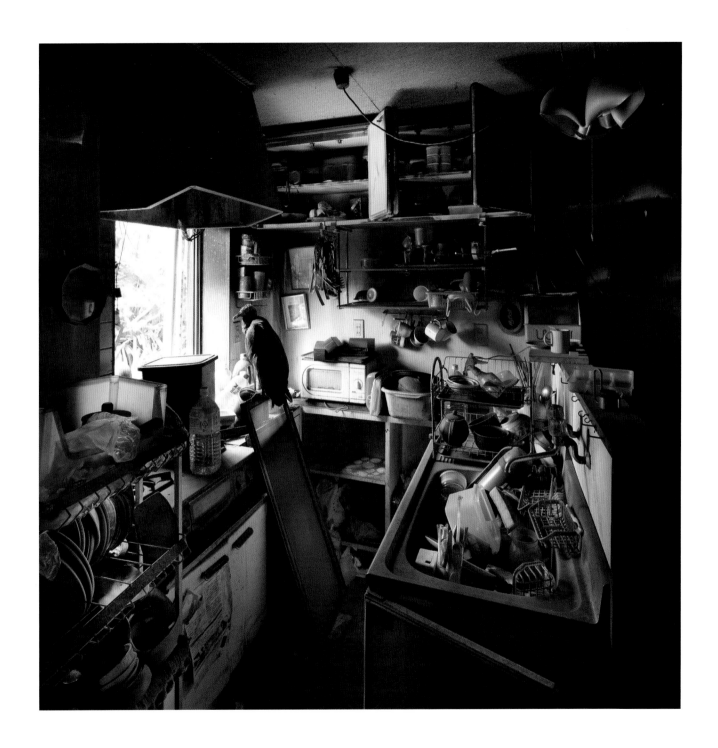

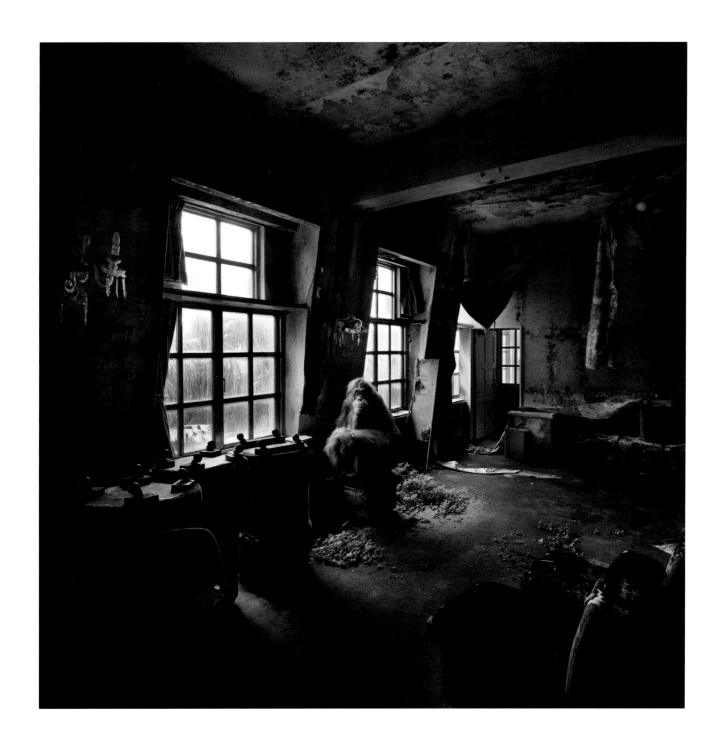

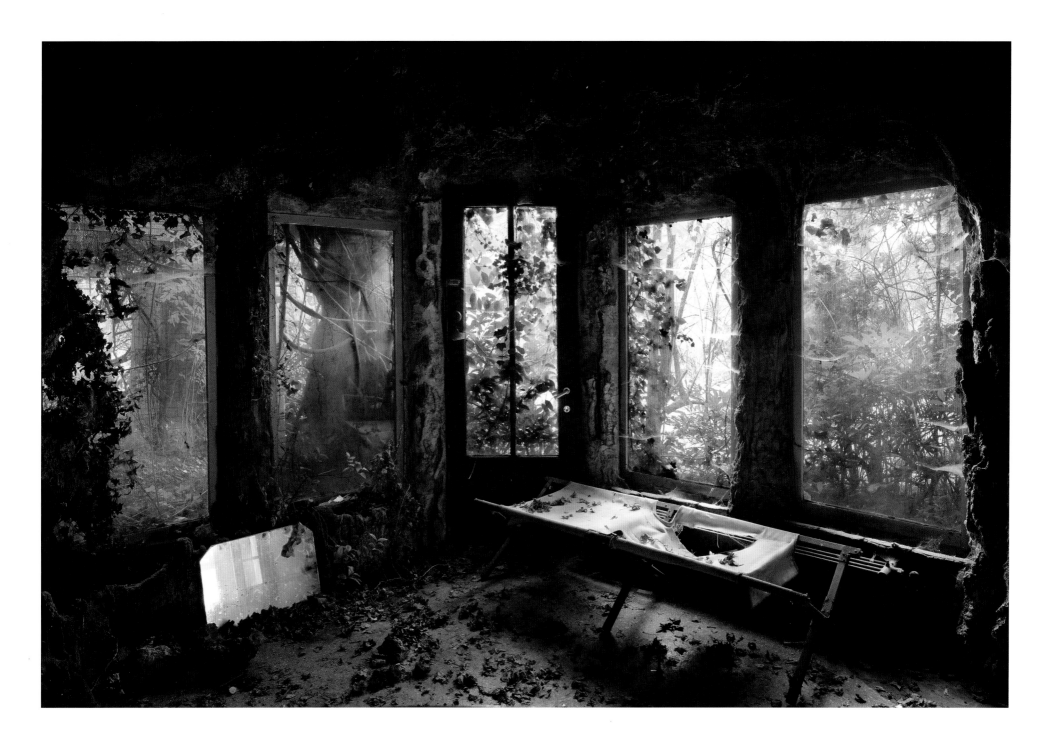

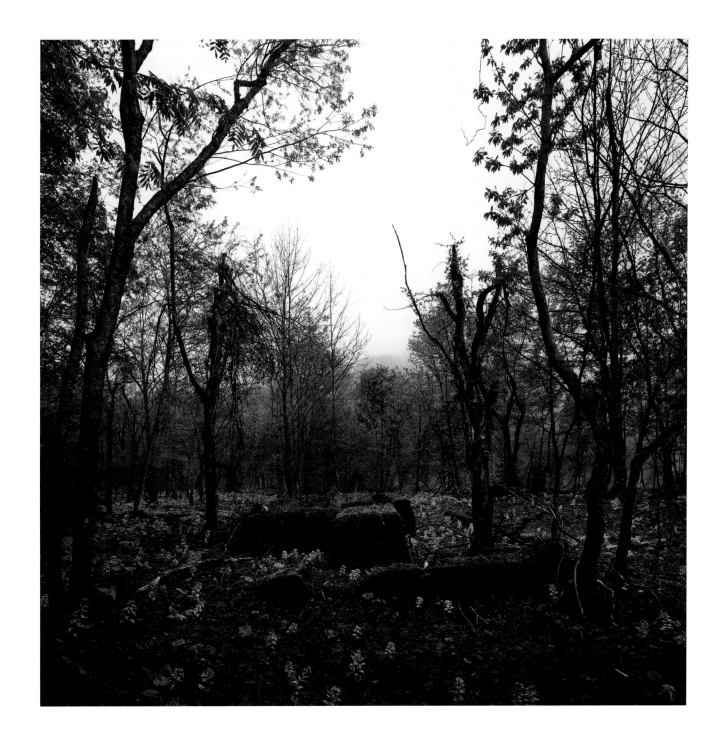

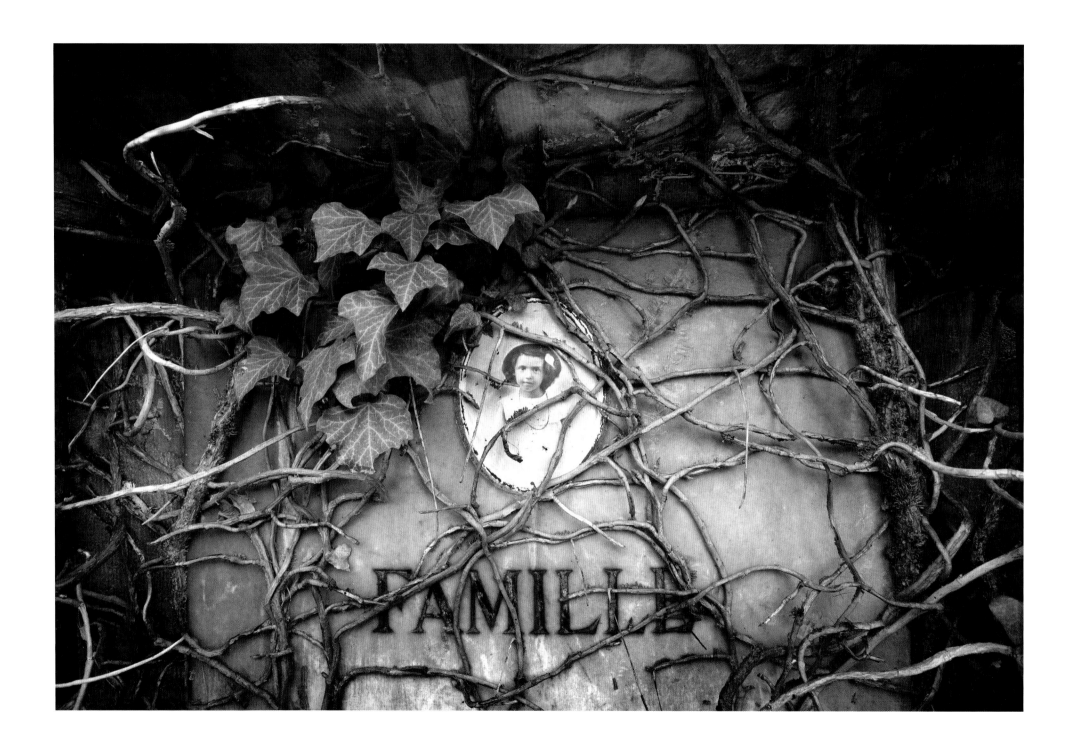

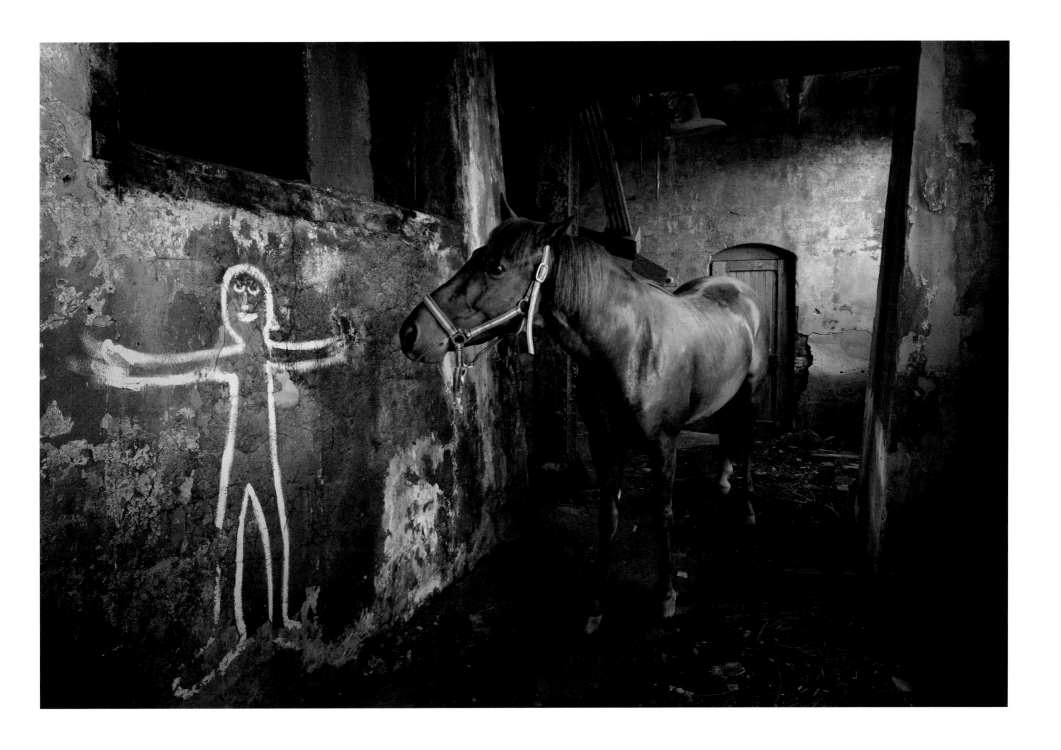

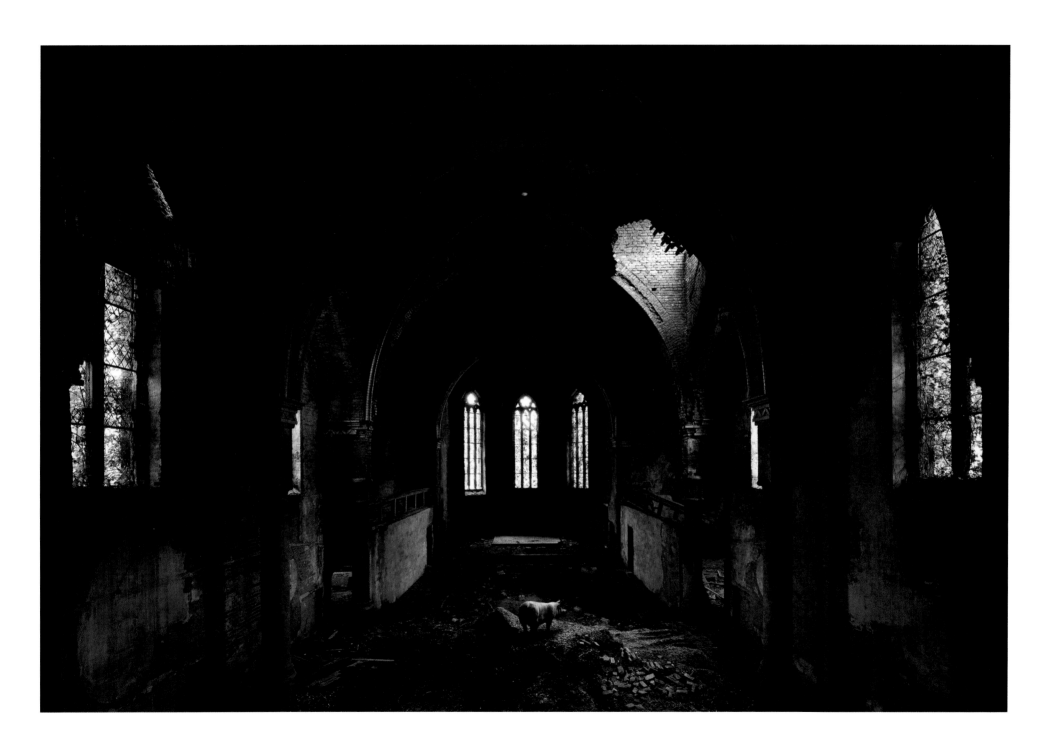

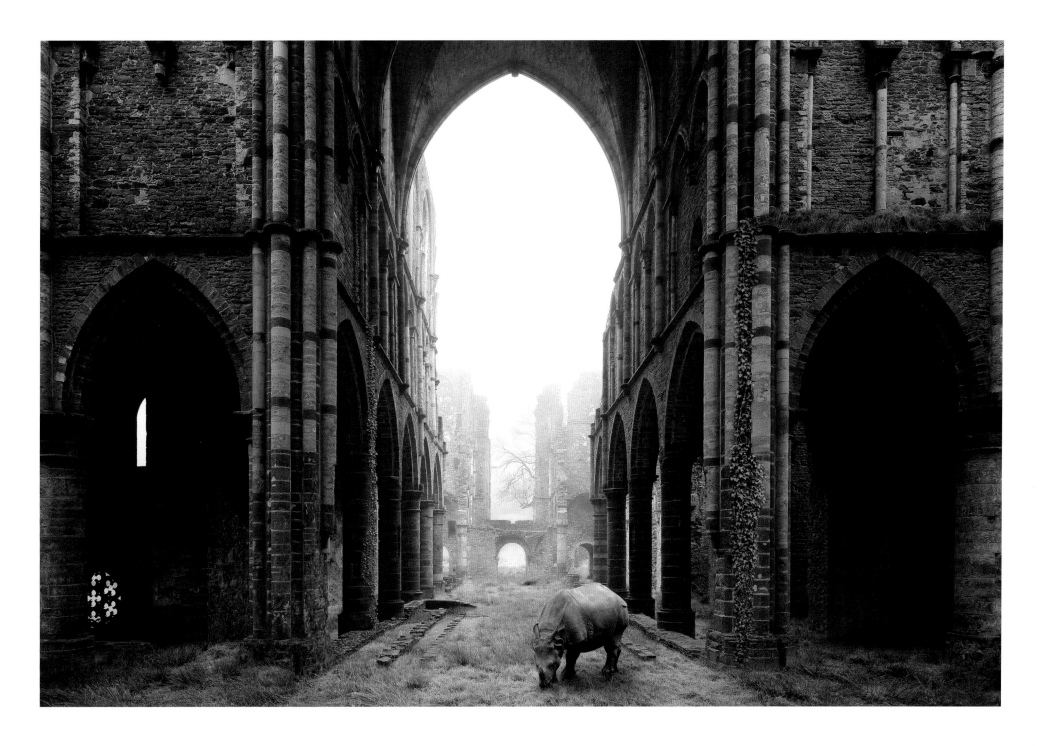

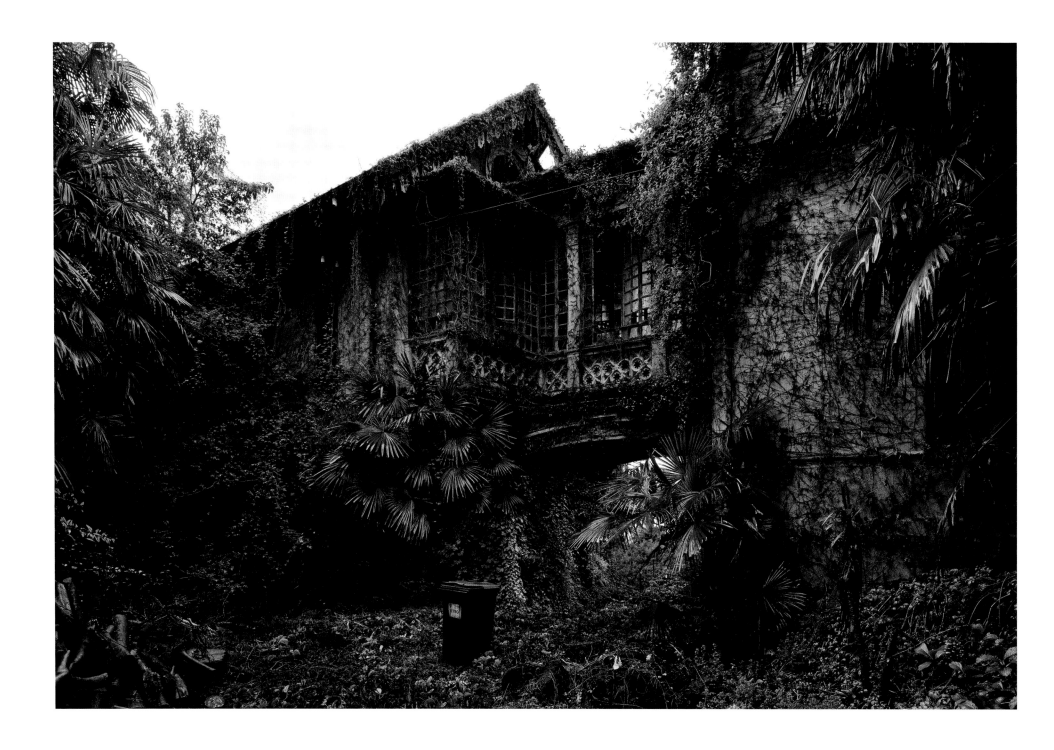

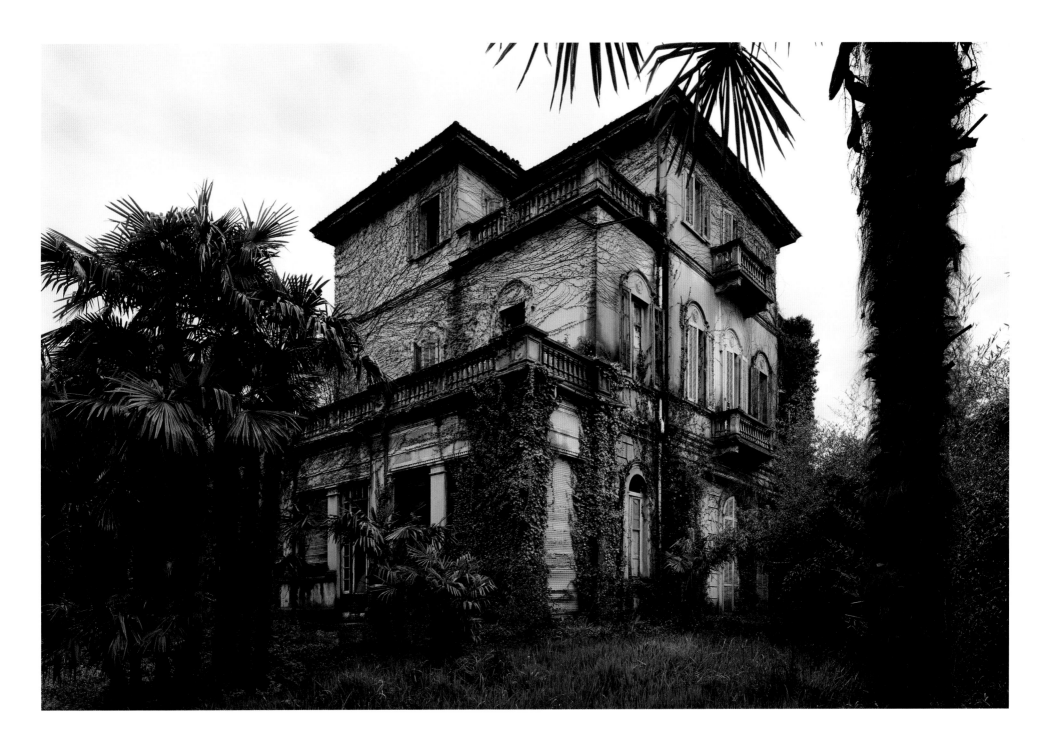

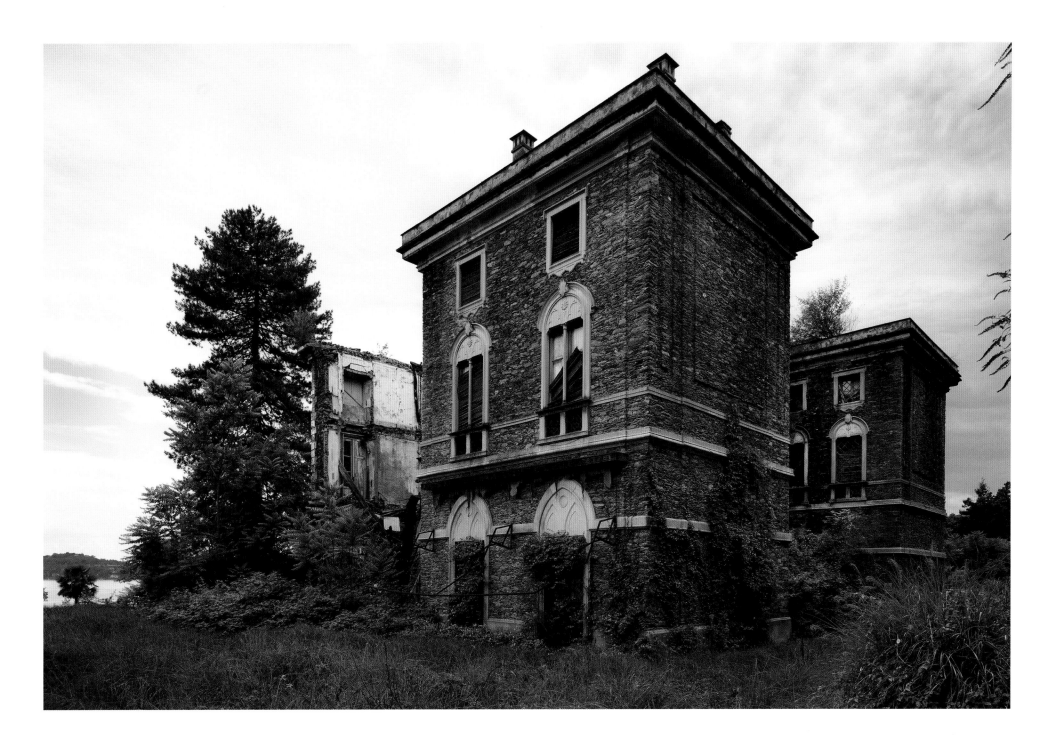

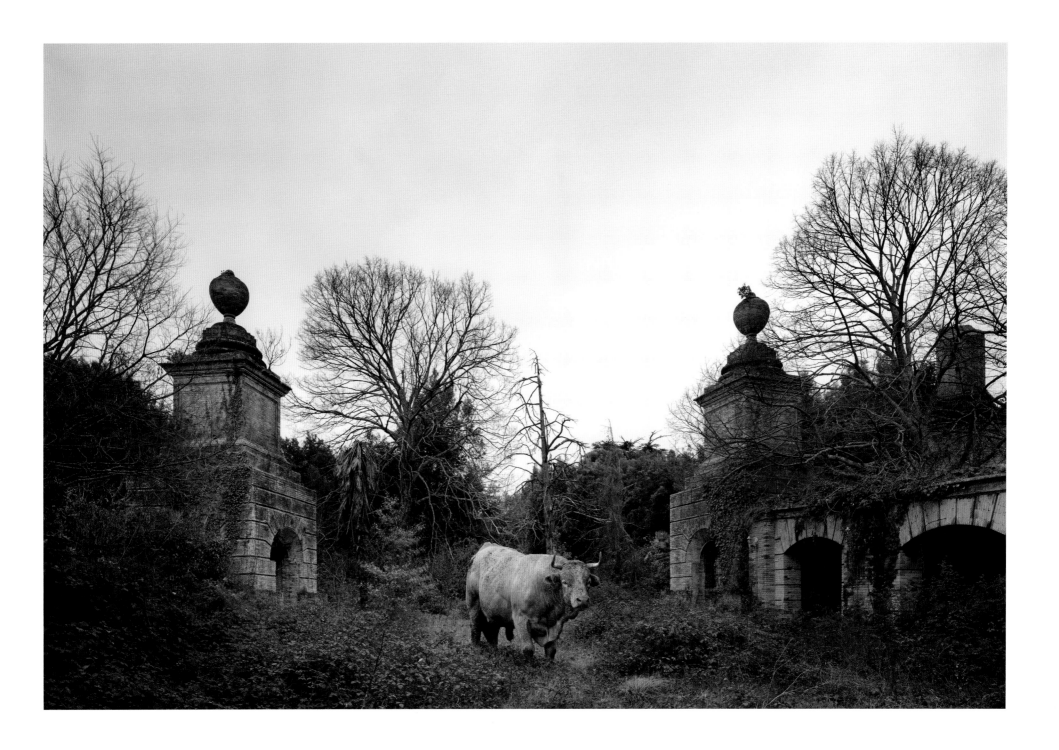

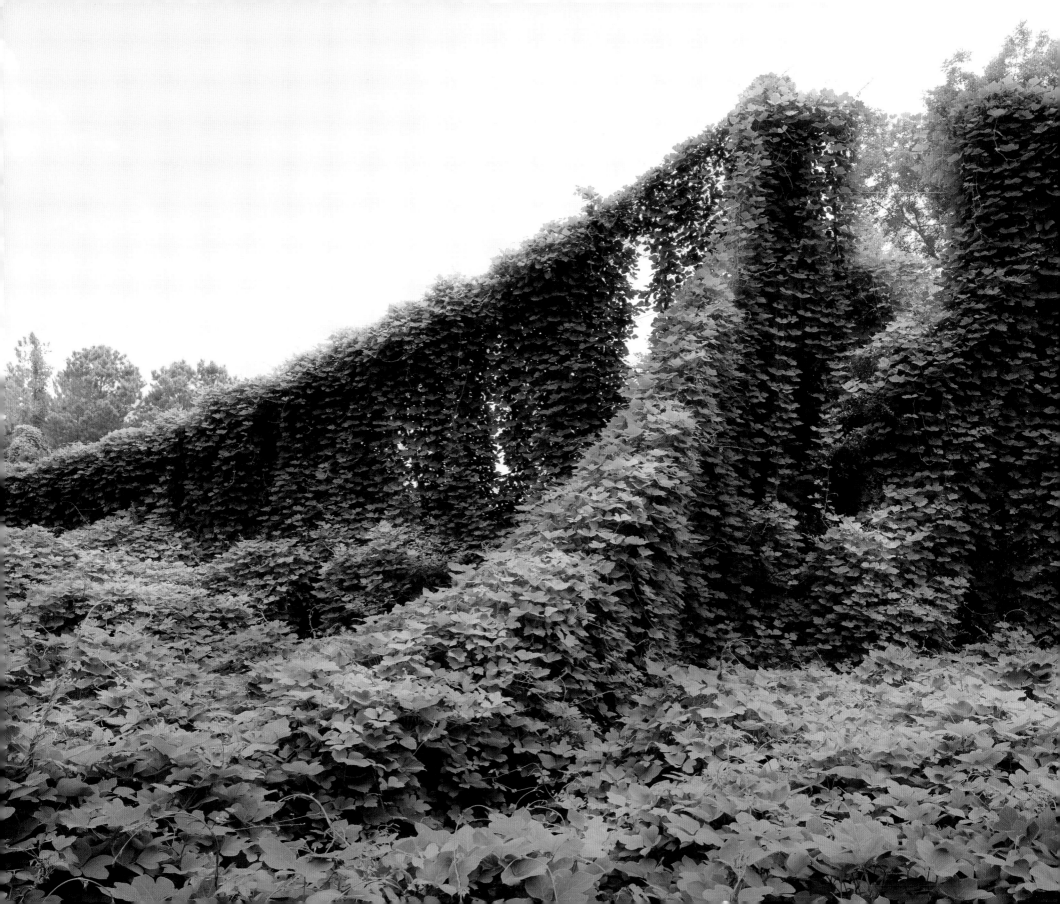

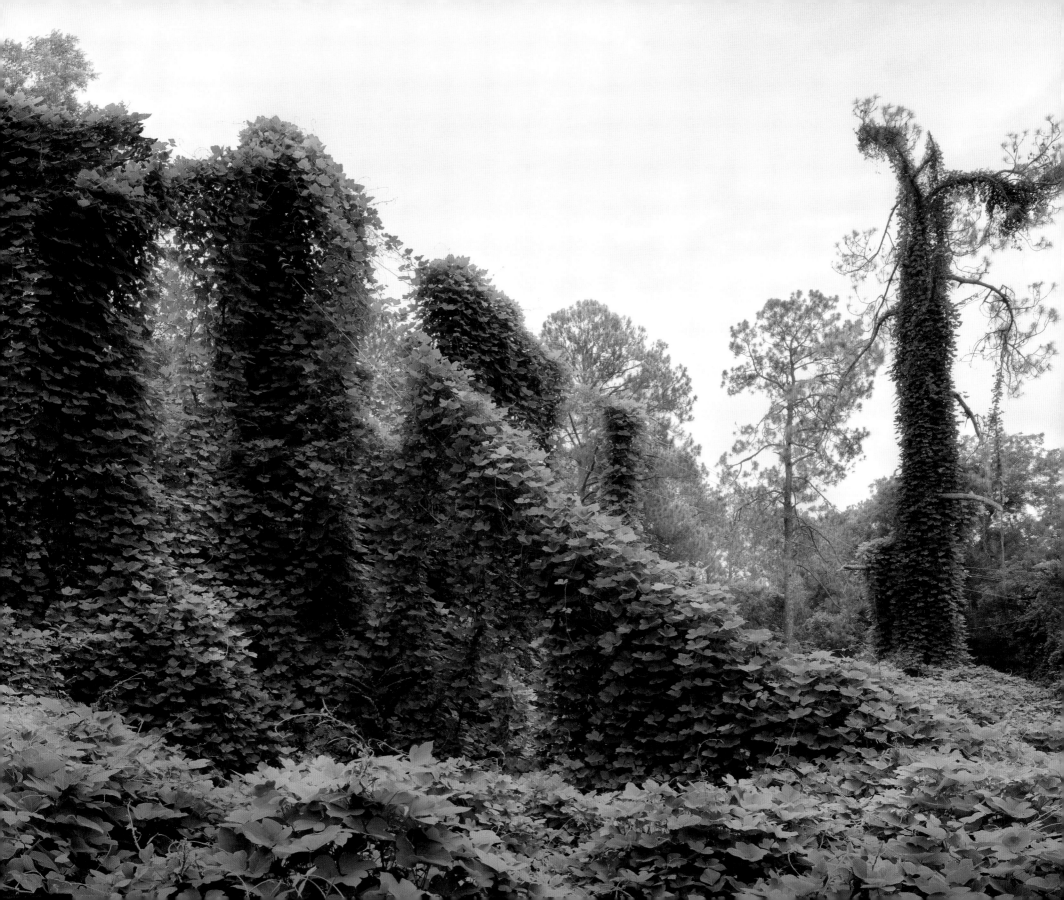

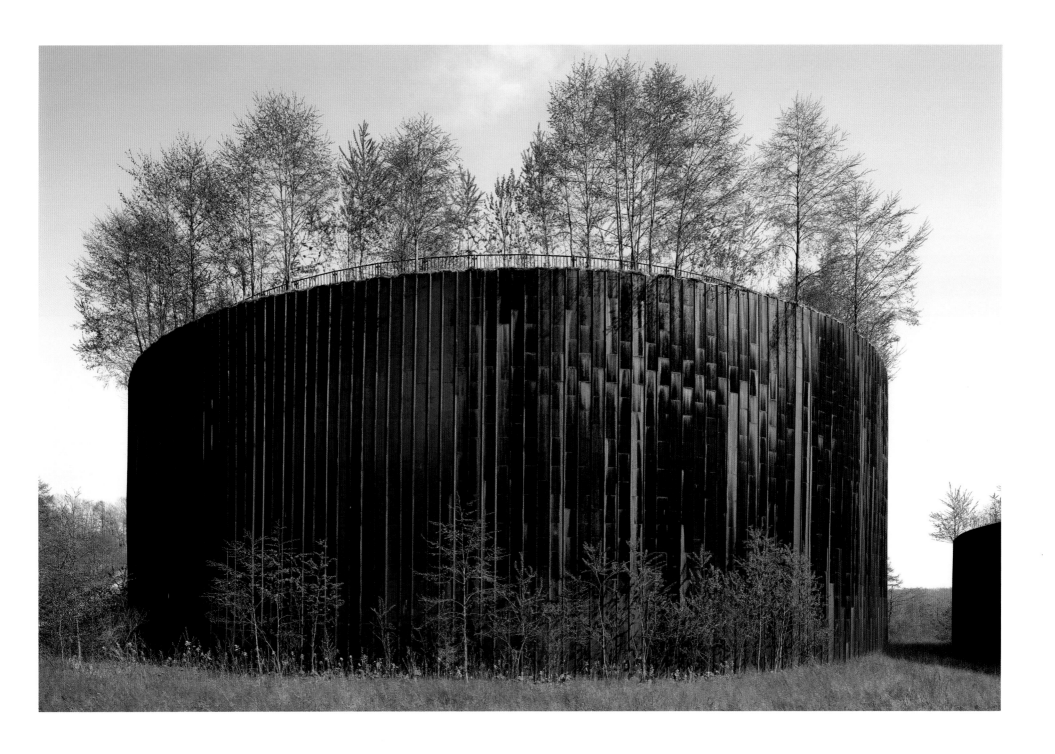

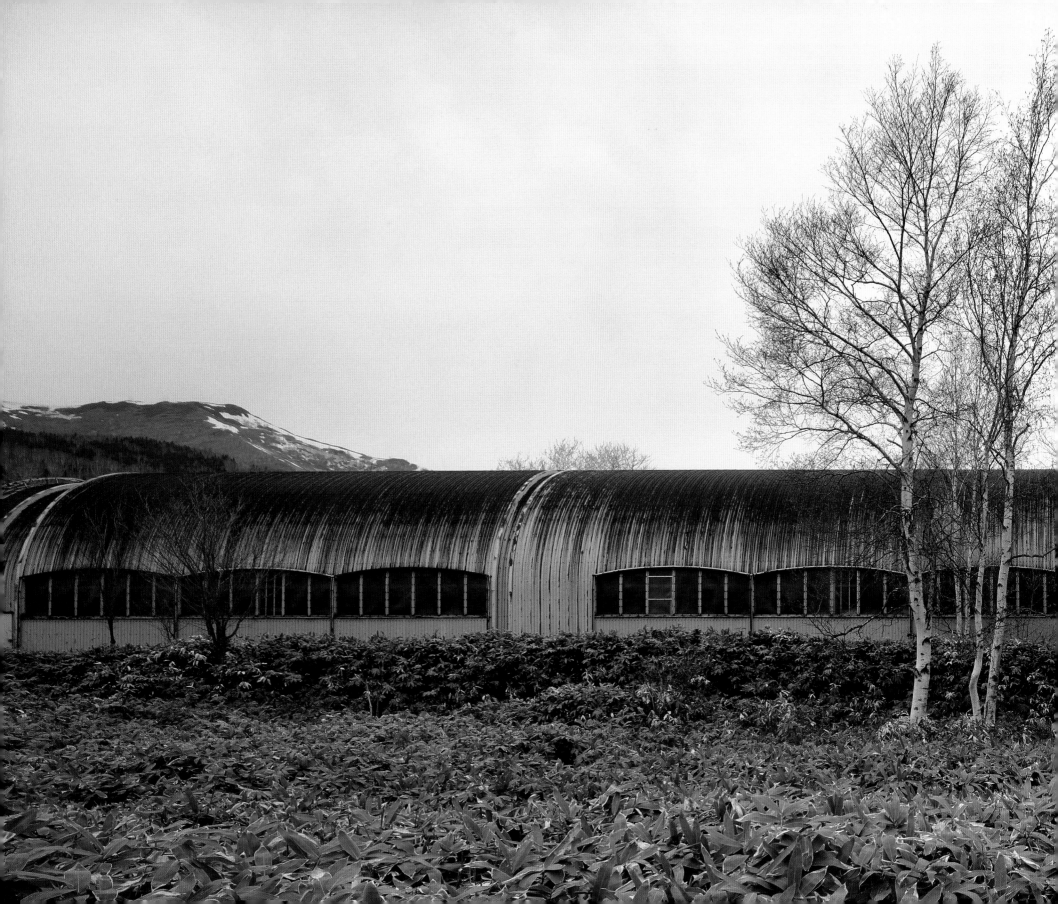

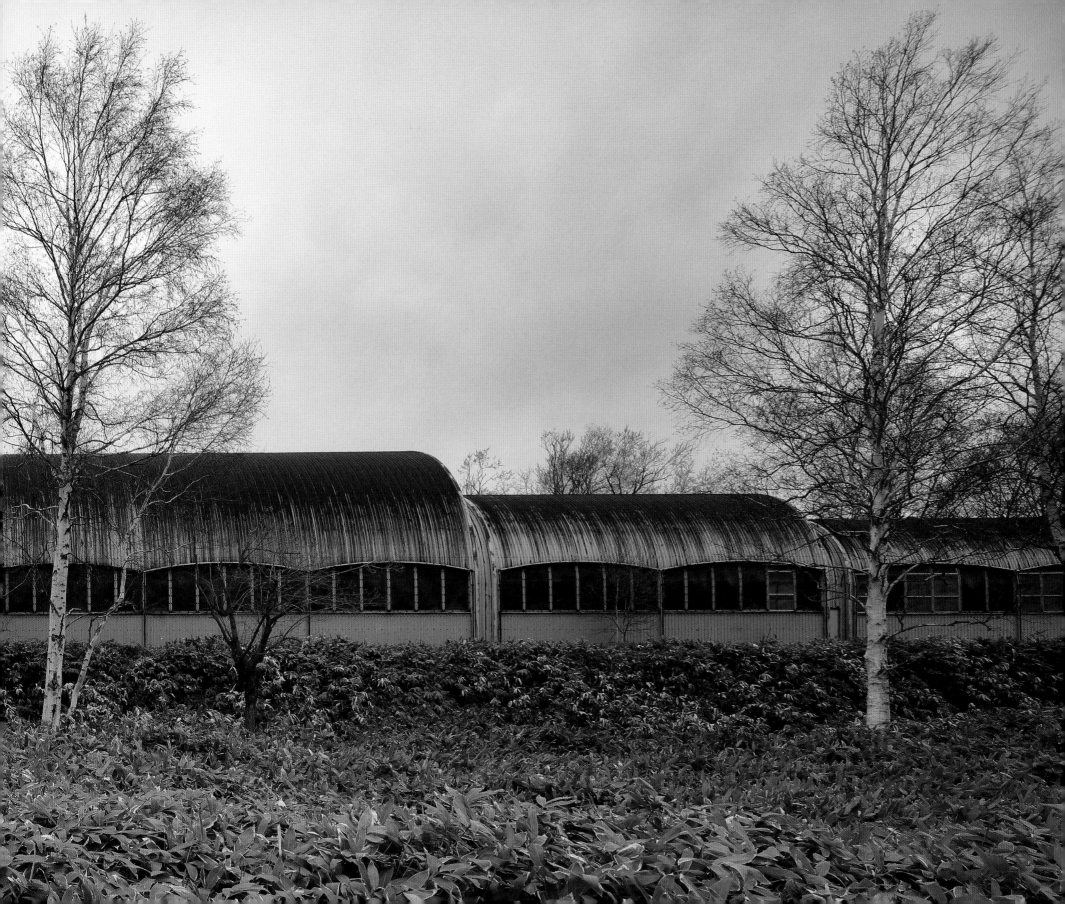

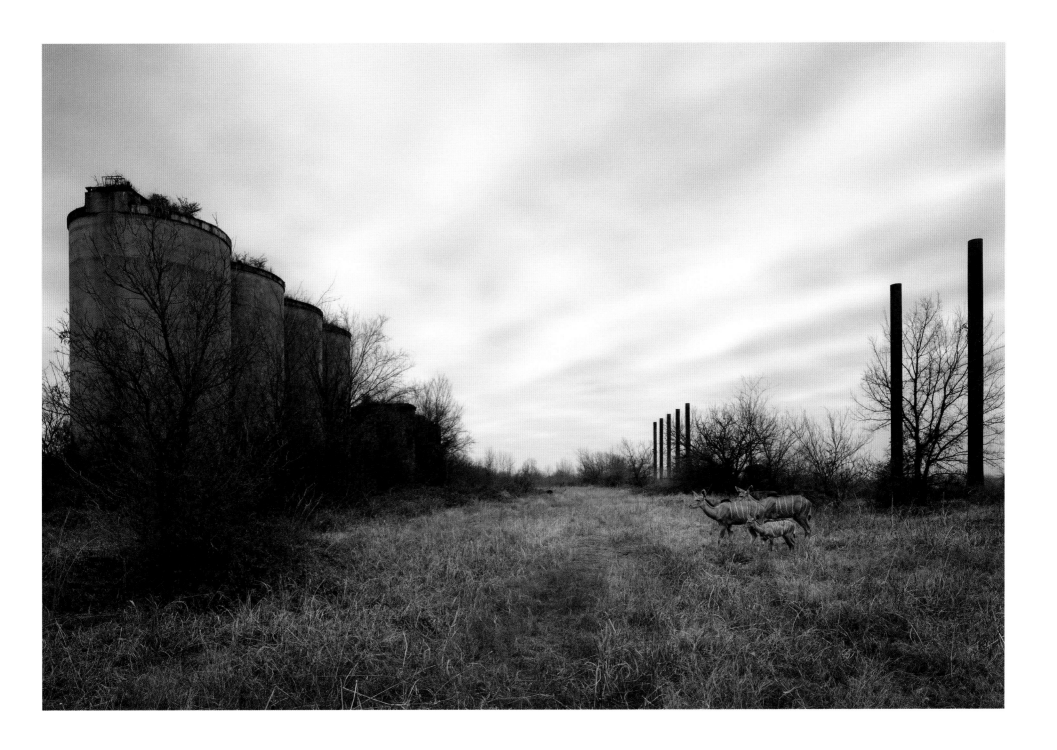

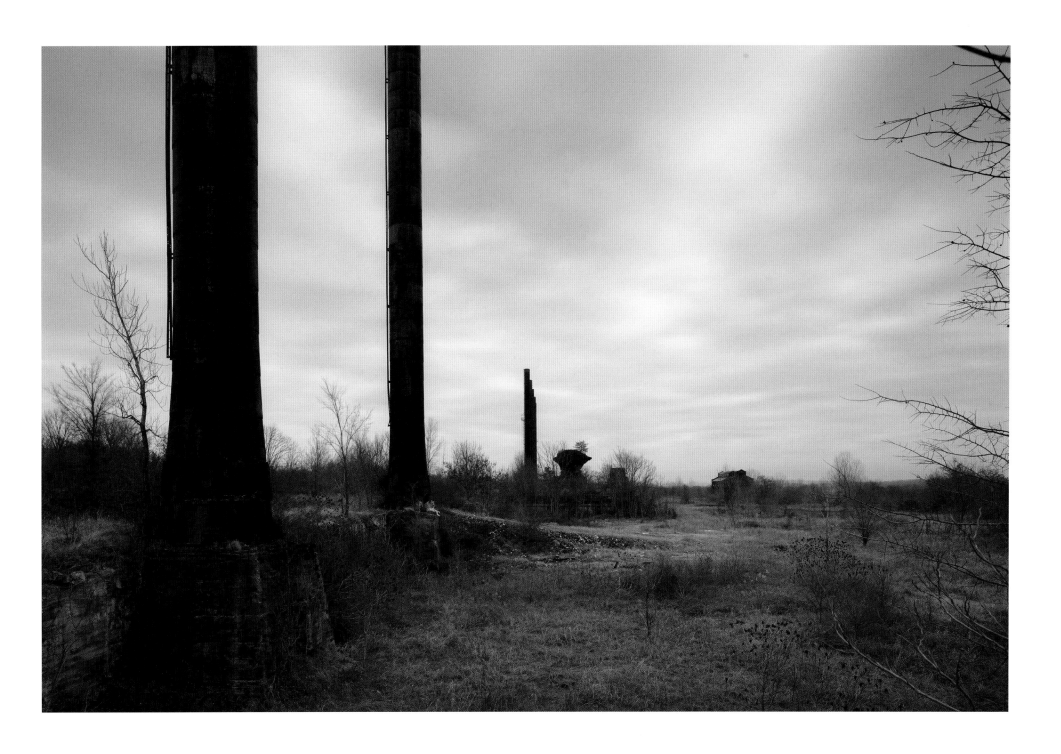

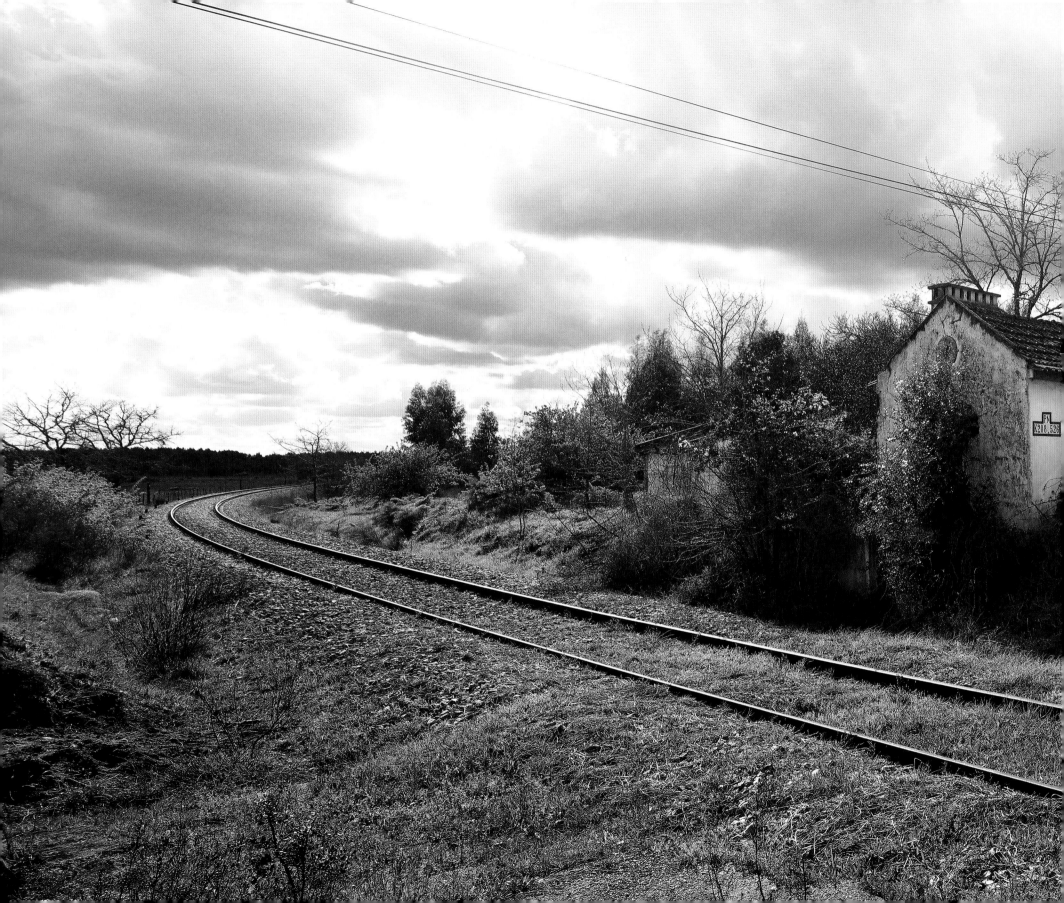

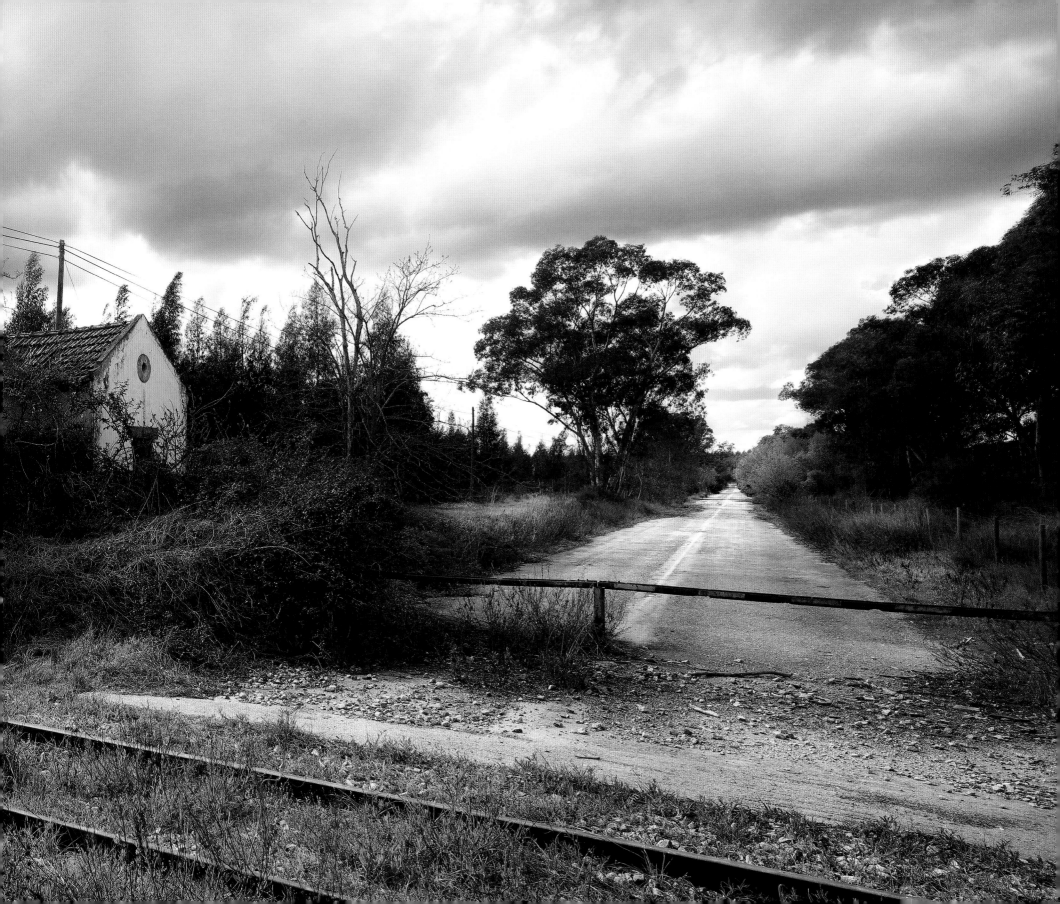

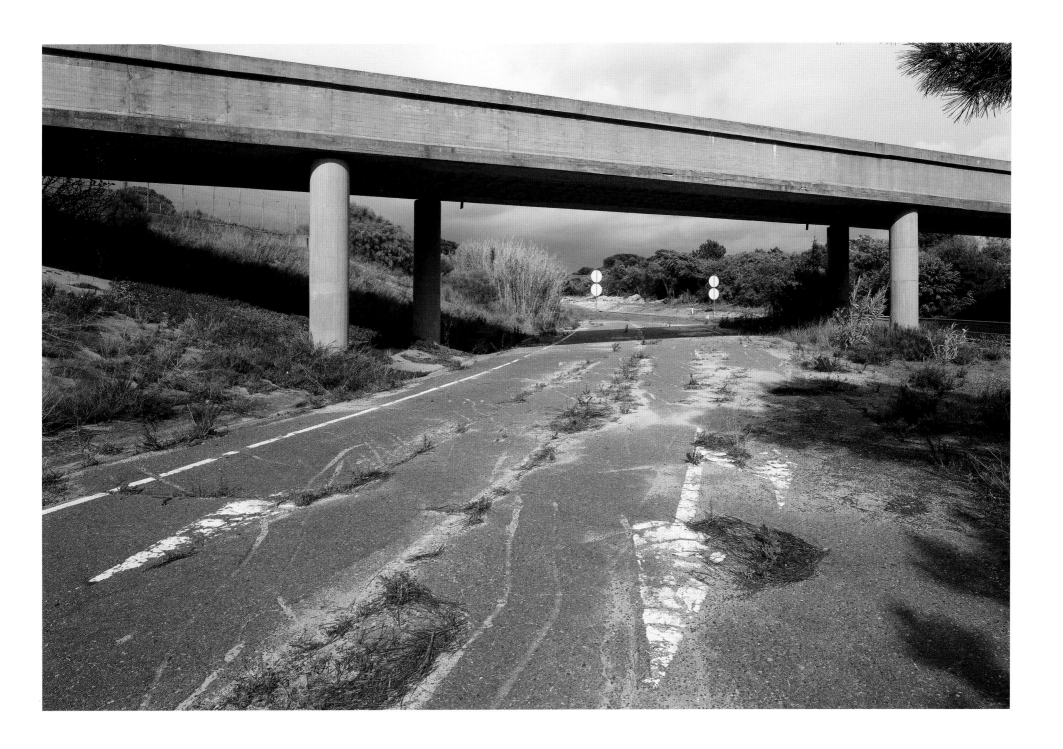

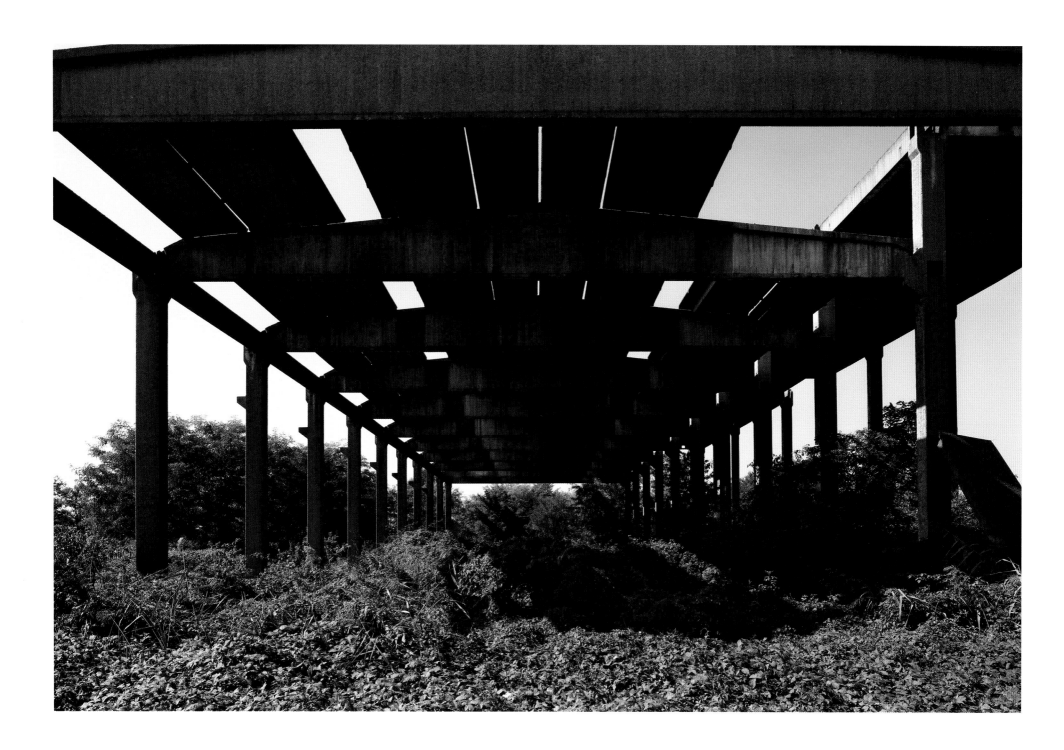

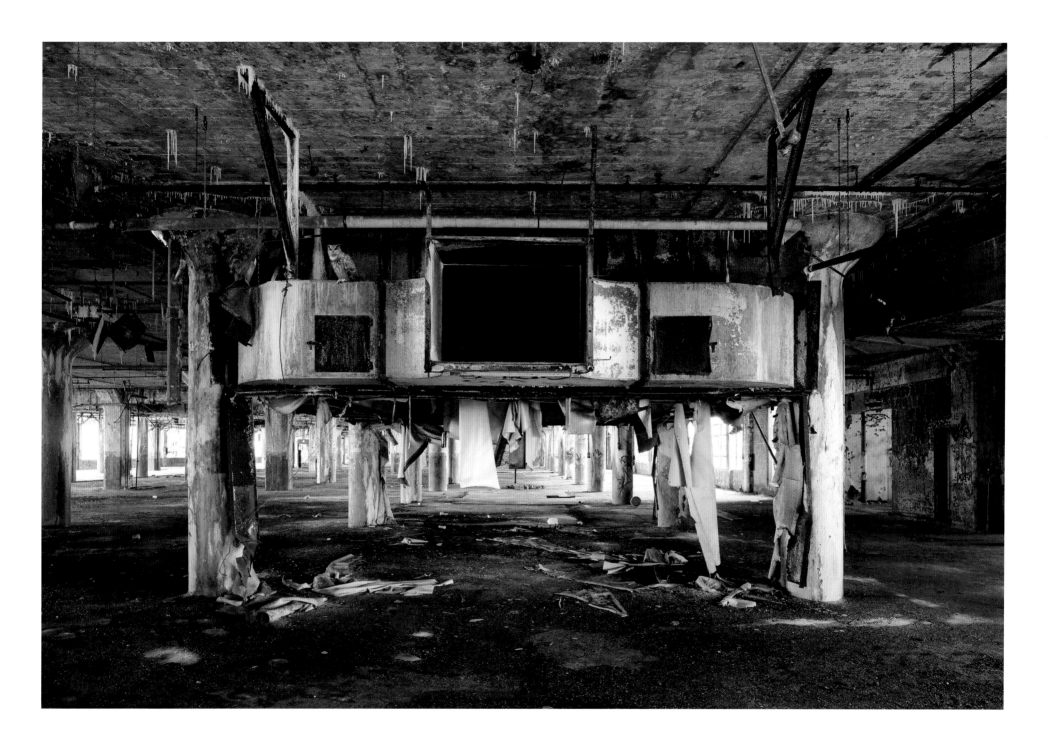

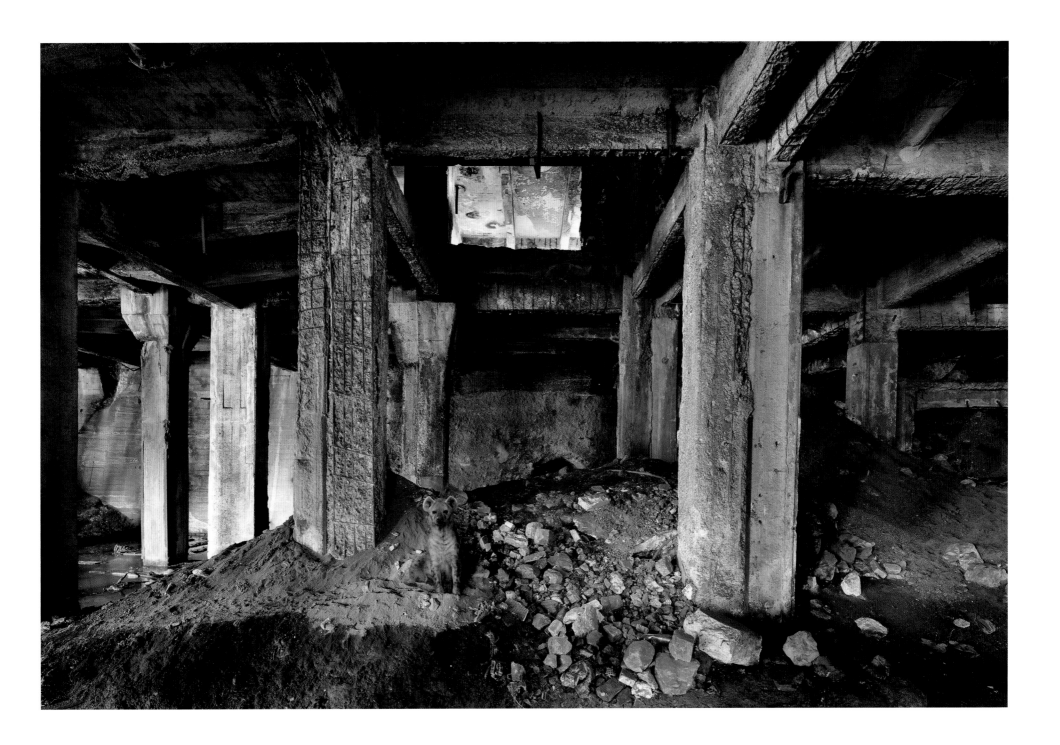

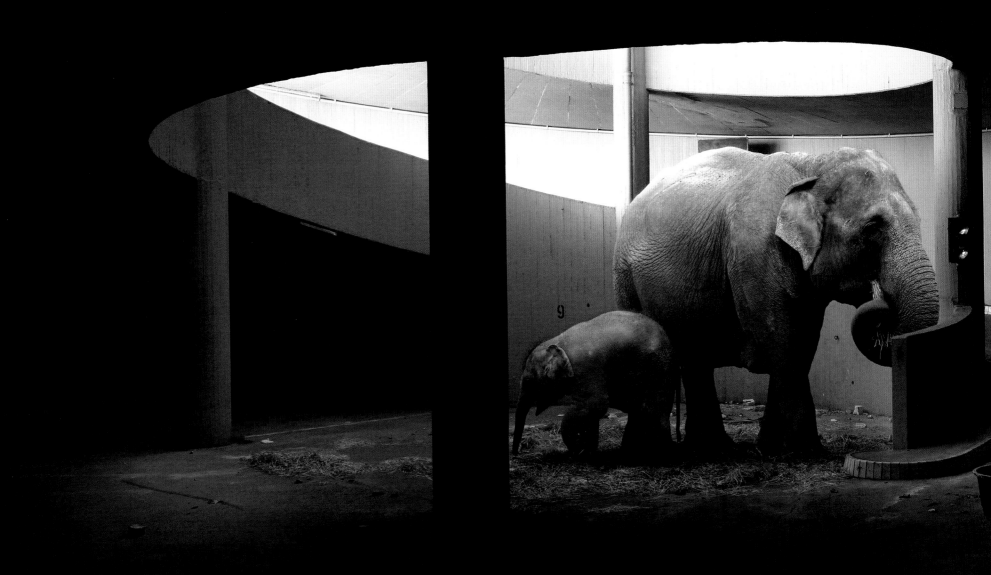

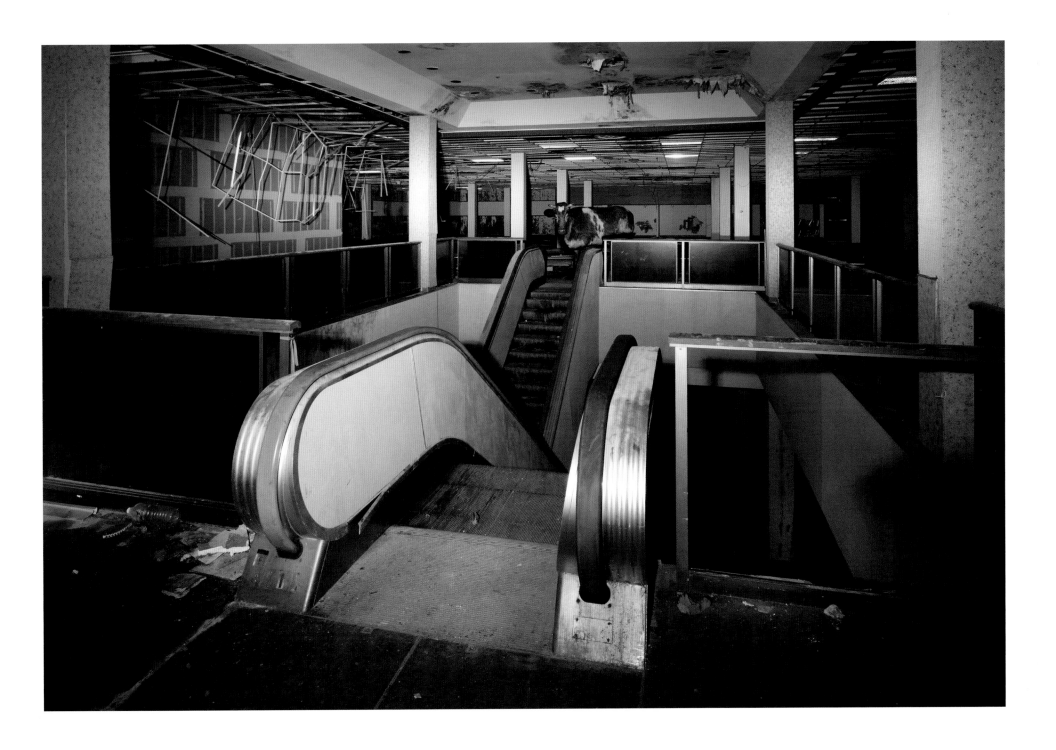

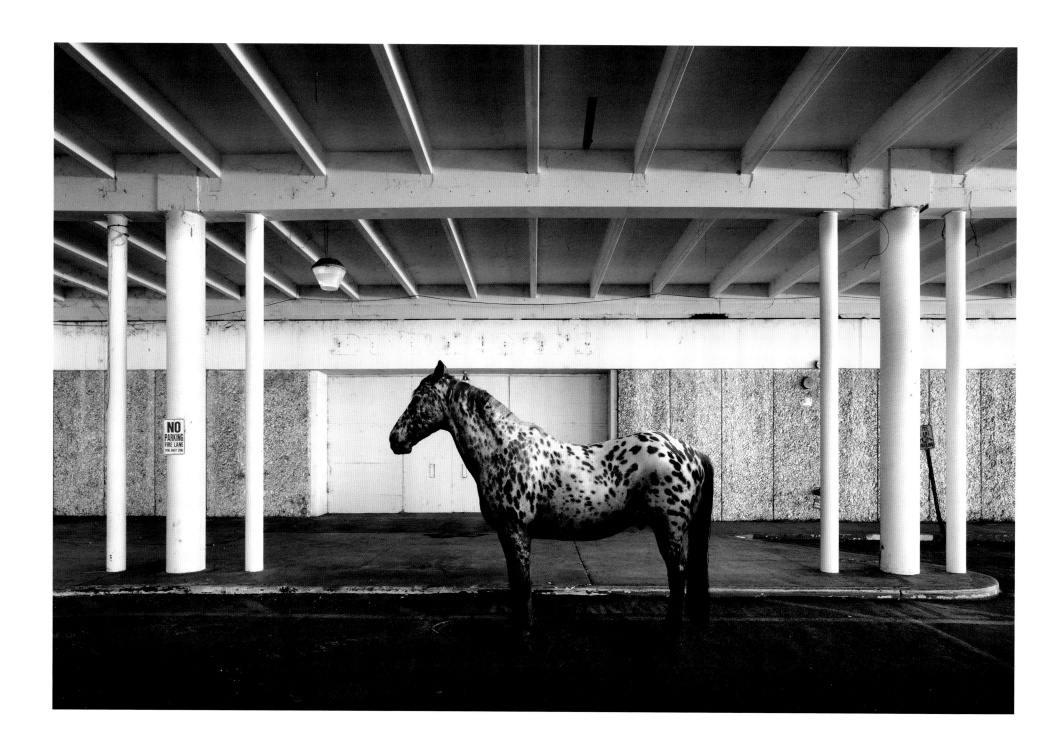

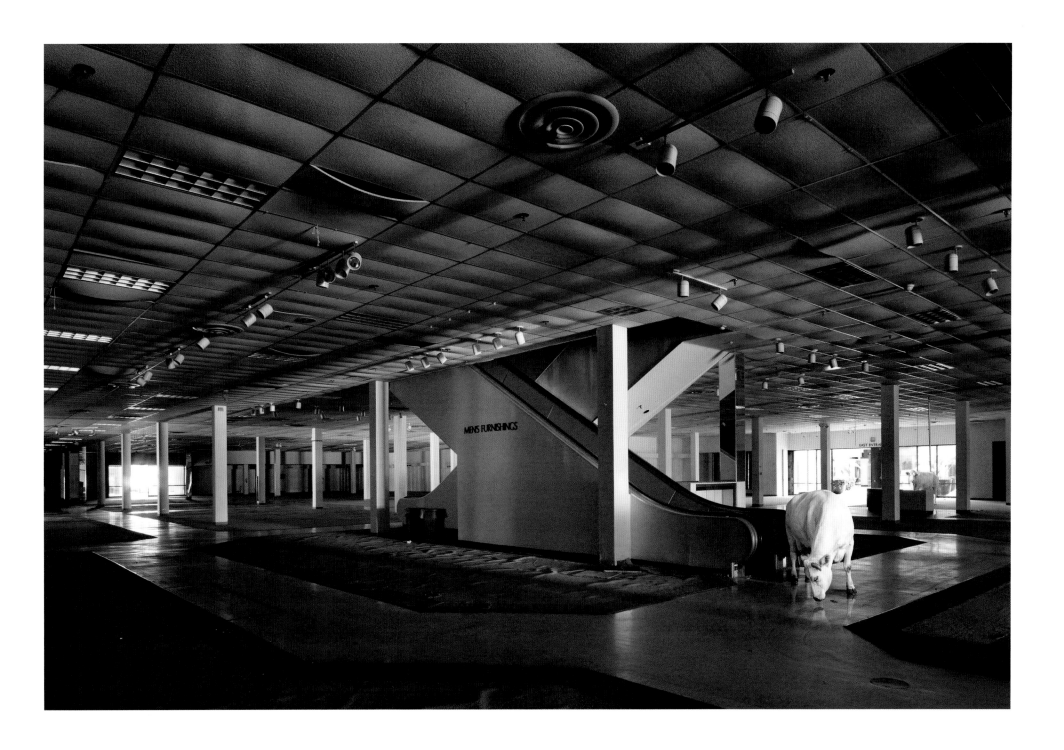

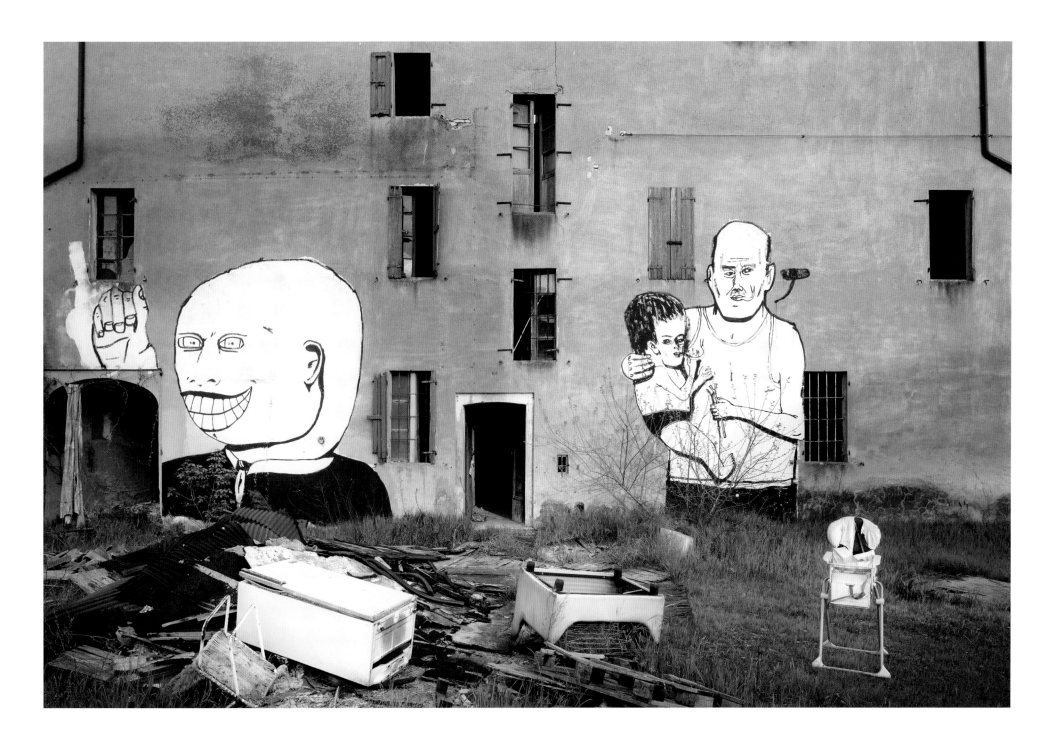

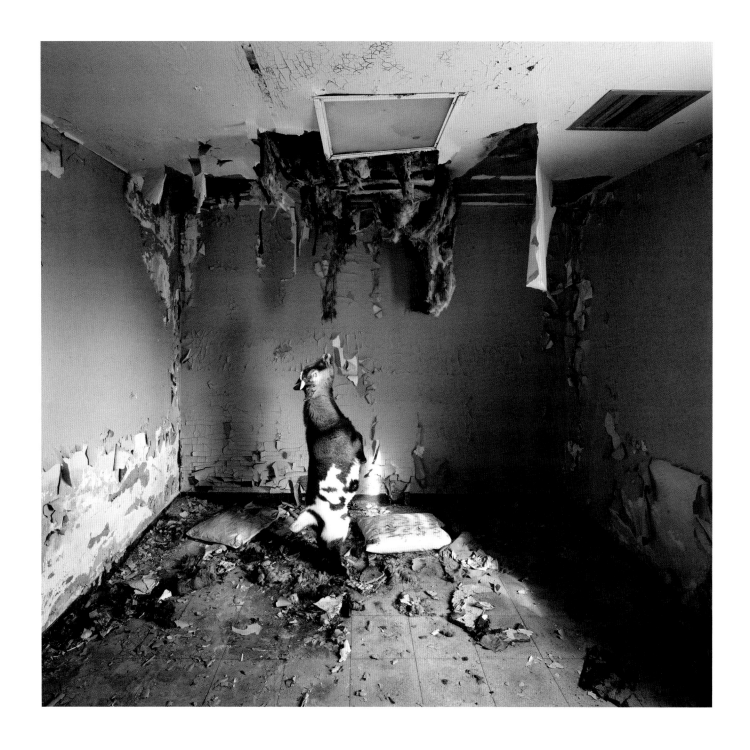

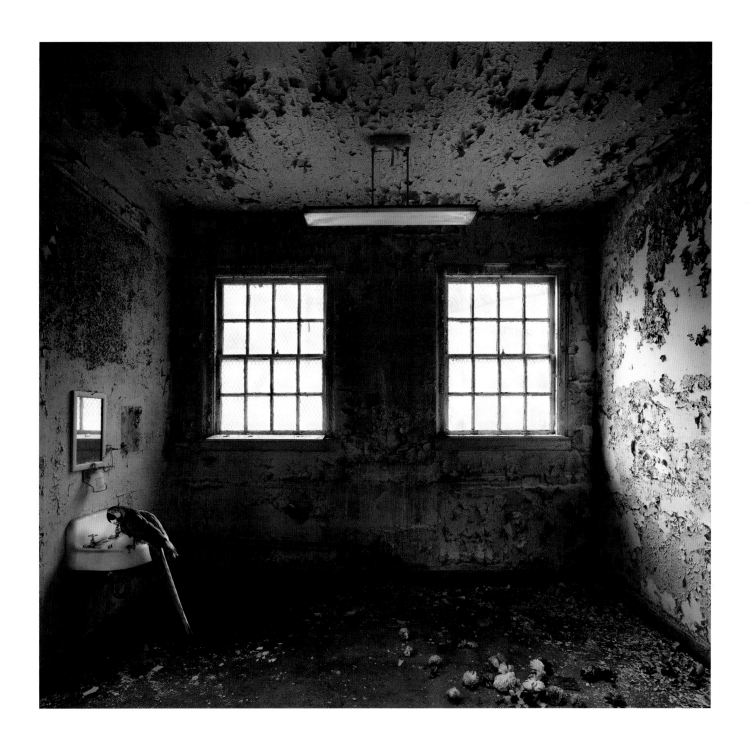

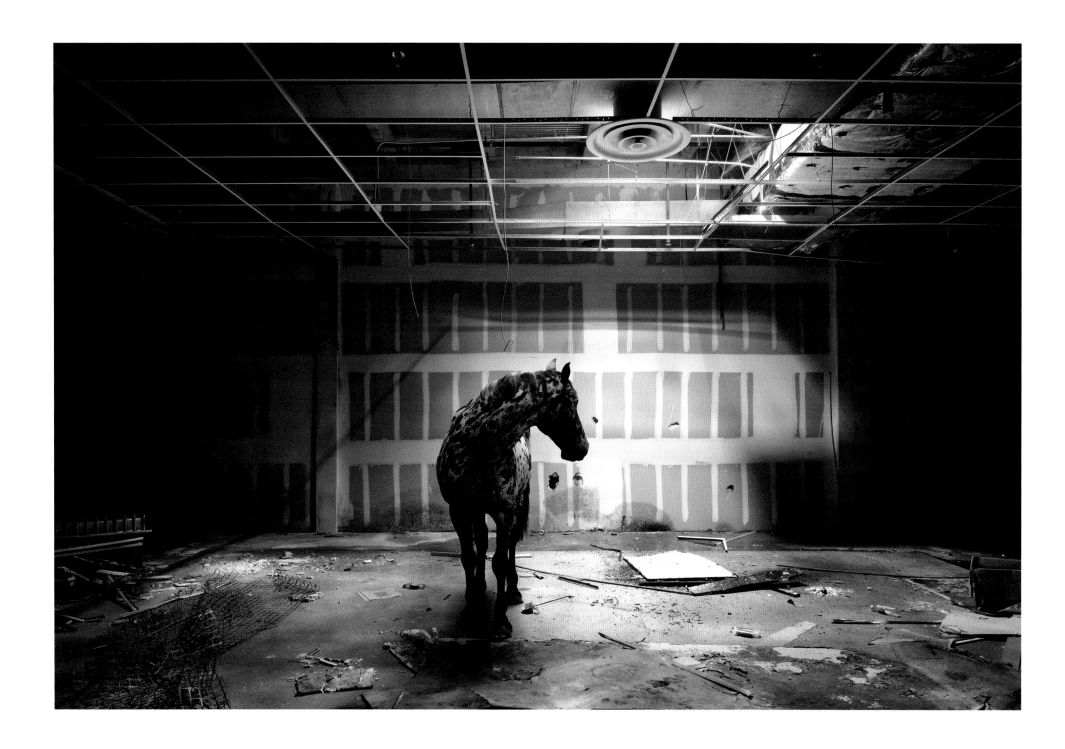

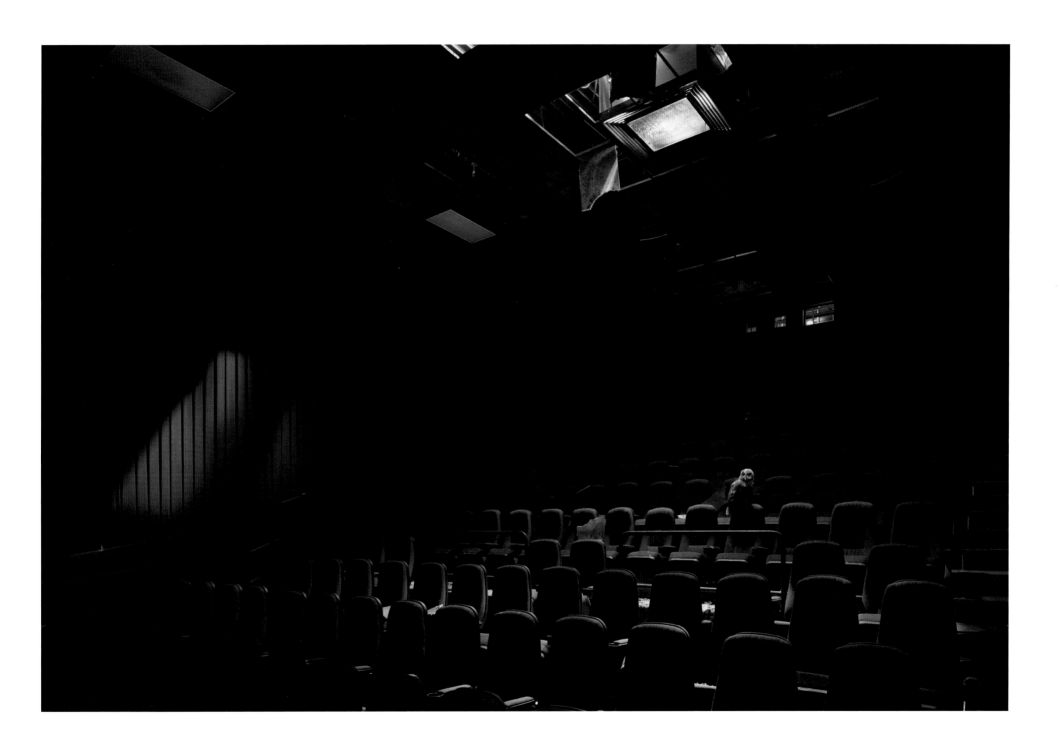

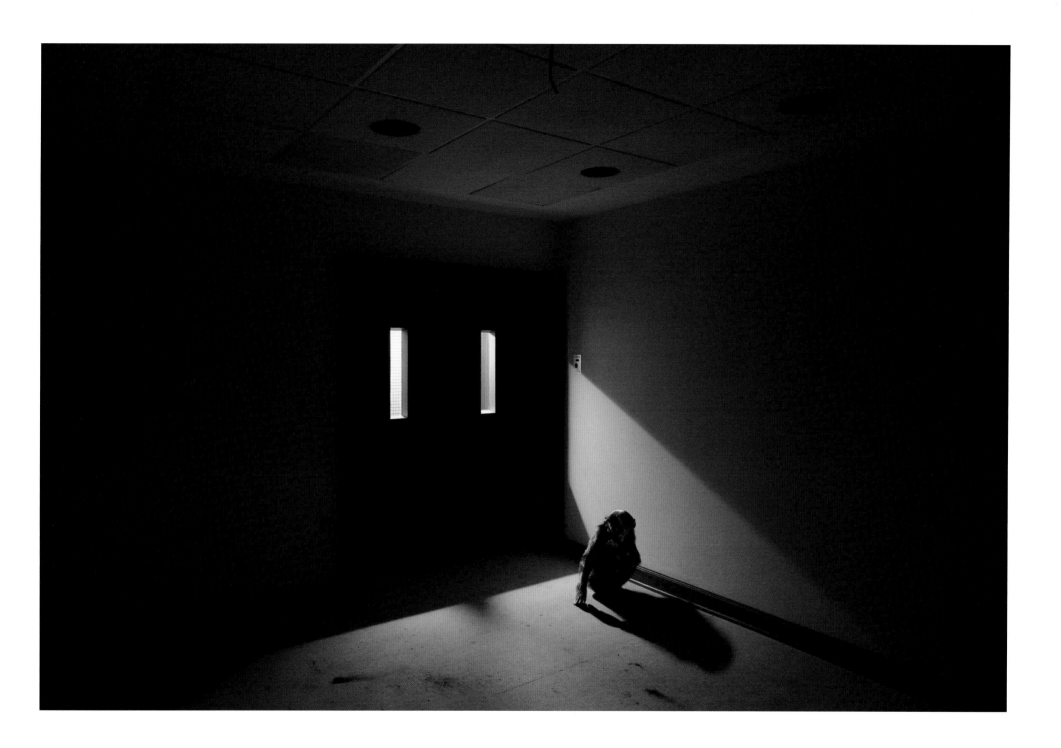

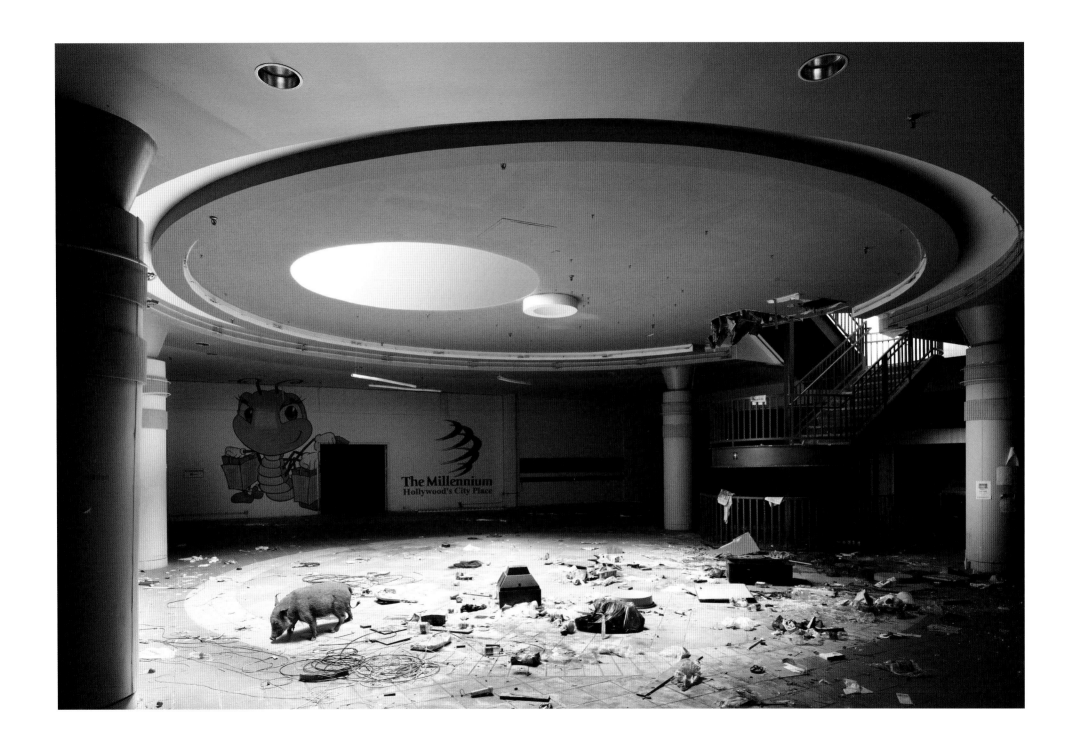

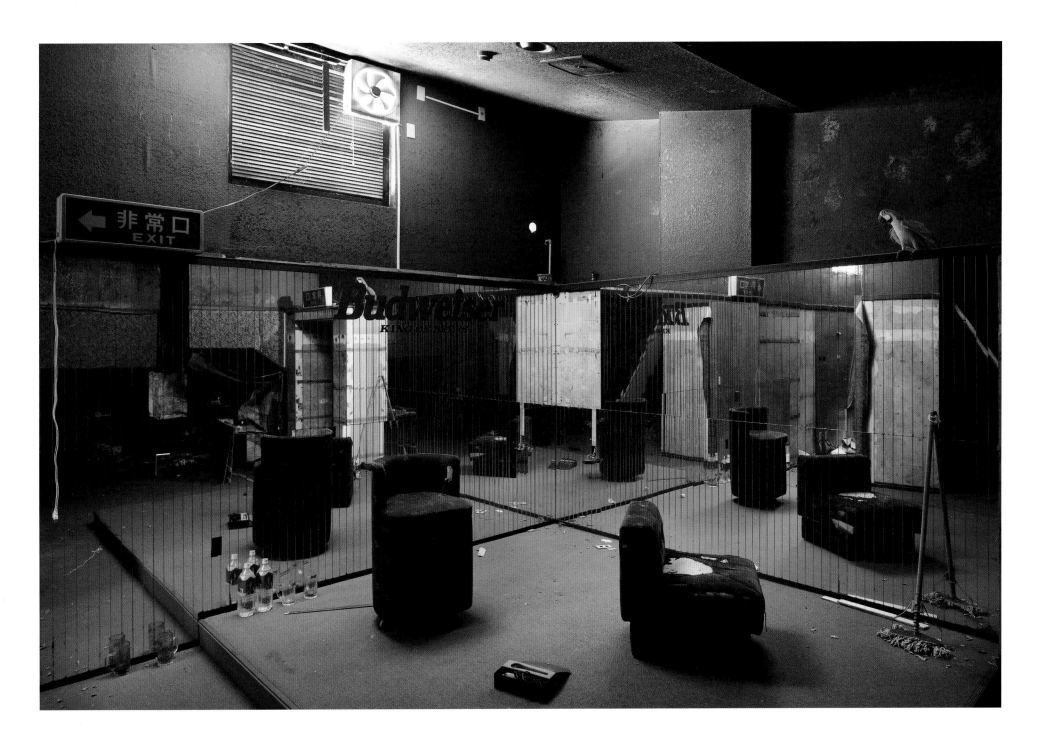

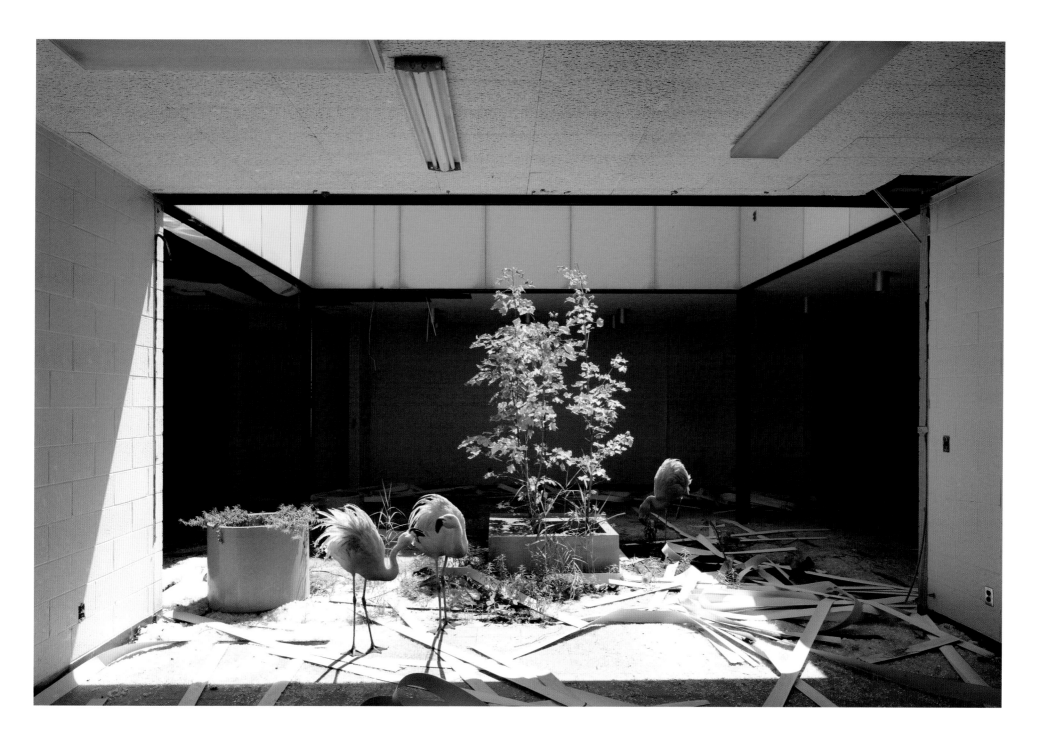

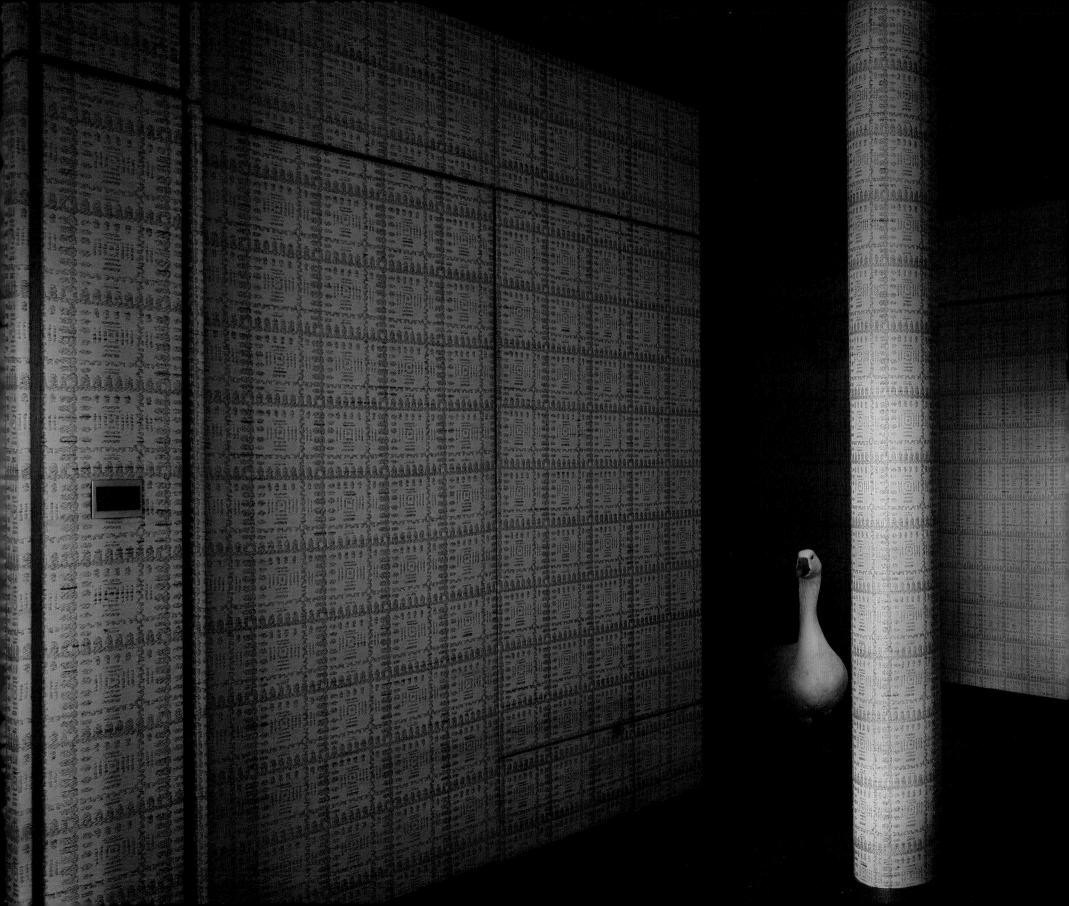

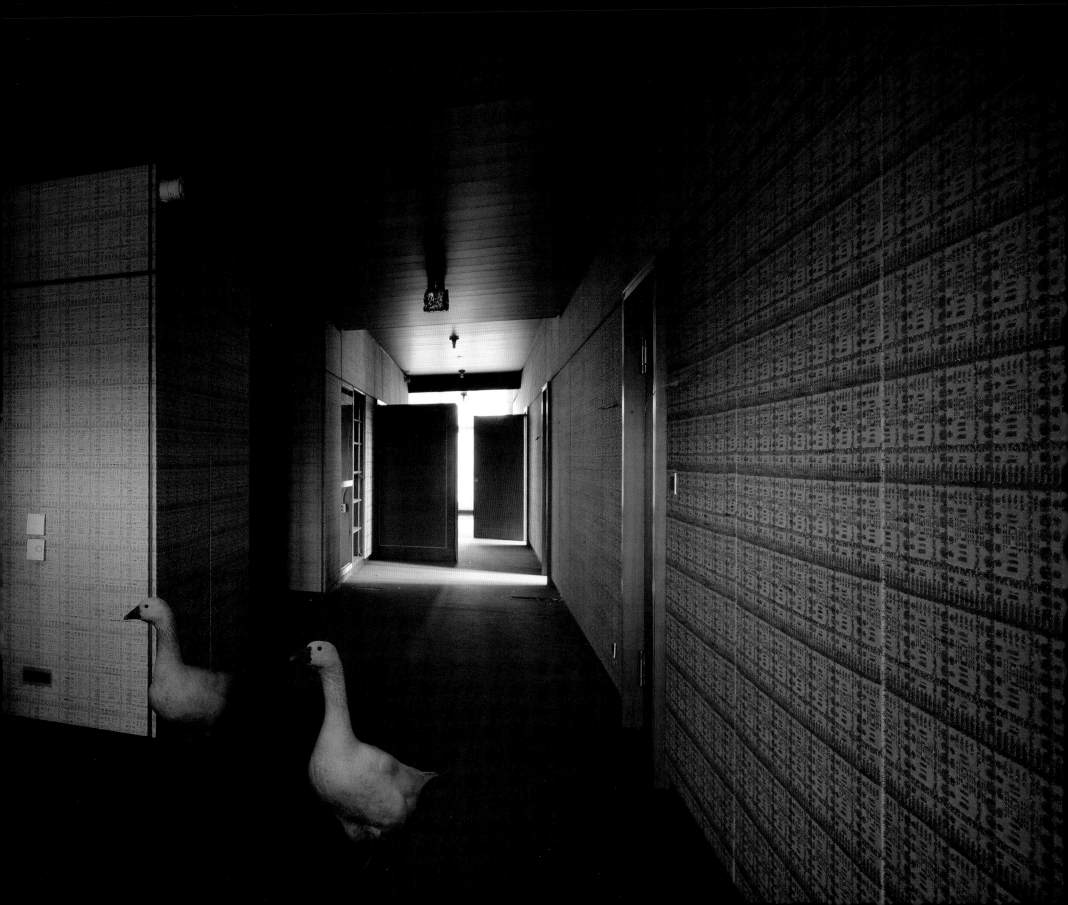

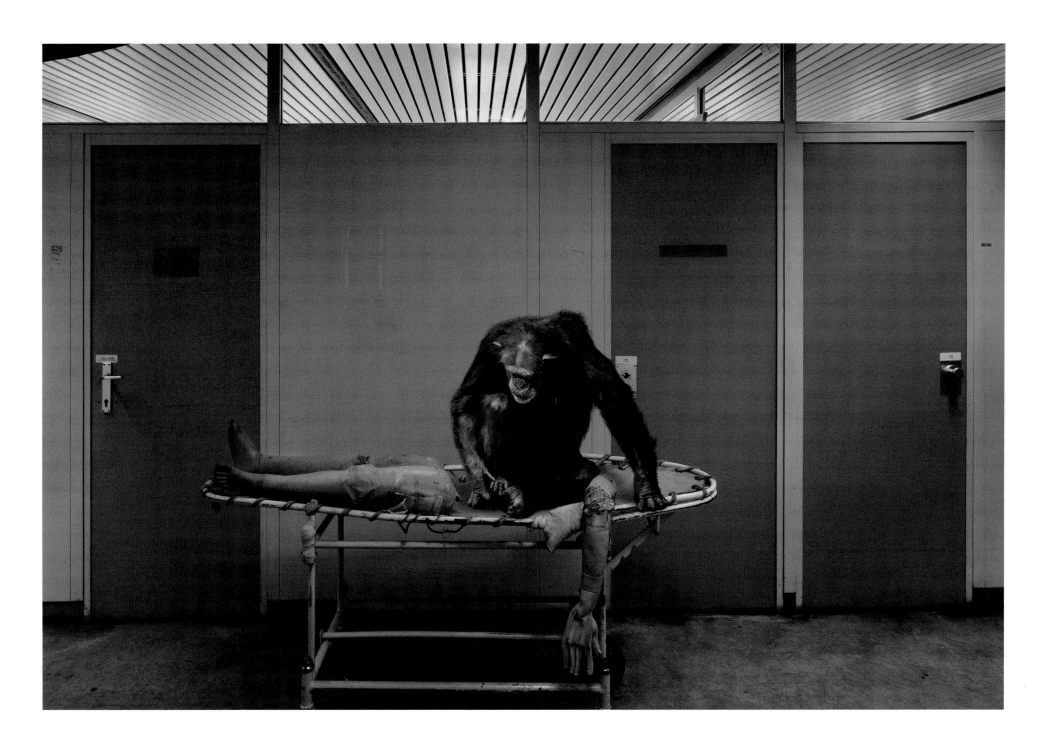

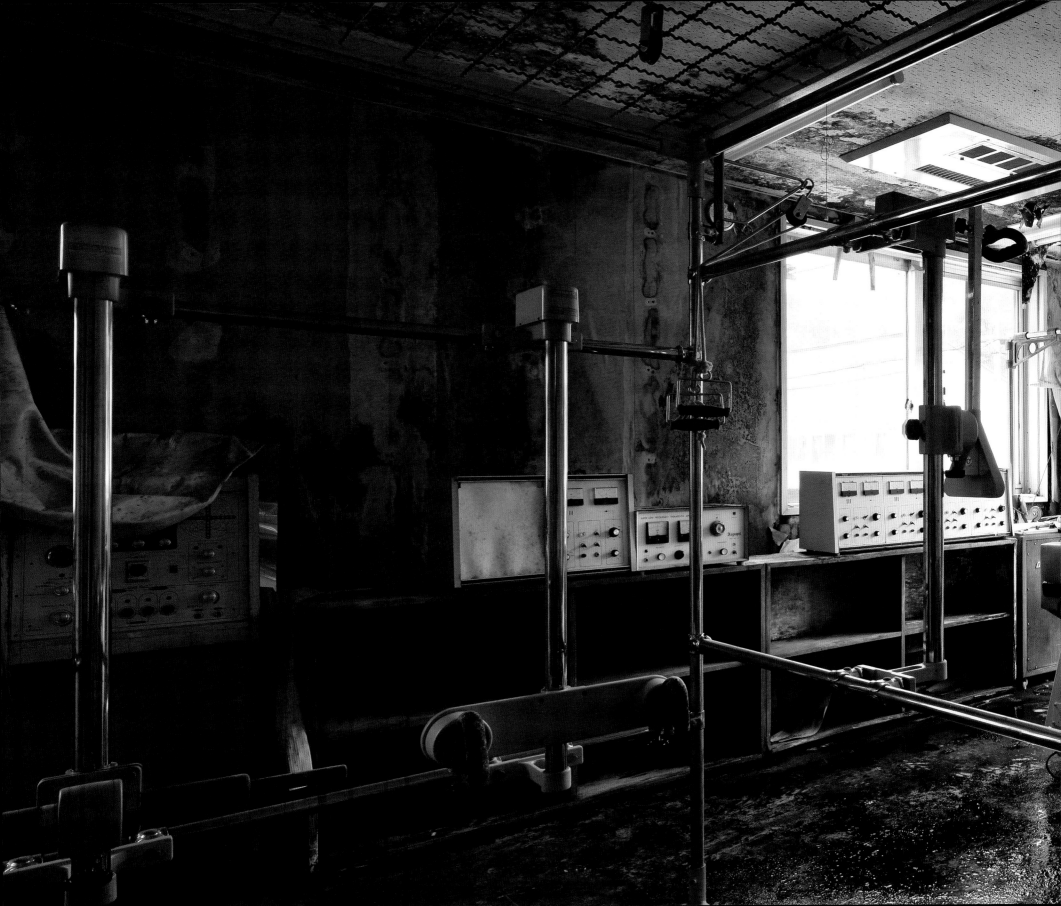

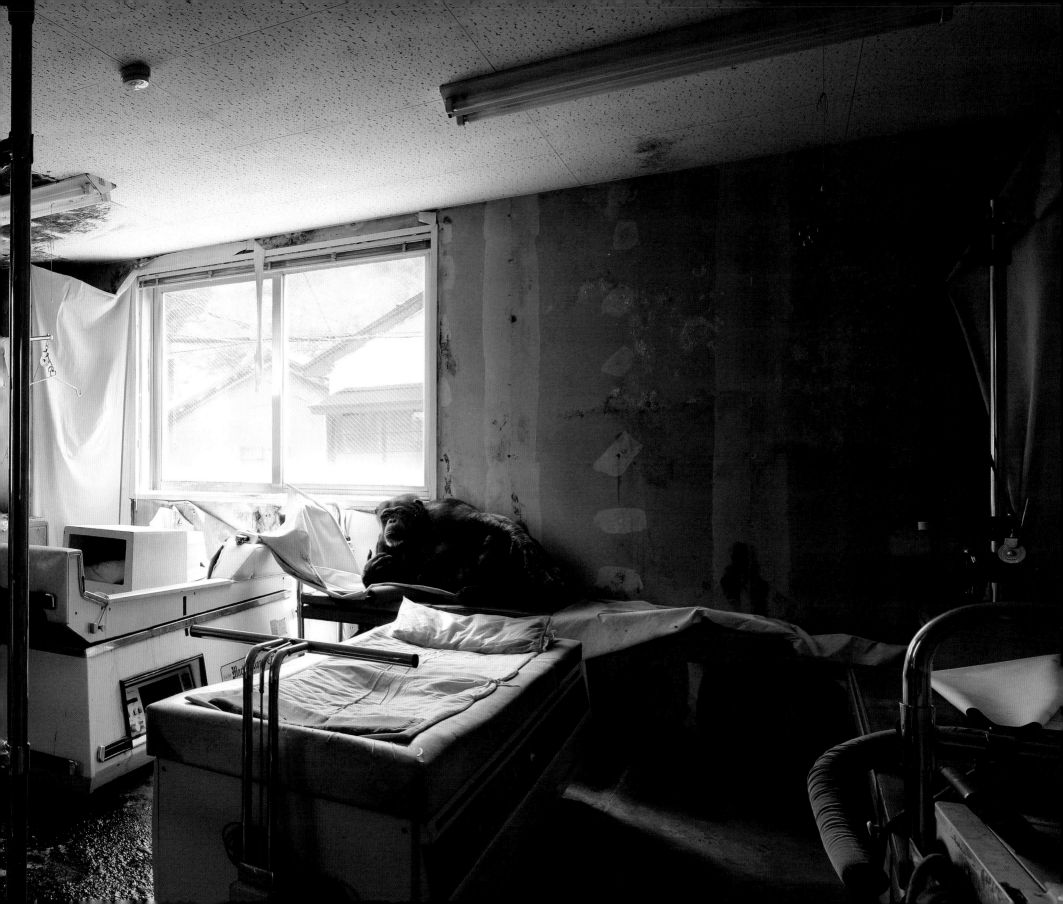

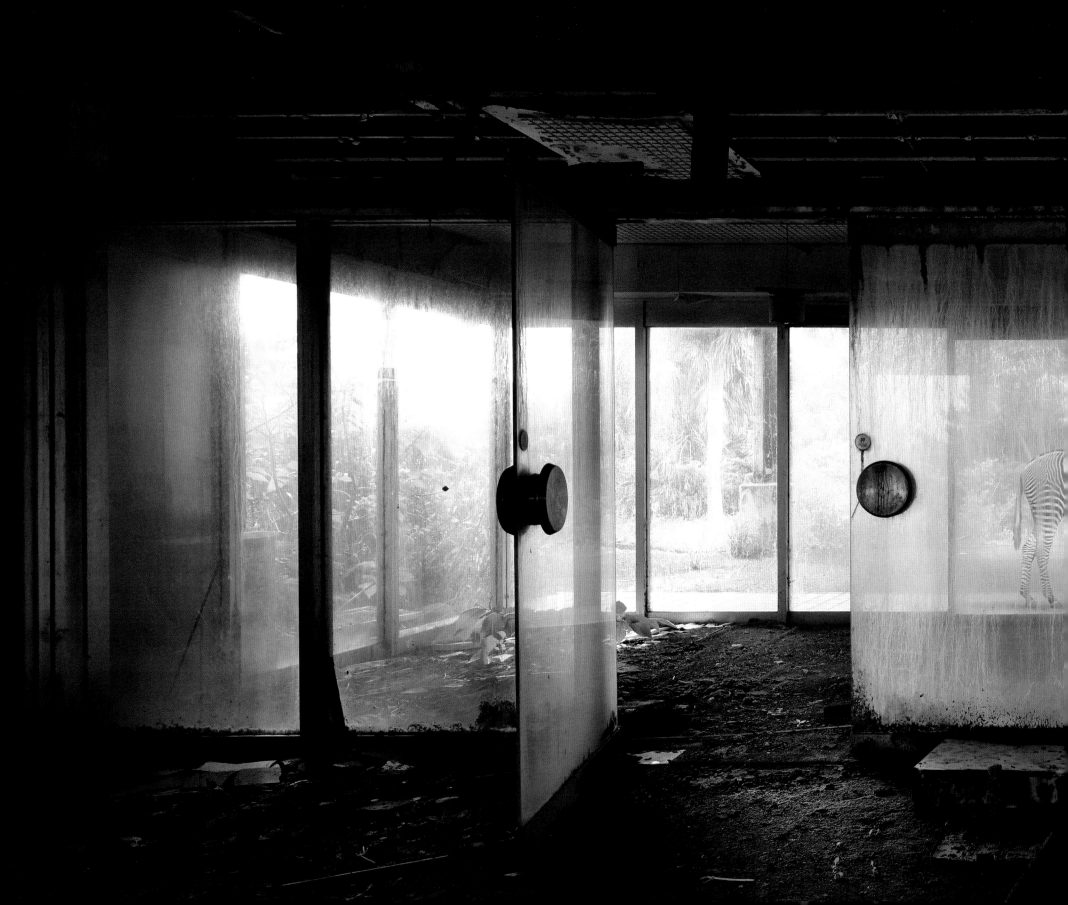

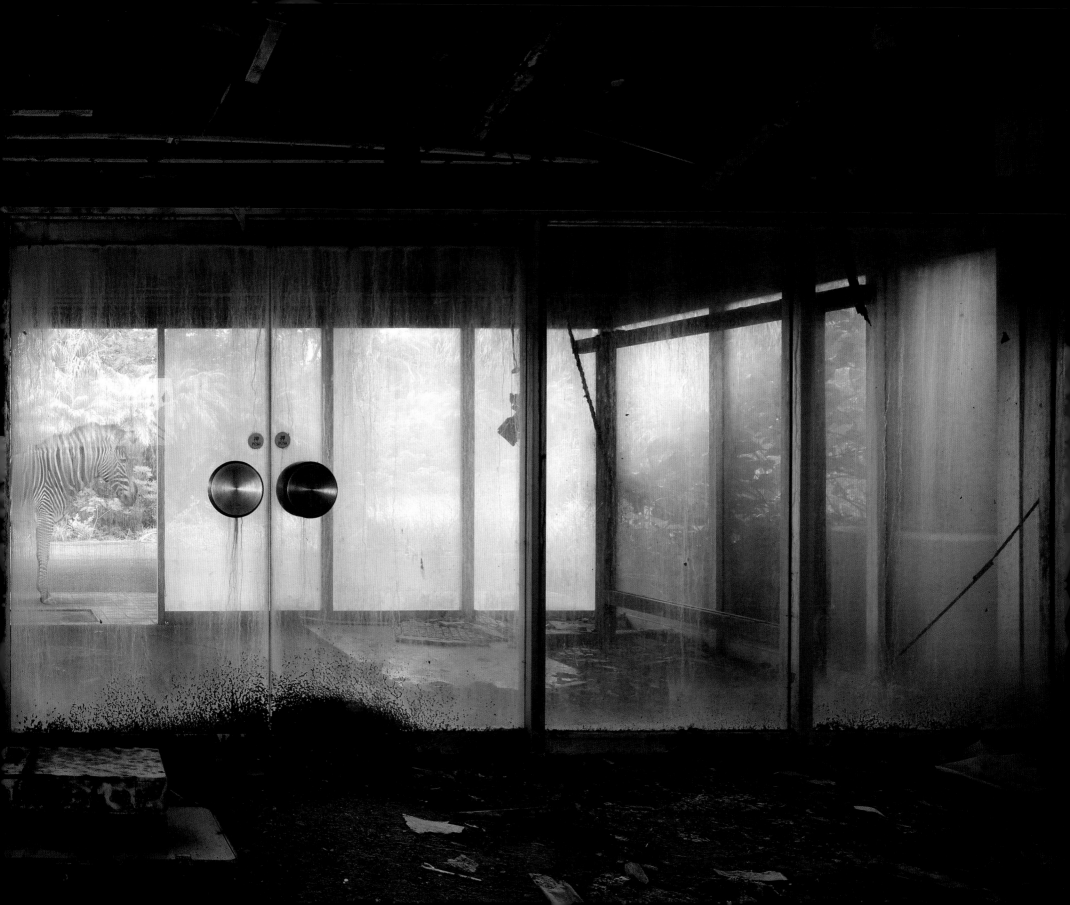

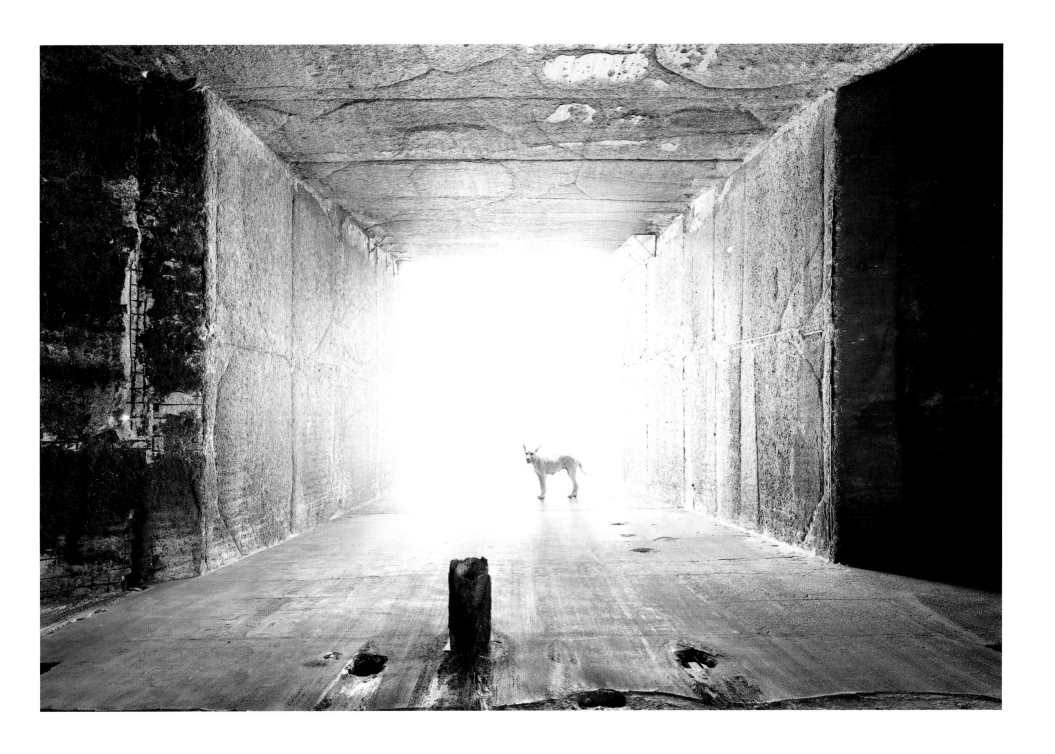

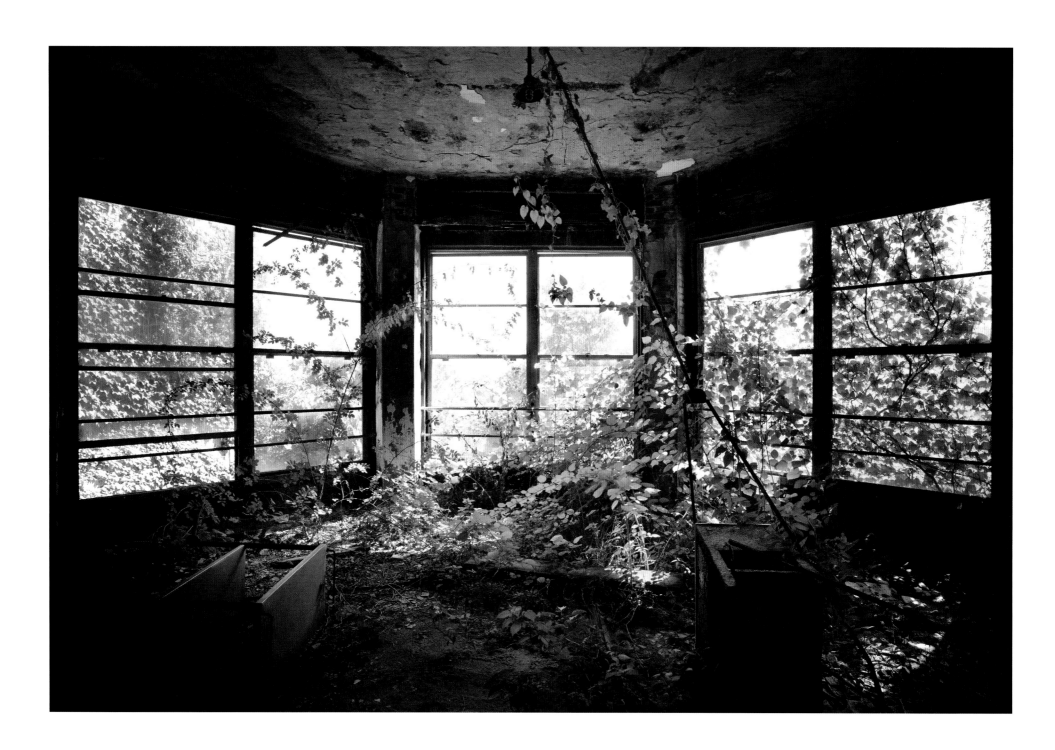

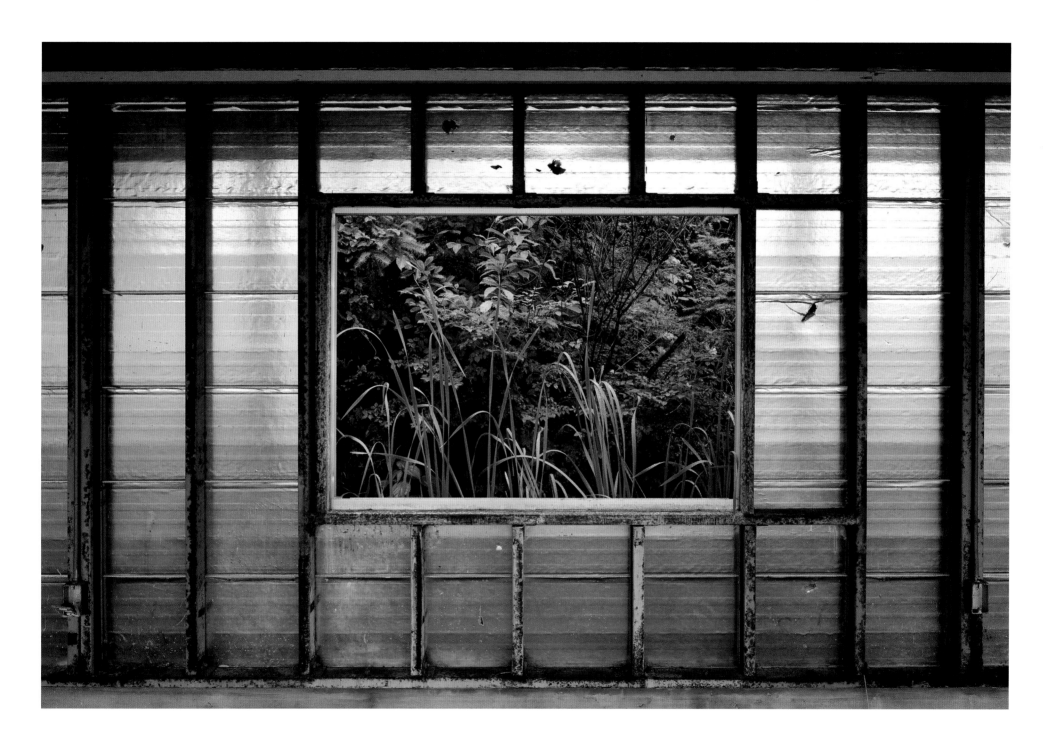

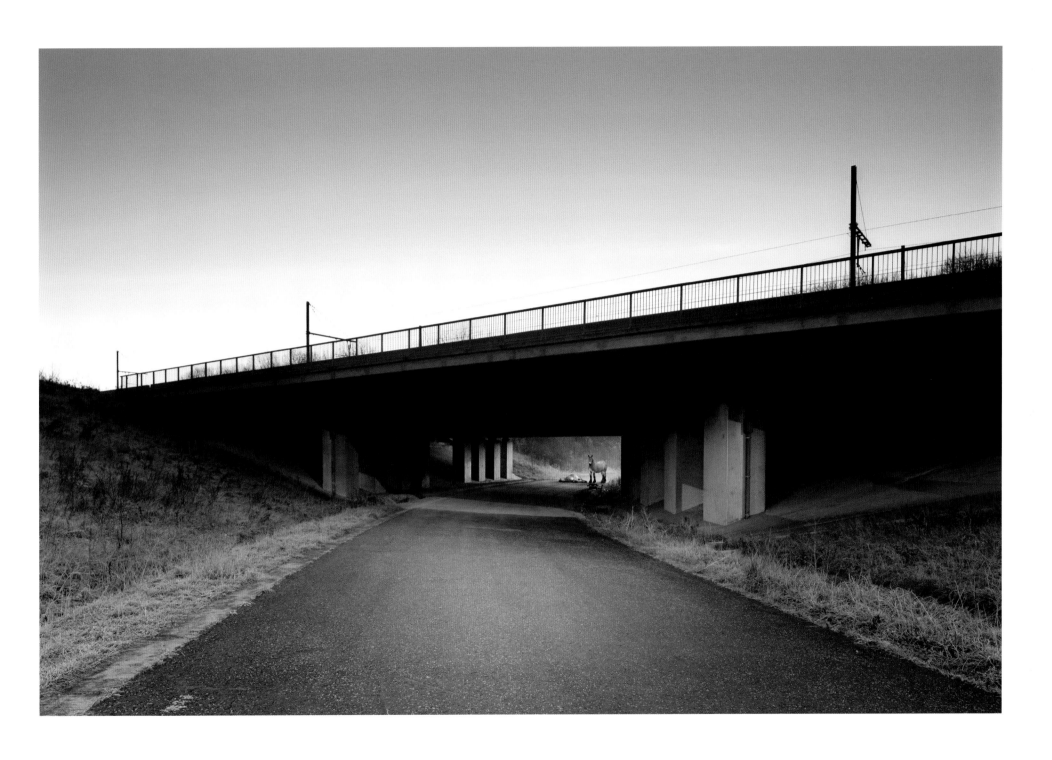

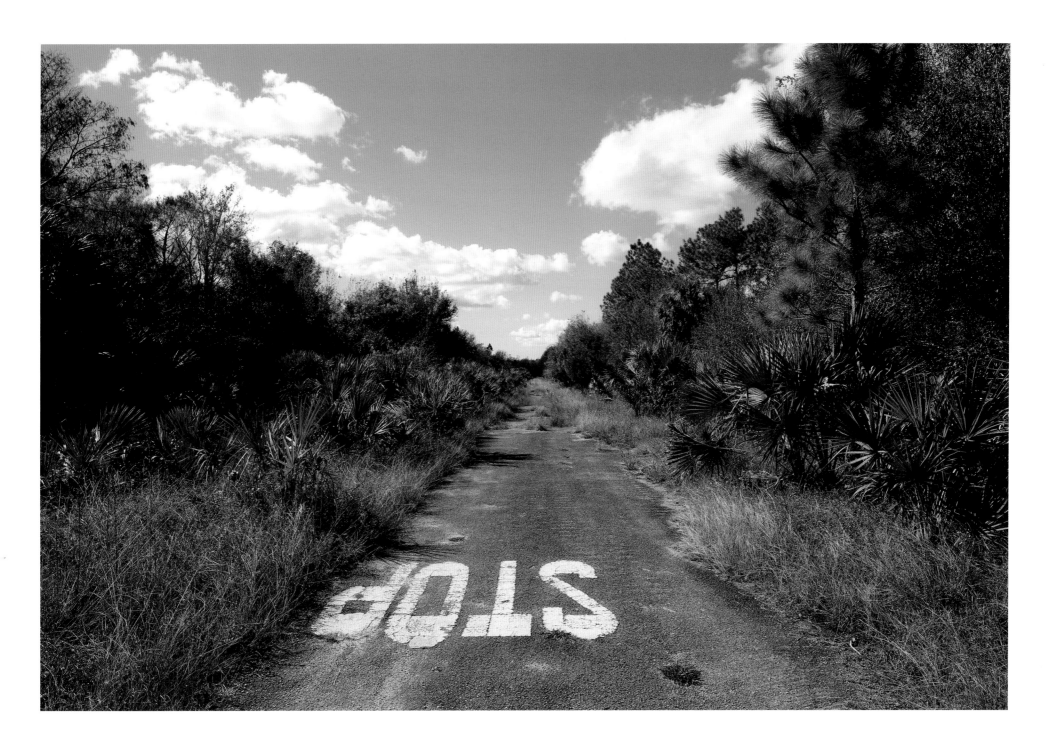

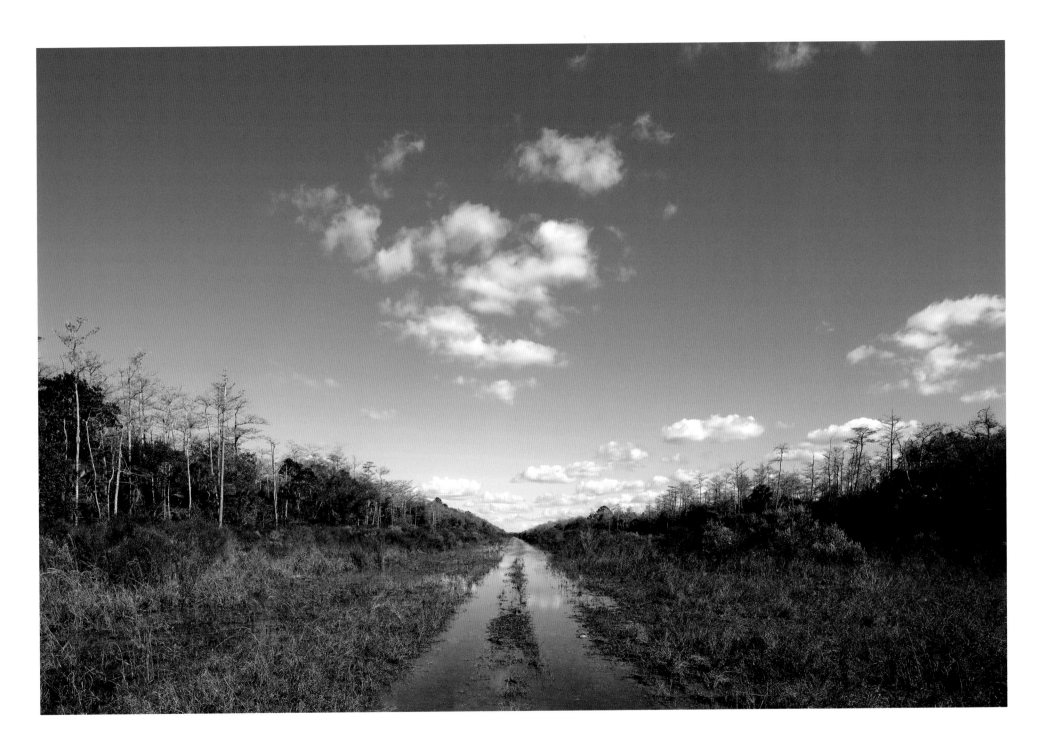

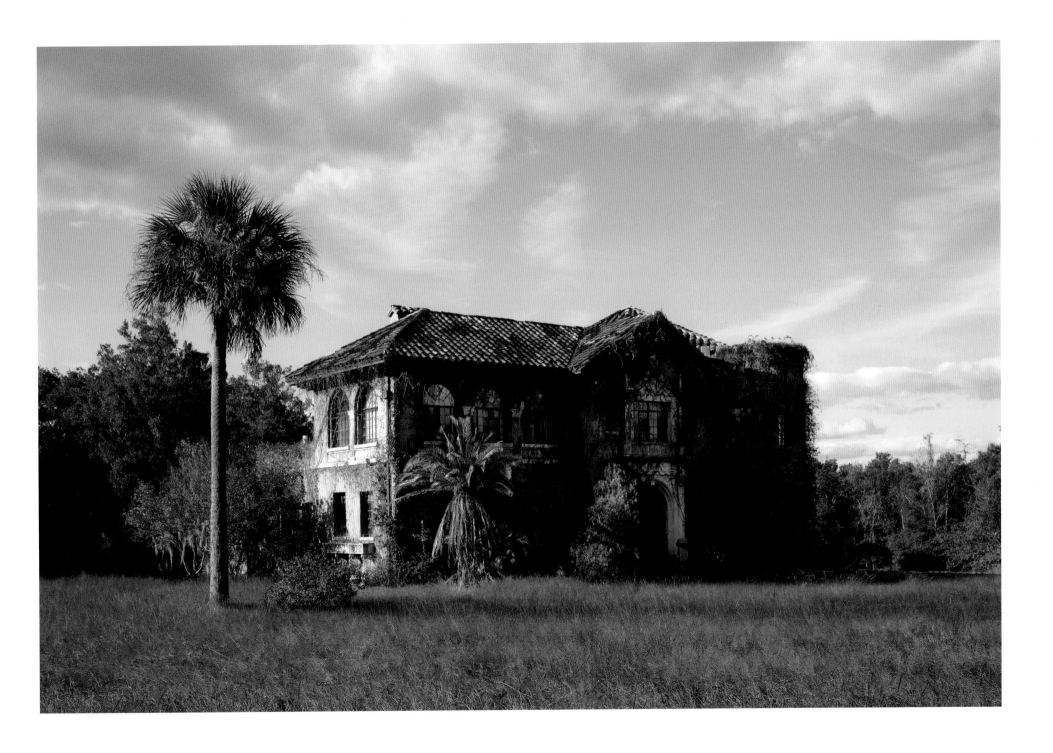

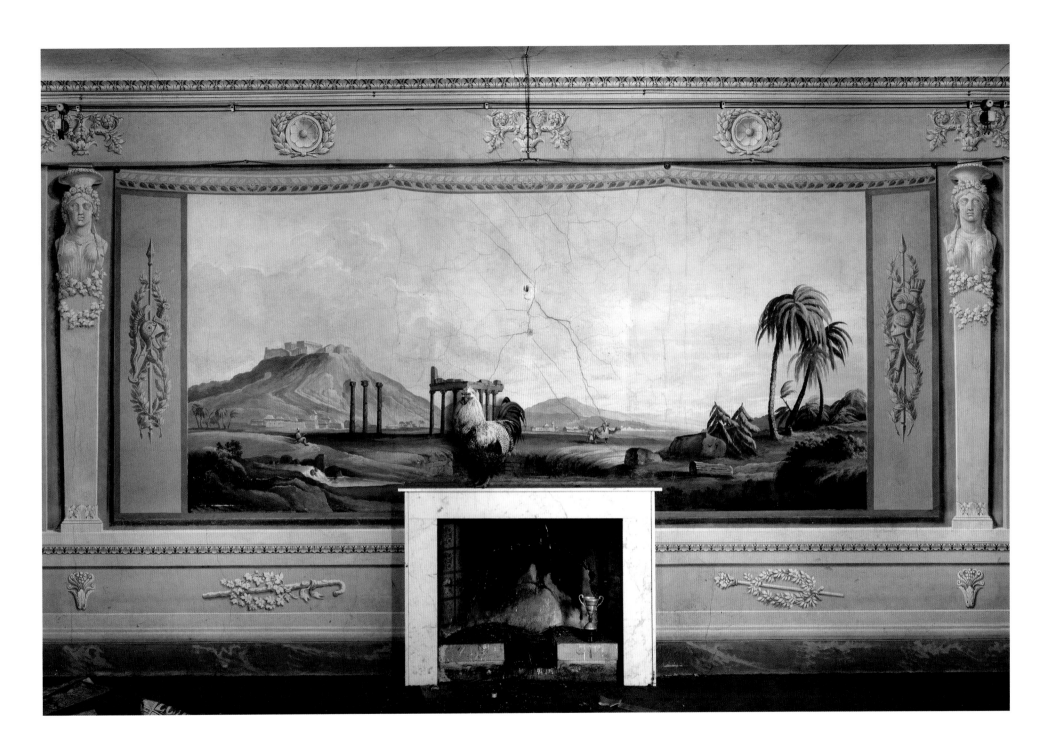

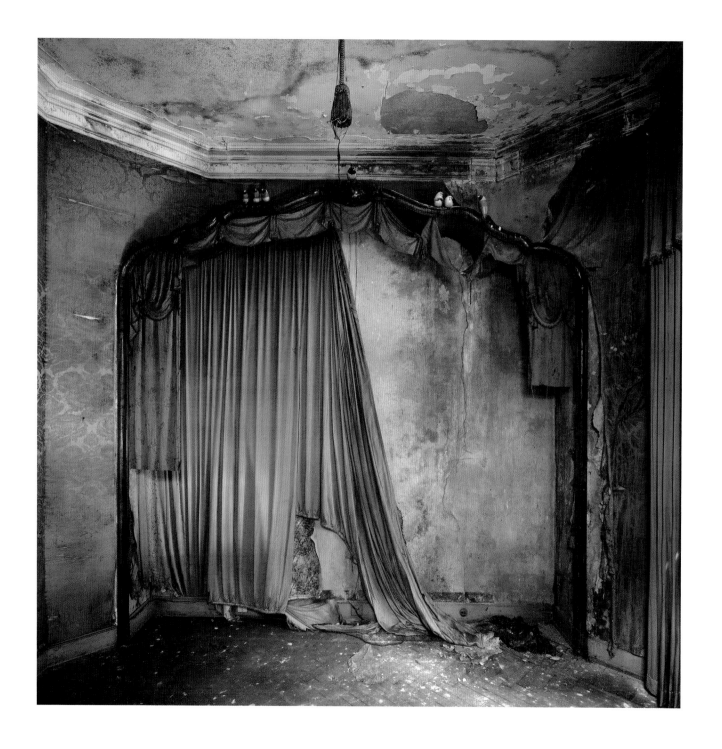

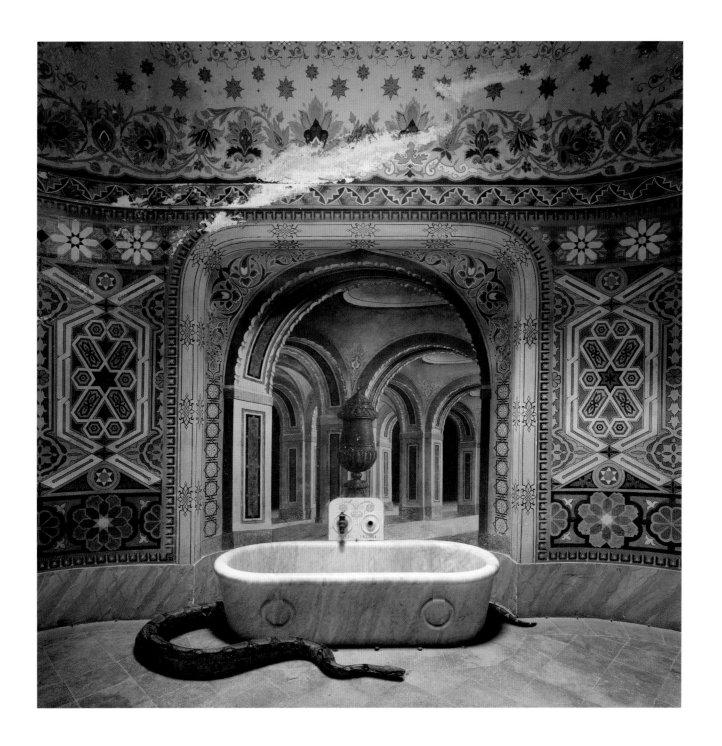

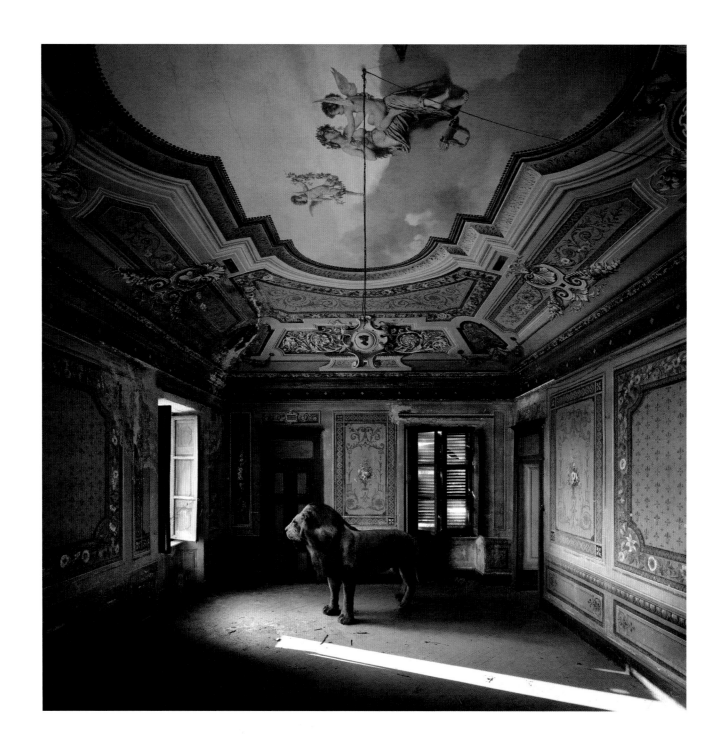

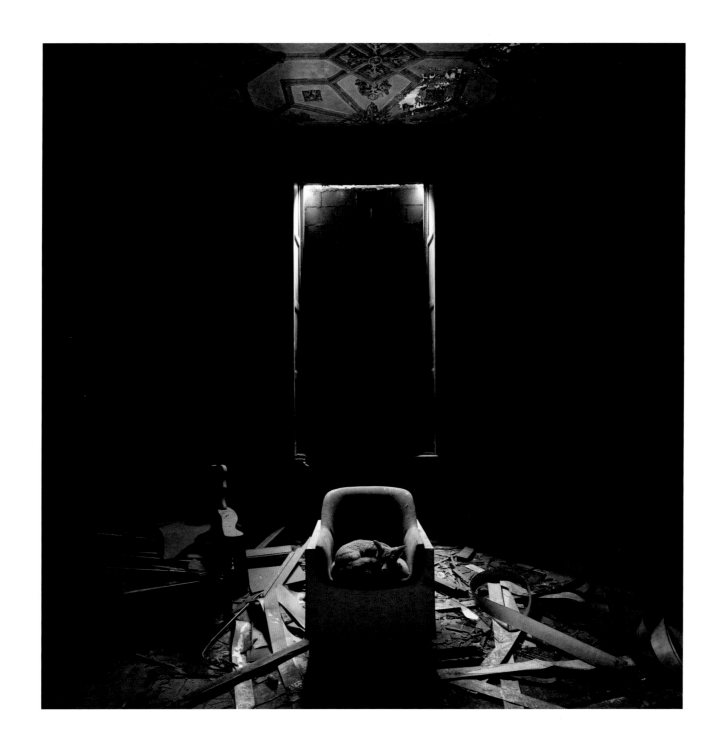

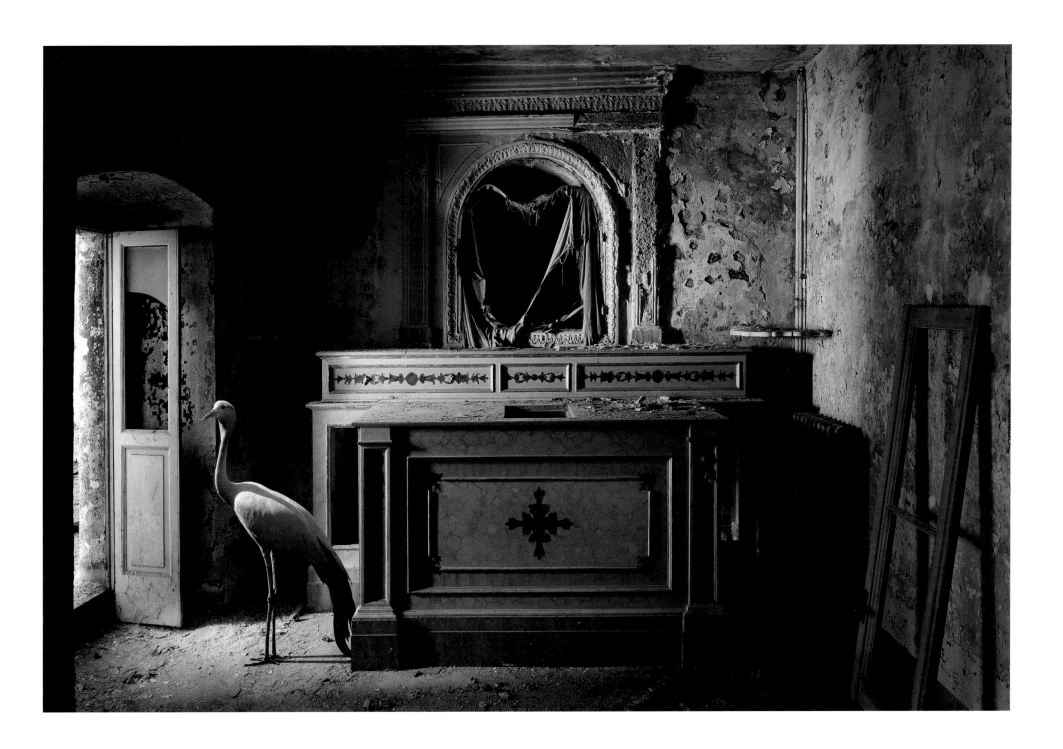

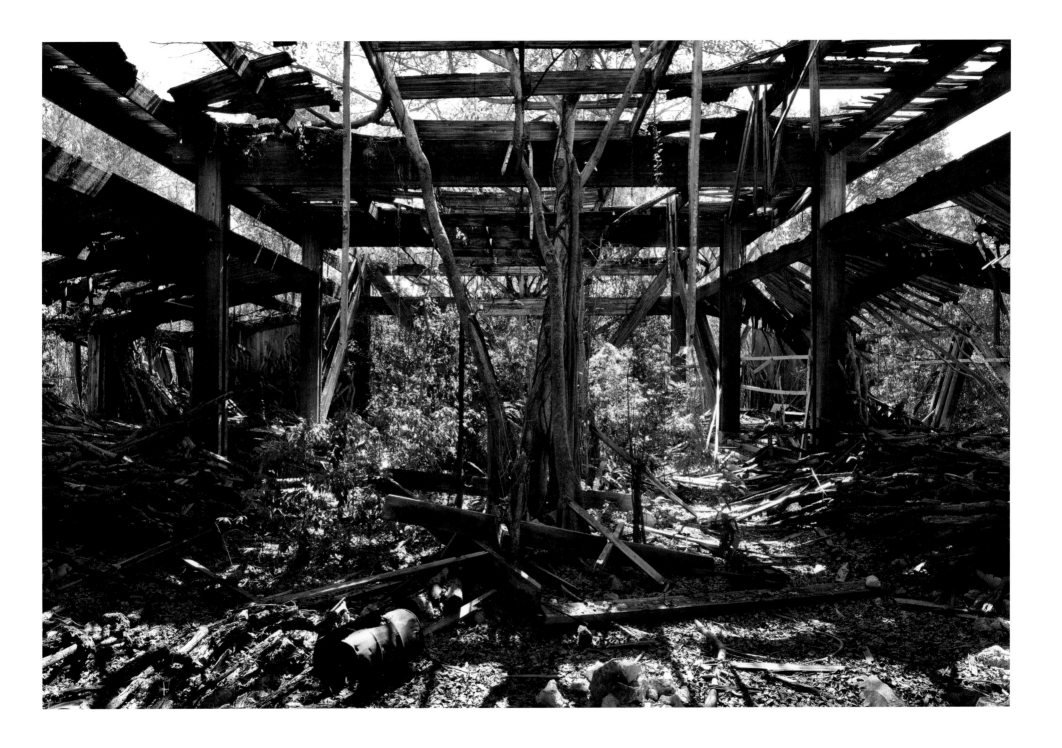

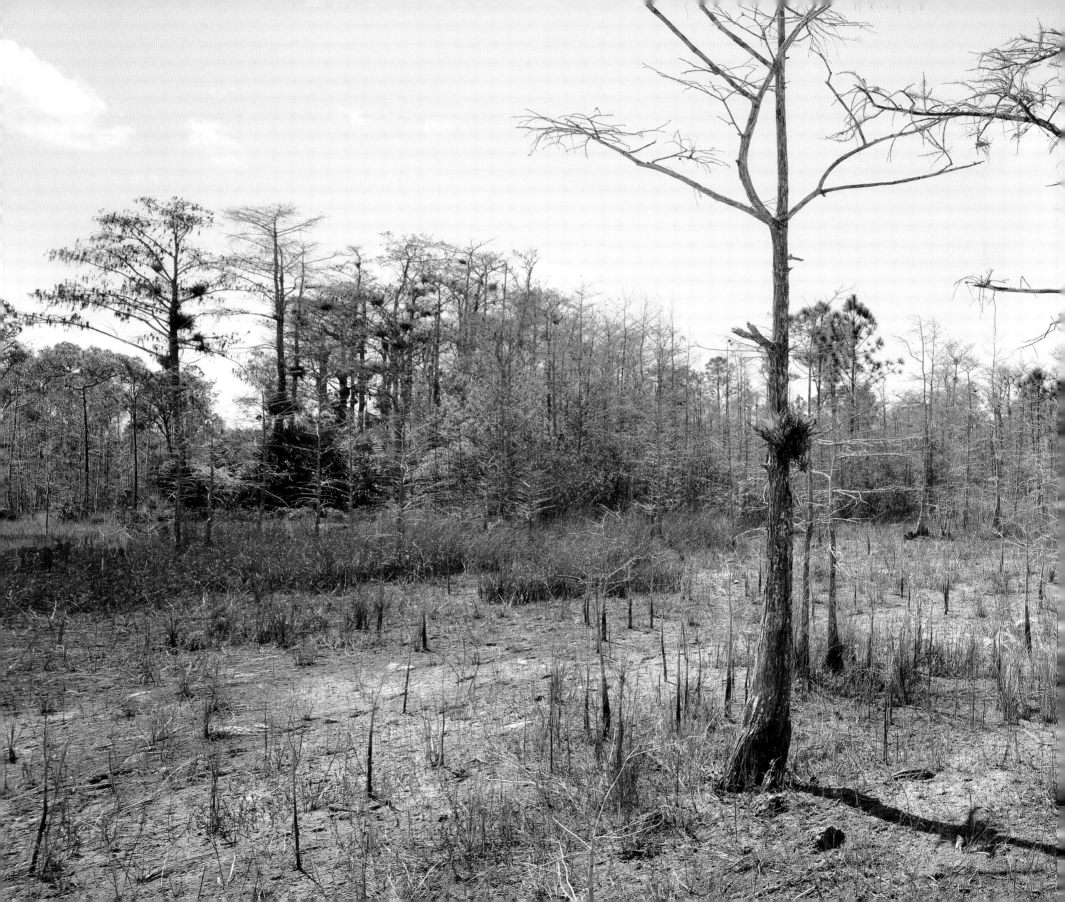

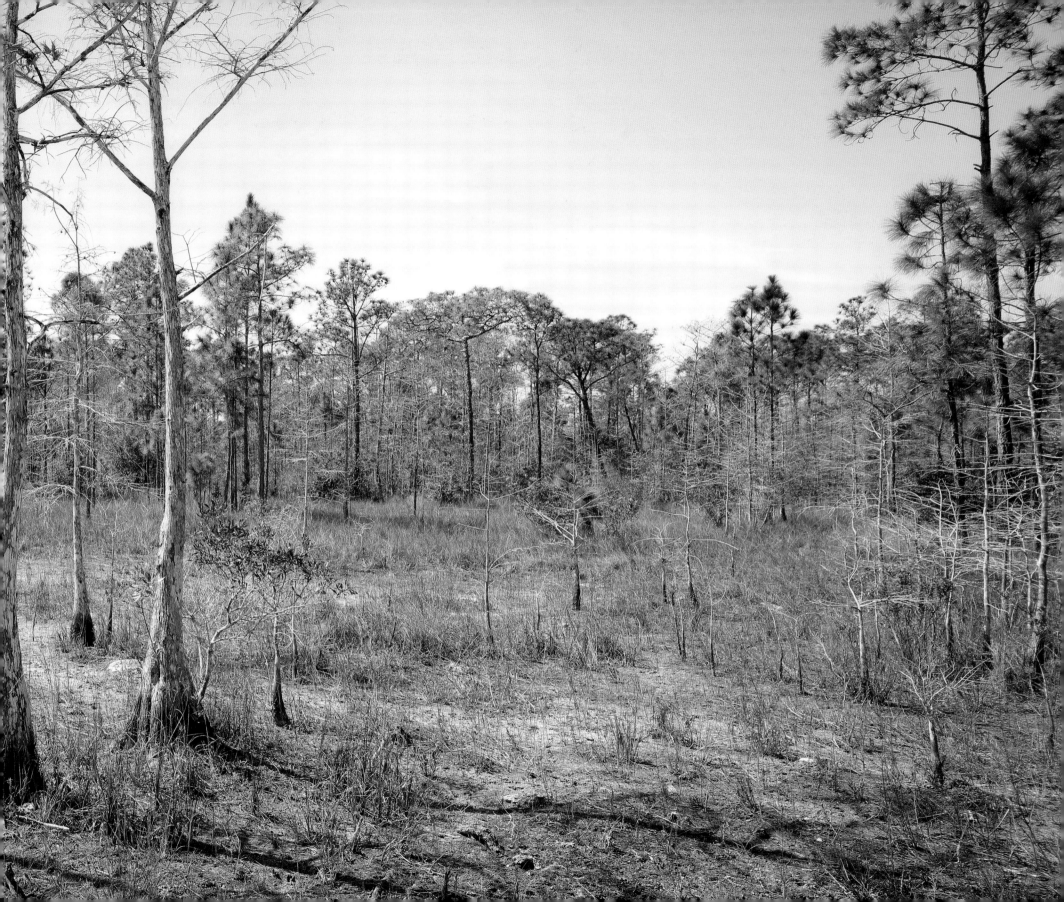

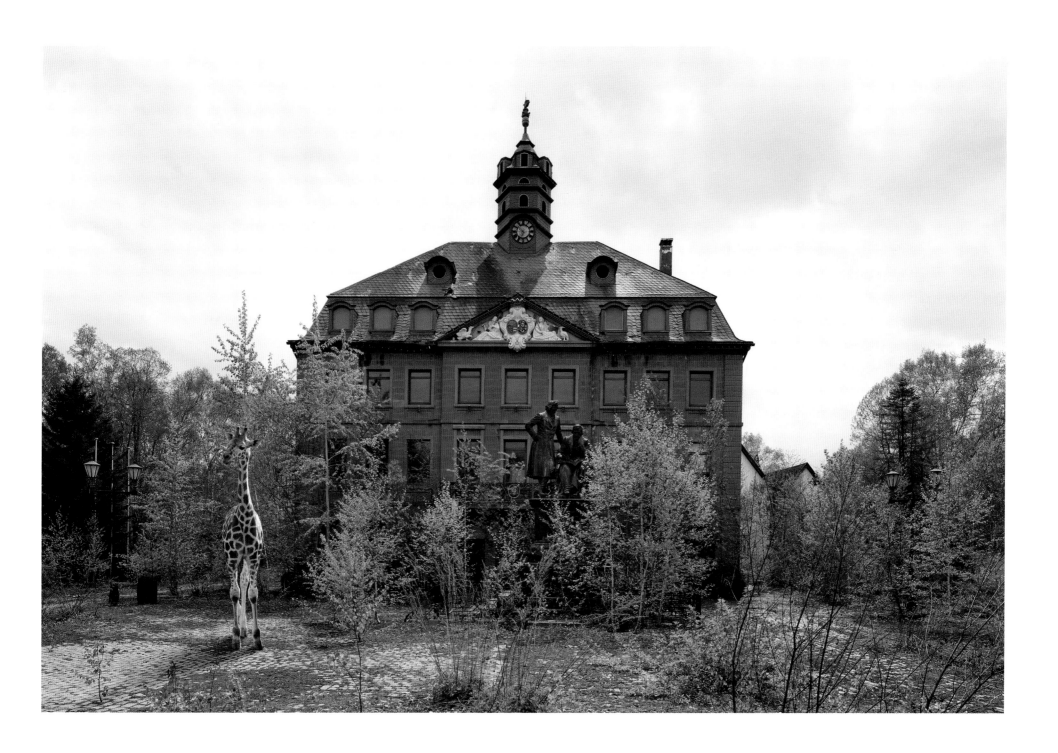

147

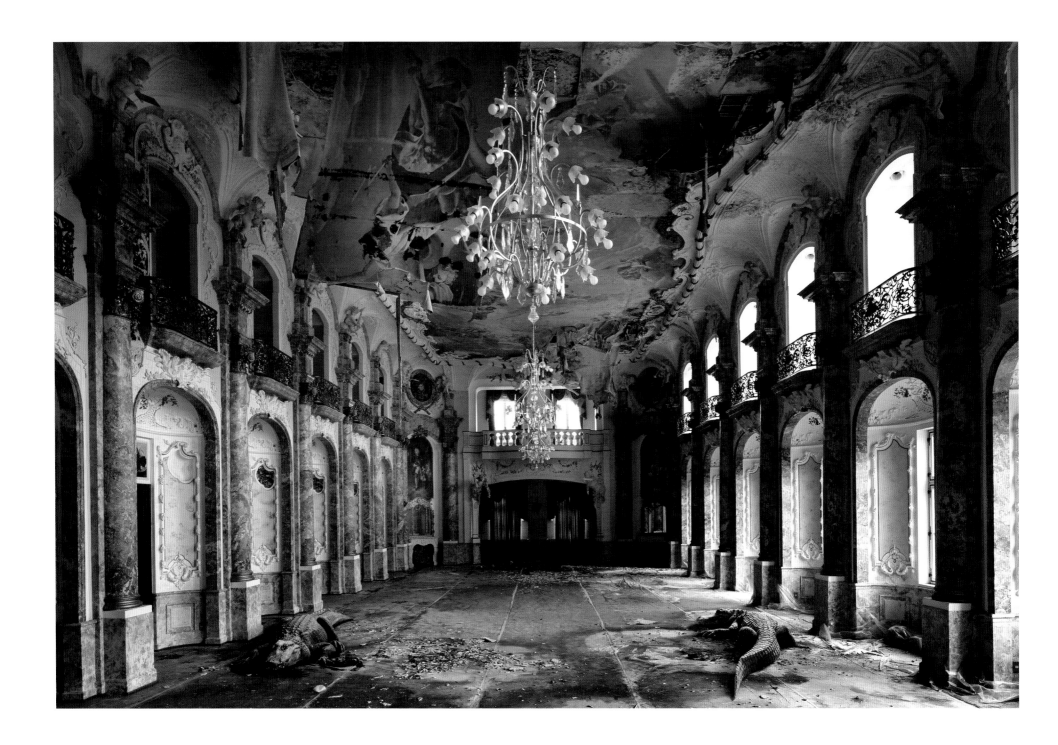

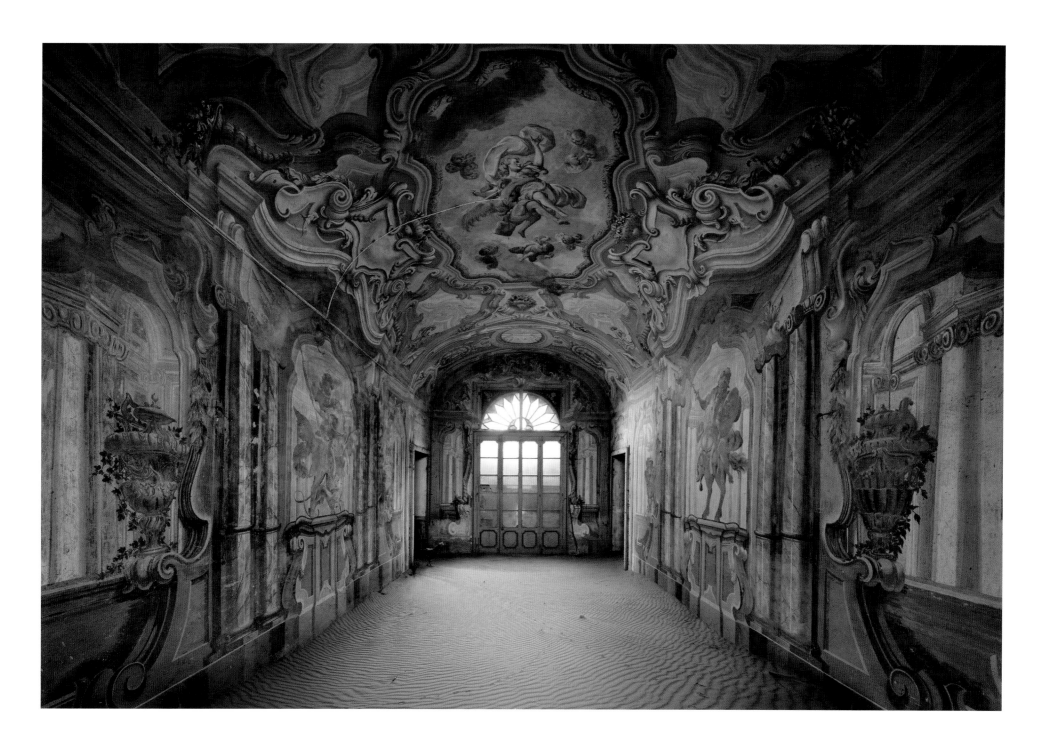

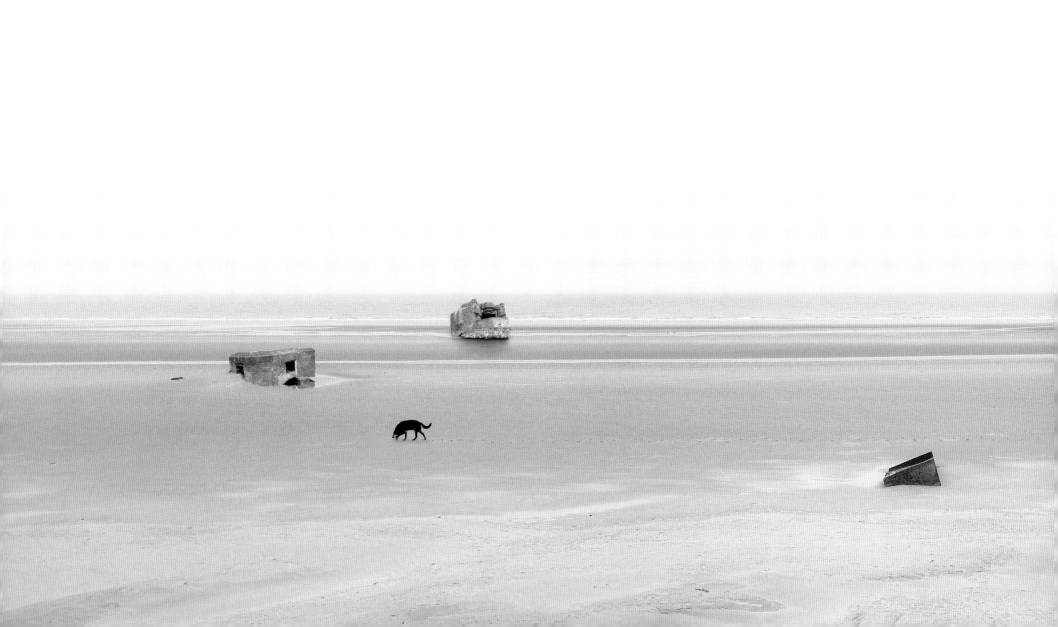

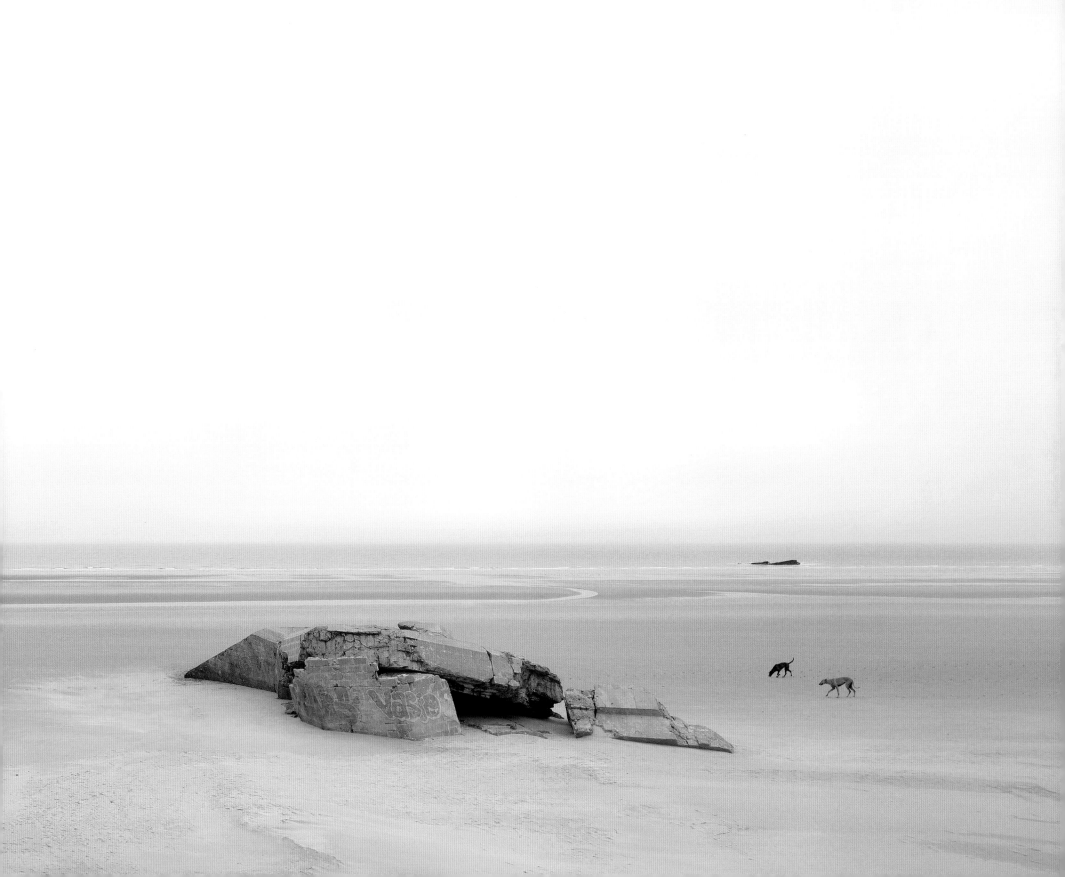

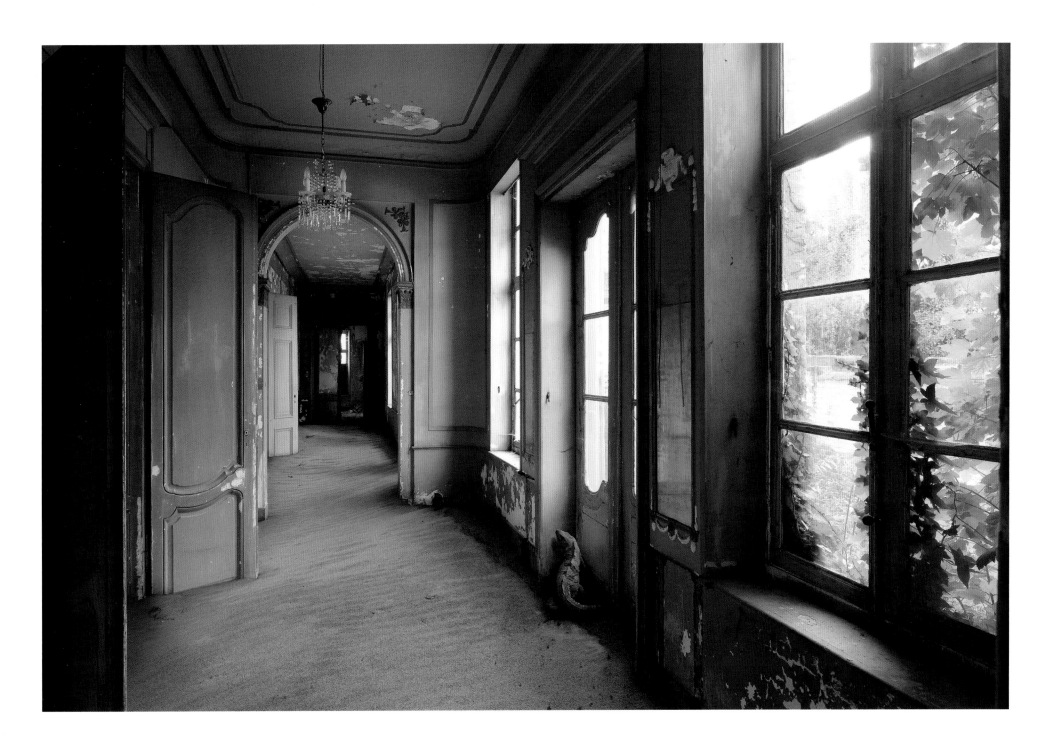

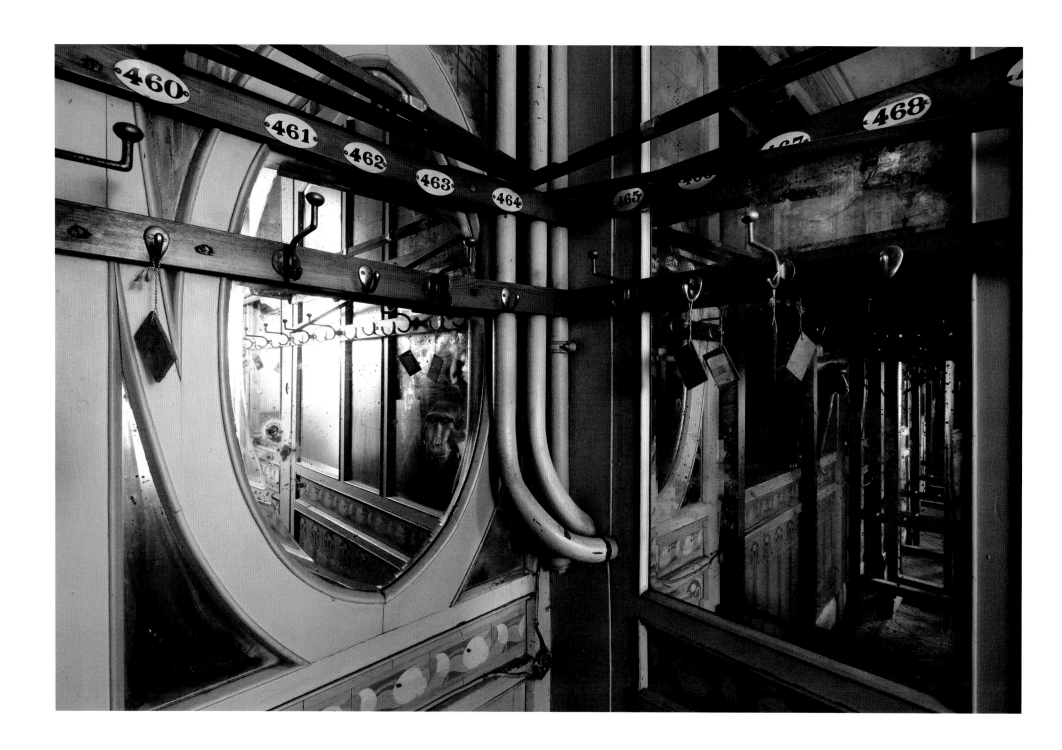

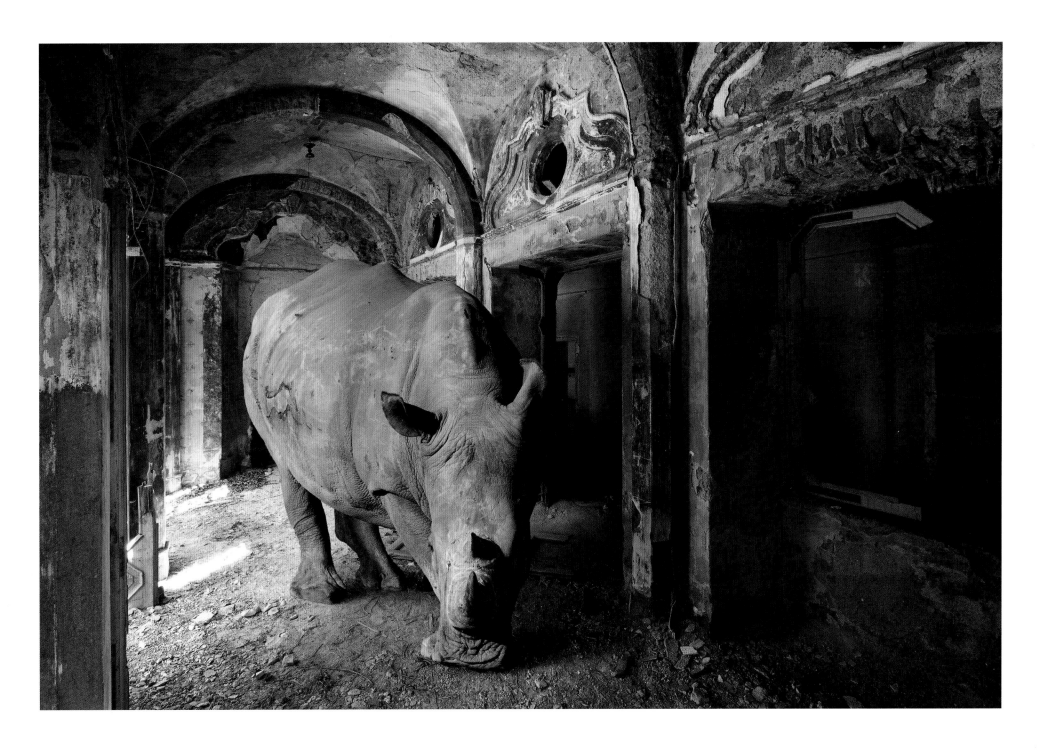

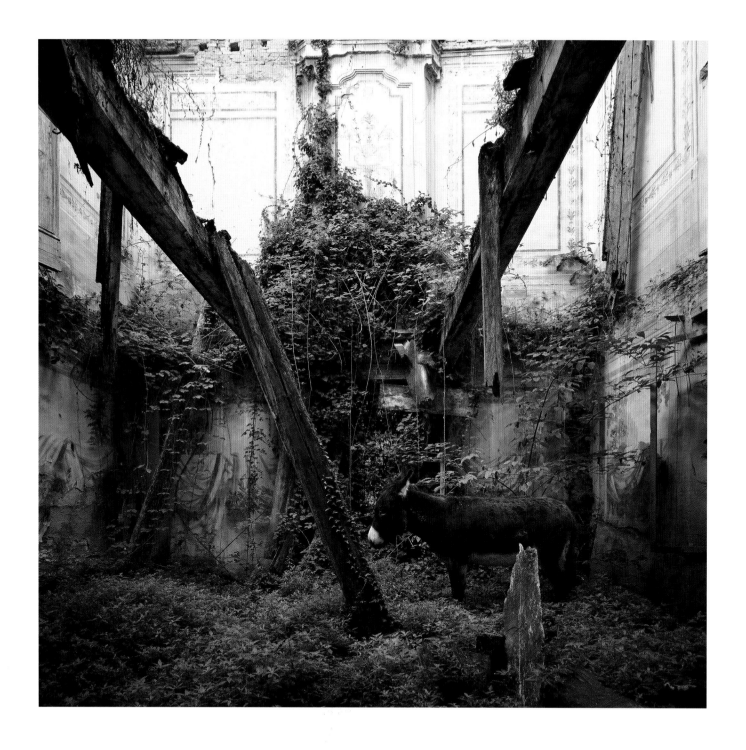

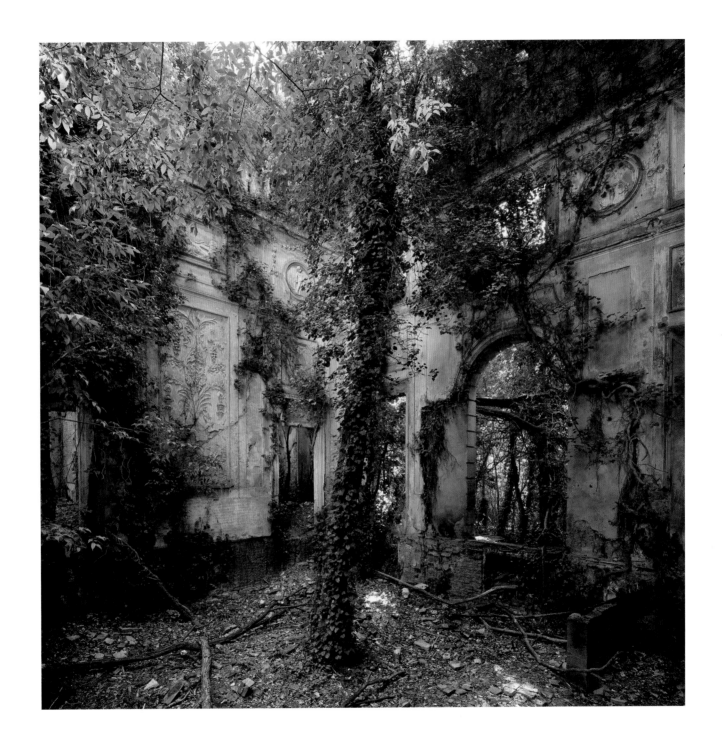

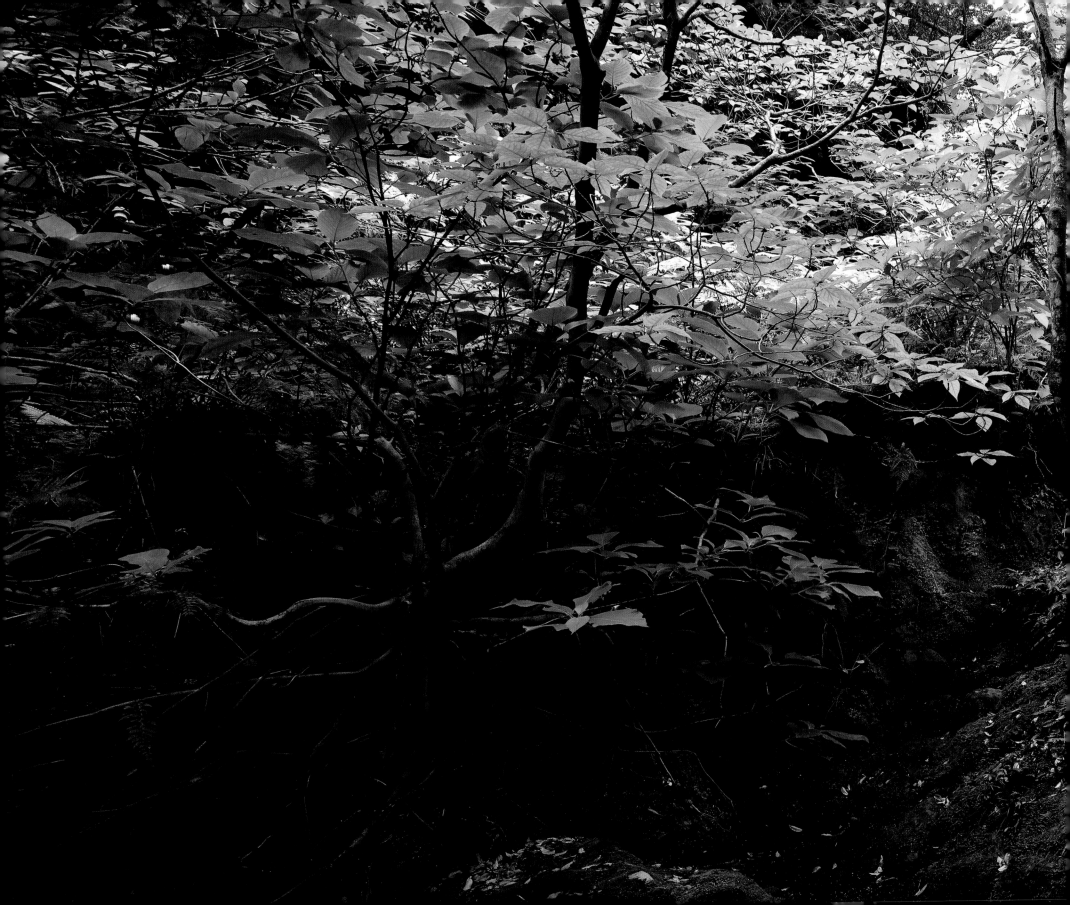

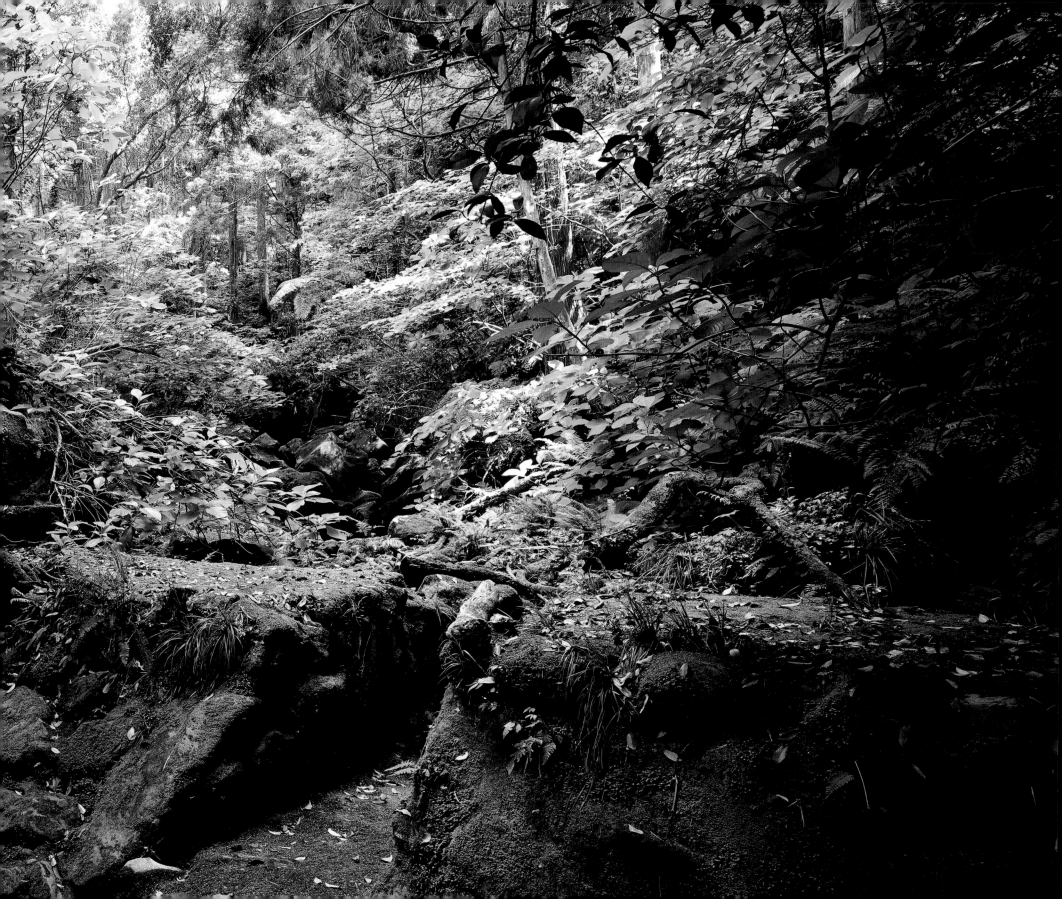

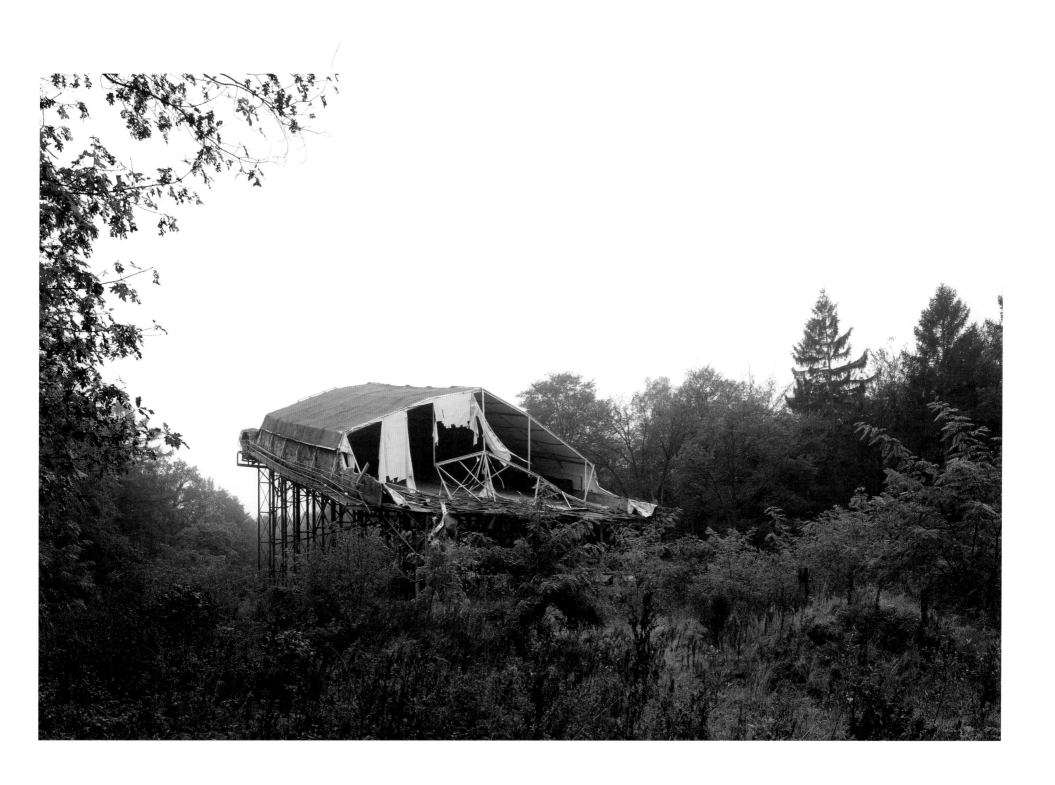

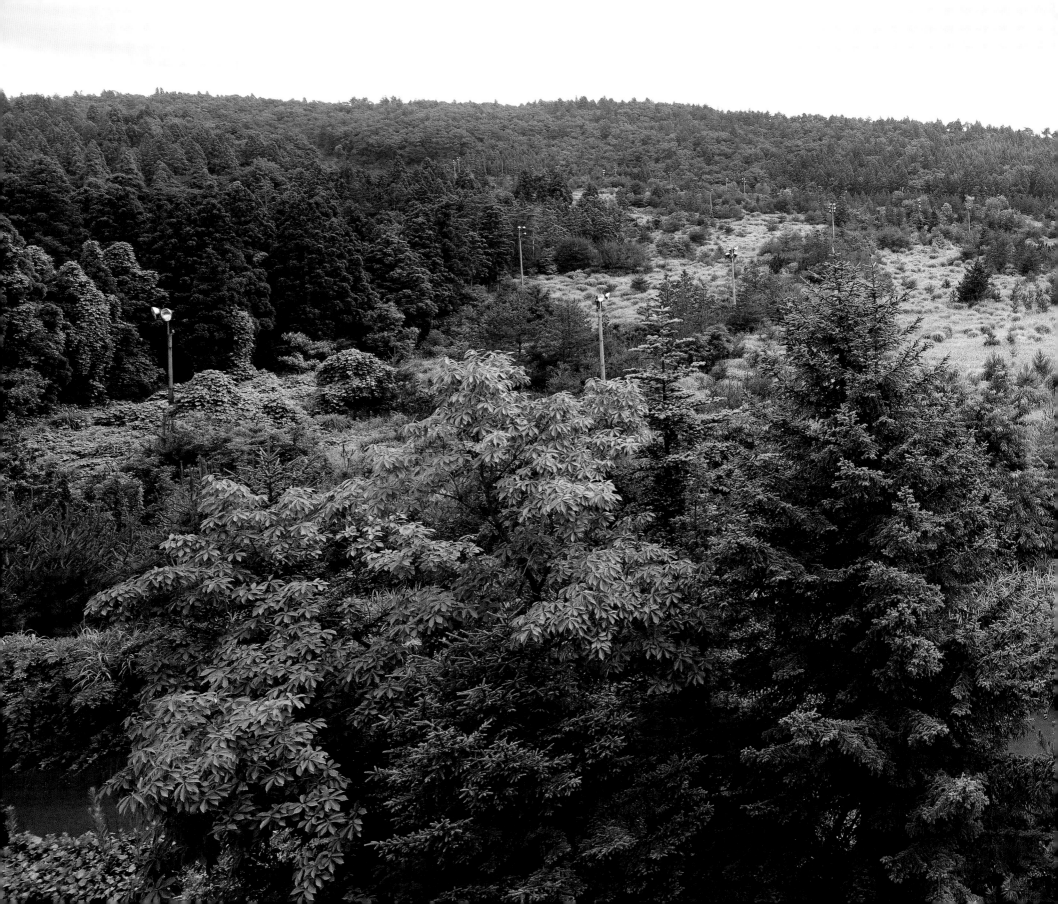

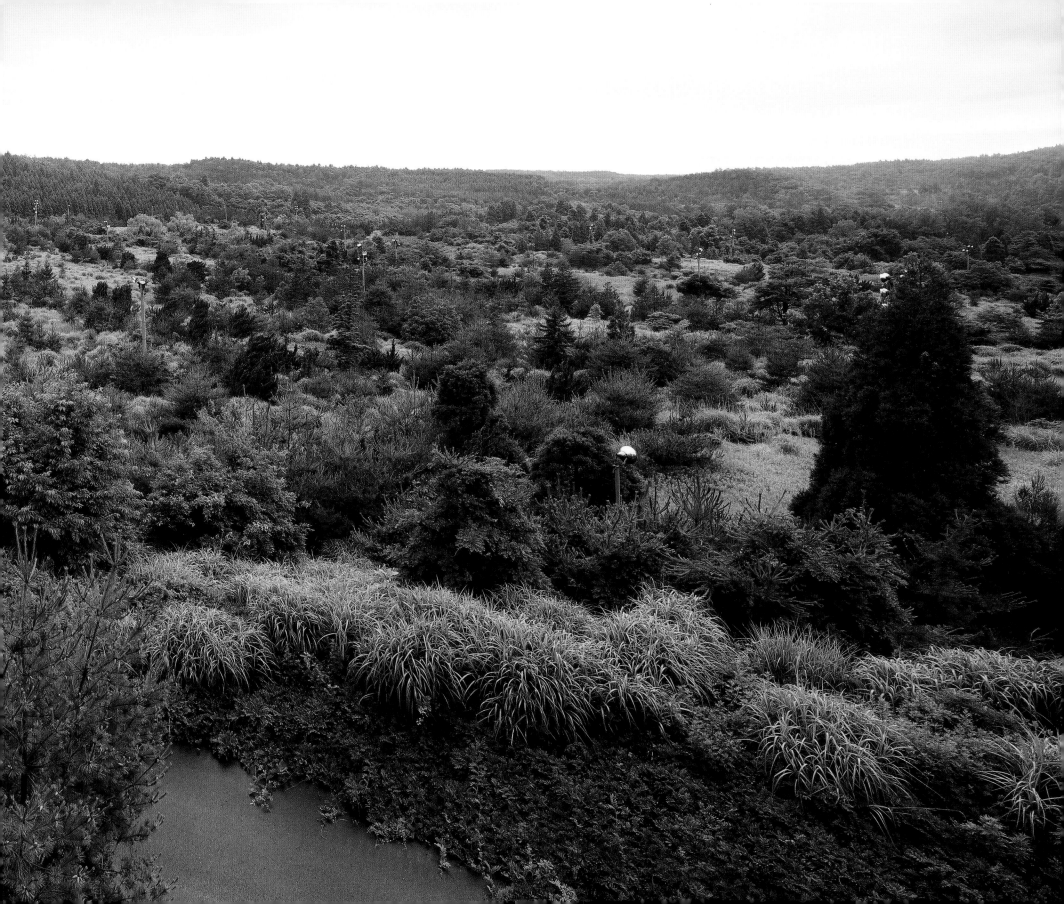

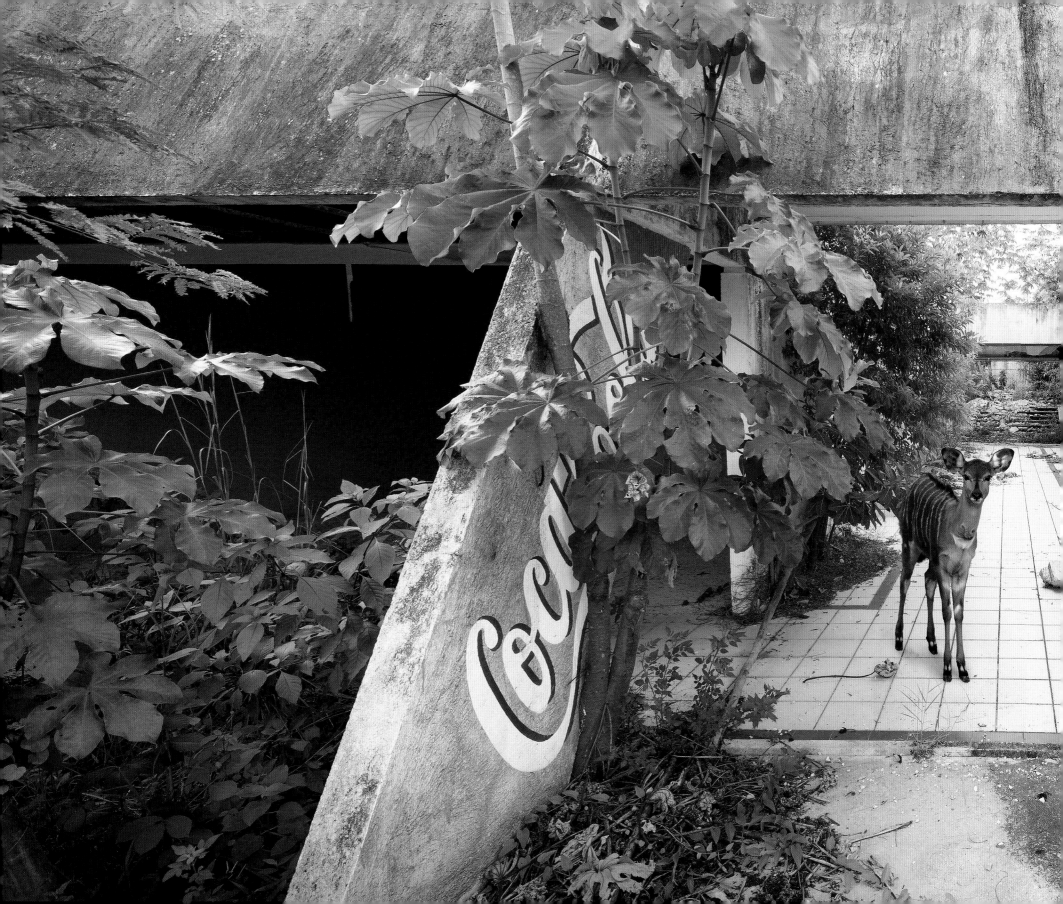

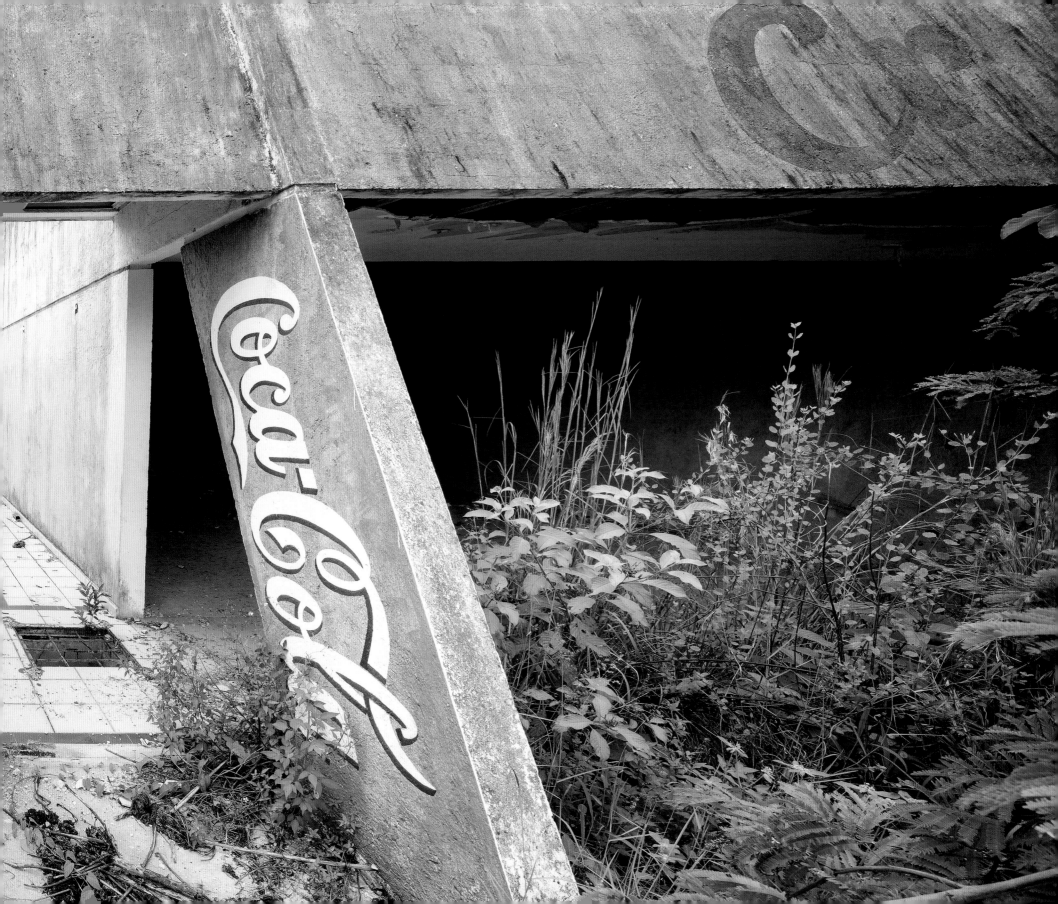

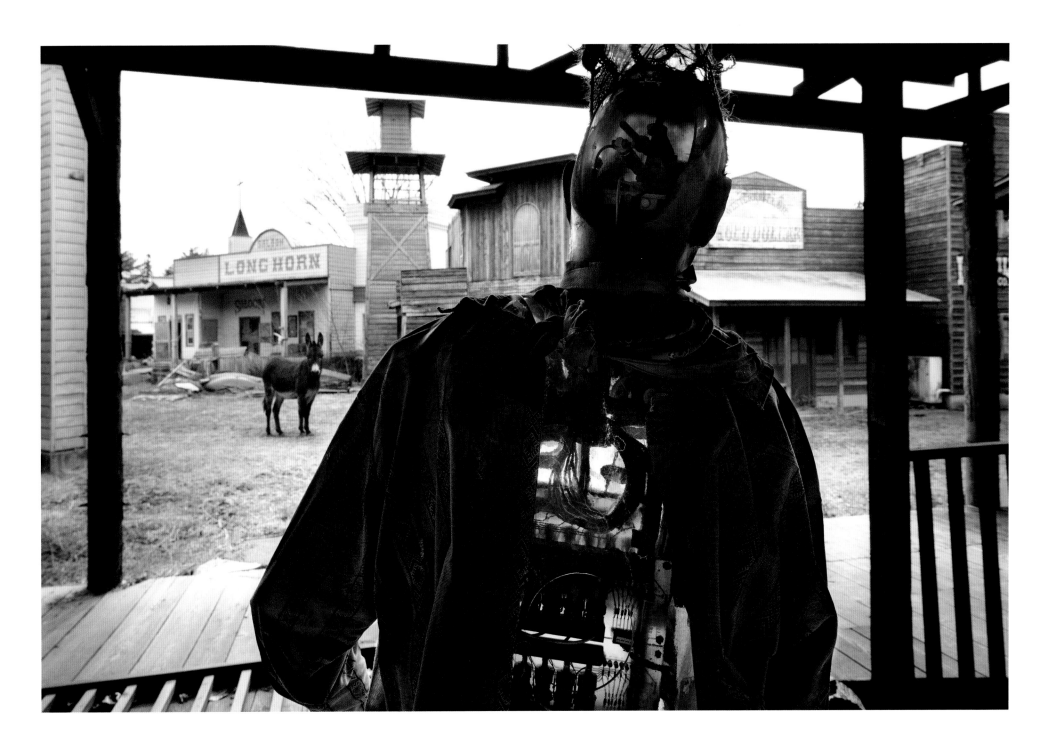

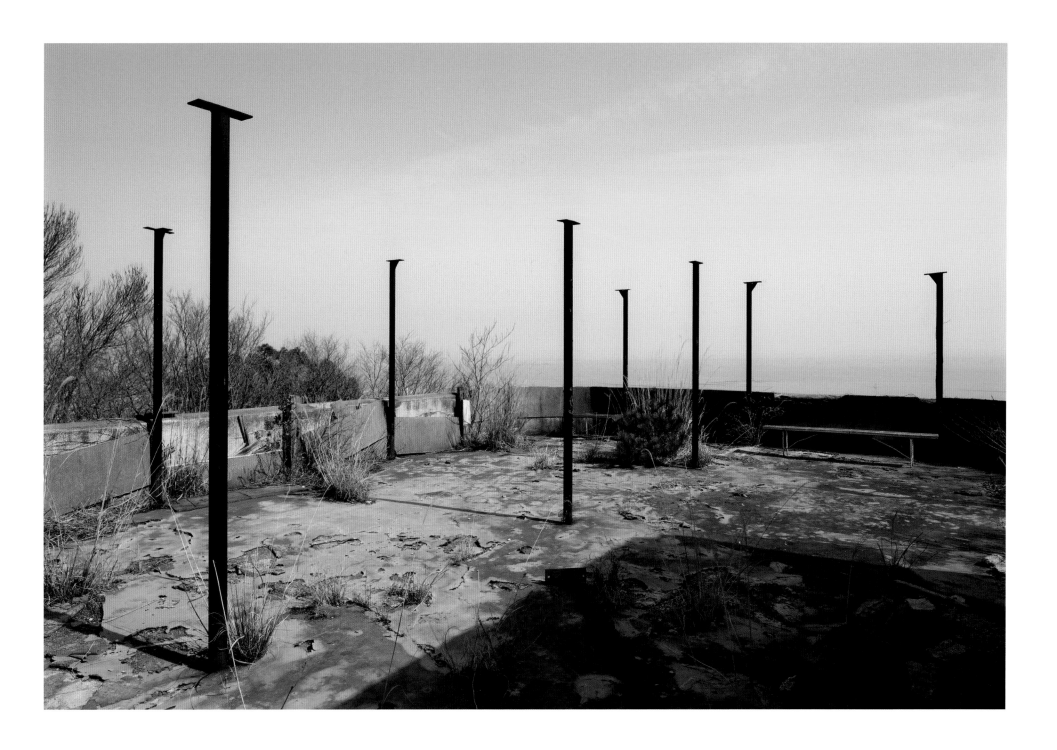

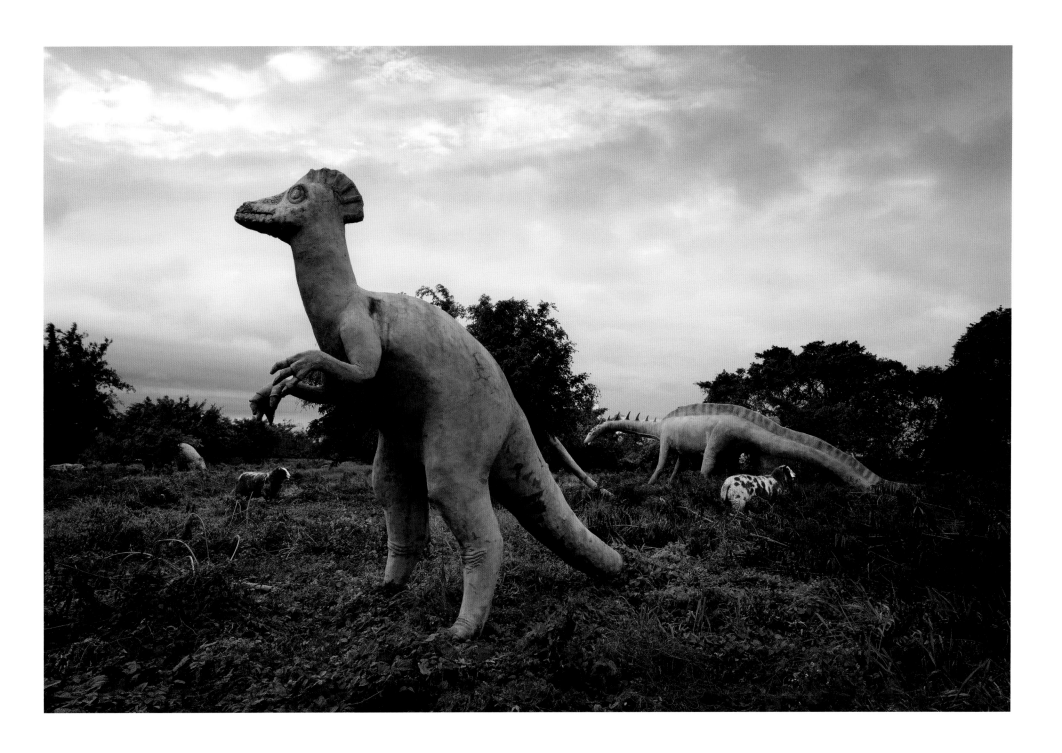

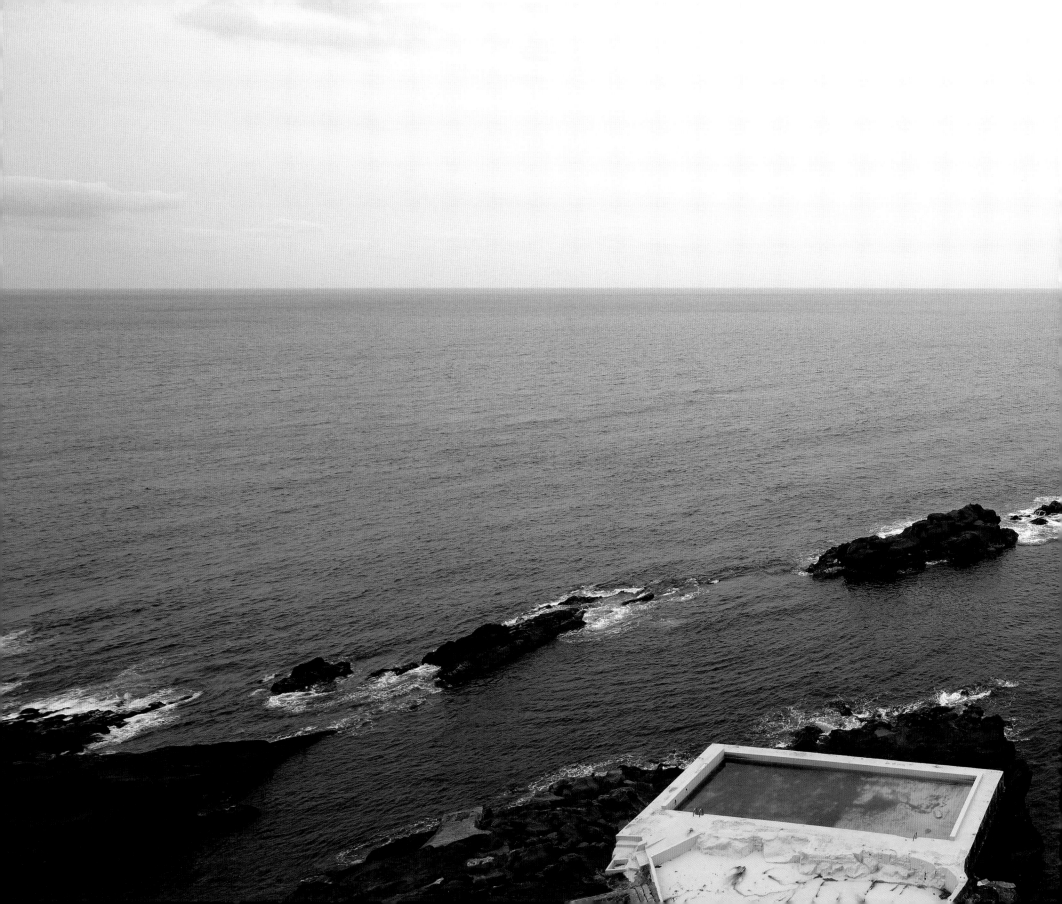

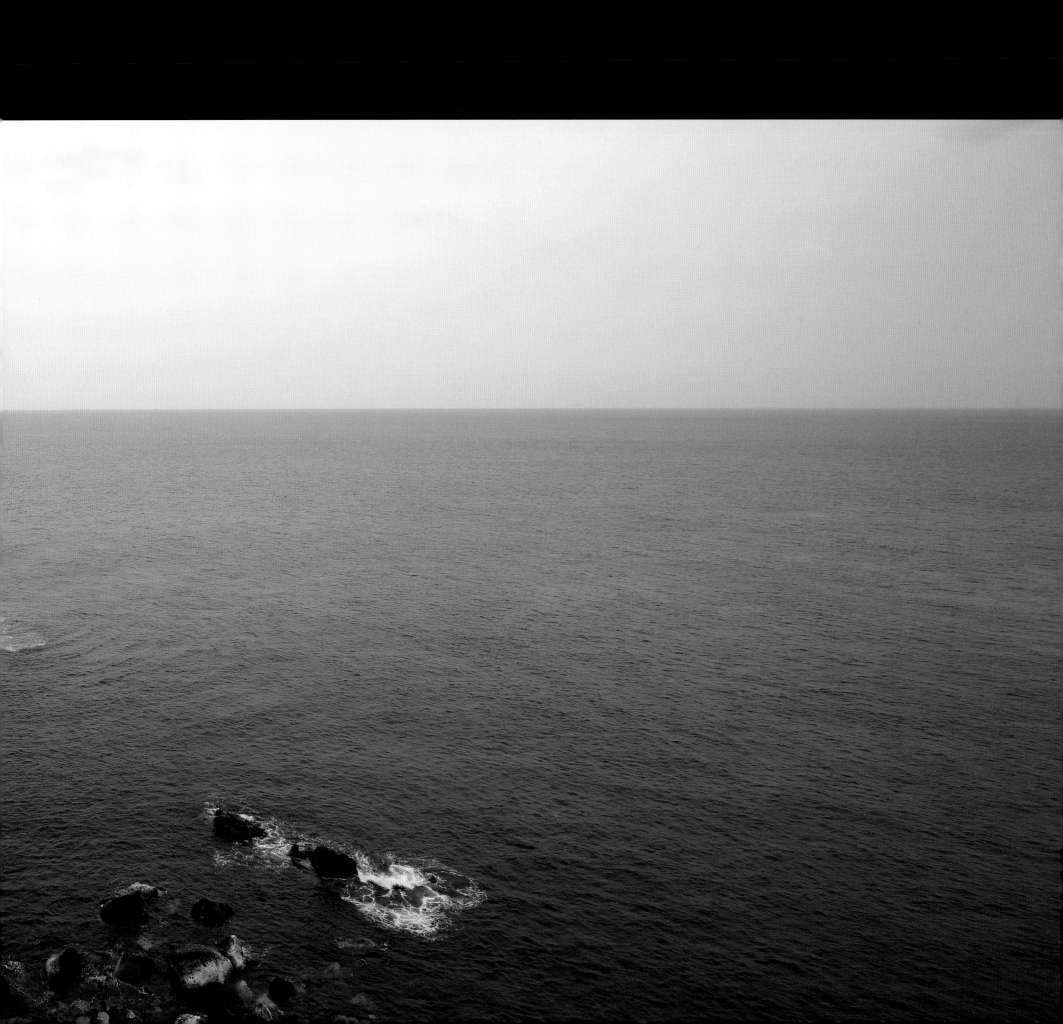

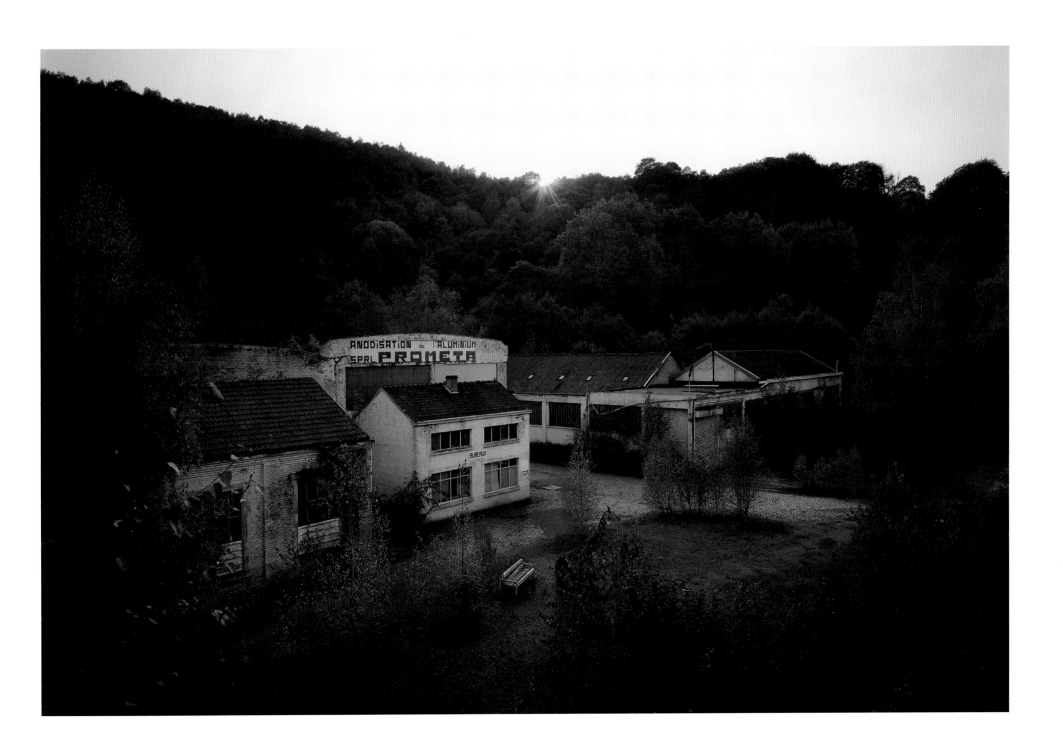

LOG

PETER VERHELST

24 hours of lost reception: the radio is beyond repair. Battling feelings
of abandonment, with breathing exercises.
Seven months it's been, more or less, without any information
concerning time, the situation in the field, or a possible evacuation,
but now the radio silence is definitive. It's impossible to determine the
location of our positions based on pings (1 an hour). What's happened
to our network?

Alternative ways of determining time in the absence of operational
equipment: the light, the sun, the stars. Alternative ways of
determining time, on the inside: focus, organization, faith.
Could our network have been disabled?
Dizziness. Loss of concentration. The oxygen regulator is running on
less than half capacity. Saving oxygen, by taking long breaks. Nausea.
Headaches. Code red.

Oxygen regulator irreparable (expiration date exceeded, cfr. radio?).
Step 1 evacuation: open chest with protective suits. Check. Step 2: put
on protective suit. Check. Step 3: rucksack with weapons, munitions,
provisions. Check.

Protocol to open the sluice to compartment C2. Check.
Hoping for the best.
C2 is completely destroyed. A ruin. Traces of impact and soot. Bodily remains (4 skeletons, intact, but on the floor, most of the clothing blown away by the airburst caused by impact). Excessive light.
Immediate return to C1. Decision to leave base. Weapons and munitions. Check.
Evacuation plan 1 and 2. Check.
I am opening the sluice now.
Exit.

Neither the Geiger counter nor the aerometer show abnormal values, but

It is morning (the sun has not yet reached its zenith). It is particularly confusing/overwhelming after all that time (more than 2 years) to be outside again. Feelings of fear, a heightened state of alertness + emotion, feelings of vulnerability. I focus (breathing).
Zigzagging, I make my way to a higher part of the landscape, the evacuation point. I scan the surroundings.

What has happened to the landscape? Abundant grass, creepers, climbers, houses with trees growing through the windows and roofs. Antiquated names: woodbine, pollard willow, poplar. The horizon.
The sound of my breathing: like a deep-sea diver.
How many years have I been underground?
Again gauging the area with the Geiger counter and the aerometer.
I decide to take off the gas mask.
Air!
Keeping gas mask at the ready.
I take off the protective clothing.
Euphoria. My body's drunk on air!
The sound of a bumblebee. I bring a sprig of grass to my nose, the moist soil!
Speaking to myself strictly, and scanning the area for hostile elements. A magpie flies up, startled.

(darkness)

Am I now a PING (and for how much longer?), escaping an apparatus that is deaf to incoming signals, but that continues emitting signals for years, simply because it has been calibrated that way, and works on energy from the wind and sun? The realisation: the pings with which I charted our positions did not indicate the coordinates of the operational units, but those of the wasted, the ones that had been switched off/disabled. The graveyard.

Am I alone? Is there someone who knows I am still alive, who is now trying to localise me? Is there a helicopter taking off?

A cloud cover settles in. Darkness.

I dig a pit and apply signal according to the evacuation protocol.

I cover myself with branches and leaves. Breathing exercises.

The deep, dark brown of the earth.

I am the earth. Waiting for the bass-tone of helicopter propellers.

(night/heavy clouds)

Racket at some distance. Unidentified. No infra-red viewer.

Weapon at the ready. Switched to alpha setting. It is so peaceful I can hear everything, feel everything and smell everything, poised for swift reaction.

Rustling. Barking/howling in the distance?

Heavily clouded sky. Evacuation period lapses.

On the way to evacuation point 2. Leaning forwards. With heavy rain, I put on protective clothing and crouch in a ditch under a tree.

Weapon in lap.

Reaching the outskirts. Many stripped buildings. Not stripped, but in decay. Tall grasses in gardens and reeds that lift up pavement tiles. The closer I get, the more water I see (a flooded metro station, flooded houses in lower areas, floating fridges with deposits of algae, fragments of Styrofoam). Houses with trees growing through windows, and in one instance, through the roof. An abundance of plastic bags. Black ones. Ten geese, 'honk, honk, honk', fly overhead in V-formation. Just before the evening mist rises. Breaking into one of the houses, checking it from basement to attic. In the attic I take up position for the night by the window.

Seeing the moon.

The clouds pass in front of and past the moon.

Barking. A pack of wild dogs on the street. They are like baboons, the way they fight. I can hear them scratching at the door of the house, but they quickly move on.

(Had a restless night. Plagued by memories, due to the oxygen-rich air, the abandoned houses, this house here with rooms, cupboards, computer screens. These lamps, the kind my parents had. Are my parents still alive? Dresses in the cupboard. Fallen chairs, as if there had to be a sudden, quick evacuation.)
Breathing exercises.

Search the house. All pieces of equipment in a state of disintegration. Rotting. Ants everywhere.

Pause at a bridge that is completely rusted (like severe burns). Abandoned cars at the edge of the road, some of them aslant on the road, the boot wide open. Barricades made of tyres and stones.

A fir tree emits a yellow cloud of pollen with every gust of wind.

The clouds draw back. I break into a villa looking for food.
The scene: I am opening curtains (I have my arms in the air, the curtains are malfunctioning) when I see a creature in the garden. It takes a few seconds before I recognize it. A lioness. She sees me. And charges towards me, only to stop a few centimetres short of the window, to sit on her hind legs and claw at the air. I jump back, perplexed. The lioness remains in her seated position. I approach and slowly raise my arms; my weapon is on top of the curtain box. The lioness starts to claw at the air again. And again. She does it whenever I raise my arms in the air. As if I had awoken her memories (the zoo? the circus?). A few seconds later the lioness braces herself (the back muscles!), creeps back with jaws open (the teeth!) and runs away, with the dogs running after her at a safe distance (they ignore me completely).

Am I hallucinating? Is my memory playing tricks on me?
Are these my human memories, changing shape inside the animals?

A troupe of dogs that together form one big dog. And the birds.
And the ants. And the lioness.

Disassembling the weapon.
I clean the barrel.
Sliding the weapon back together, clicking it into place.
Loading the weapon and keeping it at the ready.

I am going from house to house – opening door or window, entering room per room, house clear.
Some houses are in complete disarray. Groups of people have slept there. Some skeletons, with a dark stain around them, on the carpet or on the floor, or in a bed. Equipment everywhere, computers, radios in various stages of decay. In one of the houses: tens of computers, plugged into a non-working electricity network. Screens stand in the corner, piled up on the floor.
All those memories.

In one of the houses there are red birds flying. I do not know their name. Long, velveteen tails, like fish.

What has happened to us?

A pre-war automatic answering machine with a flickering red light (connected to a generator that's survived everything).

I barricade the door and go to sit down on the sofa next to the answering machine.

What has become of our memories?

I am going to hunt for food in the house. Tins of sardines. Crouching, I now and then look over the kitchen cabinet, out of the window. It is getting dark. I go and sit on the sofa again, with my back to the wall, and a free view of the front door. I stay there until it is completely dark. The red light.

There is one message on the answering machine. A crackling connection, and a woman's voice, saying something over and over again. She isn't crying; she seems to be sniffing, as if she has a cold, and she is swallowing audibly, and what she is saying isn't clear, but she keeps repeating it. In the middle of one such phrase the connection is interrupted.

I listen to the recording again. And again. She says: 'I love you.'
I think.
That's what I want her to be saying.

Scratching at the front door.
Howling.
Panting.
Dogs that rub against the door made of wood.
One shot, next to the door, into the wall.
The barking quickly moves off.

Three words. I love you.

Children's shoes.
Nylon stockings.
A landscape painting, still hanging on the wall from one corner.
(Like someone who has fallen down and sees the landscape
slanted, with one eye.)
Mould.

I wouldn't have survived it if I hadn't fired that shot. I mean, mentally.

Sometimes I have the feeling my personal history, my memories, no longer belong to me. They don't even belong to us (humans), but together they constitute an organism that is greater than ourselves.

Perhaps the lioness has carried off our memories, which is one of the reasons she needs protecting. Or maybe not at all.

The feeling that others interpret our memories. Distort them.

Will we, people, ever, in another life or age, be able to revisit our memories?

The thought that our memories will live on for longer, long after we have gone.

The concept of death has changed: our memories will survive us.

Beings with different DNA-structures will occupy those memories.

The ridiculous feeling of being the Japanese soldier who, decades after the war, dressed in an immaculate uniform, emerges from his hiding place and salutes. But this time there is no welcoming committee.

Knackered. On the way to evacuation point 2. On a road I see a boat that is lying on its side. As if someone has just gotten out of it. In the middle of the road. (Under the seat: a bird's nest.) On the hillsides of the landscape I see sunken roads, fields, neighbourhoods. As soon as I hear barking, I fire a shot, after which it is quiet again. Then I realize I have betrayed my presence for miles around. And I drastically adapt my walking direction: in an arc around the dry part of the neighbourhood. There are ducks and geese on the water. Like a signal, they rise up, take off, and then land, a bit further on.

Walking leaning forwards. Ready to attack whomever or whatever.
Something is moving in the corner of my eye. Growling.
Bending forwards. Sitting on one knee, surveying the area through the gun sight.
I can see the pack of dogs fighting and tearing something apart as they bark.
I empty my round of bullets on them.
When I have come closer with my knife (one of the dogs is still convulsing), I can see it was the
lioness they had pounced on. She lies there with her eyes open. Horribly mutilated in the stomach.
Heel tendons, bitten through.
Panting.
For a moment she tries to hiss, but her head is heavy.
I put her out of her misery.

It isn't only my memories that change shape in the animals,
but their memories that also take up their position within me.

Exhaustion.
Nosebleed. Retching.

The red birds in the house. Jewels on the wing. Brocade dresses,
gently rocking on a coat hanger in the breeze.

I am close to evacuation point 2. Now I can smell and hear the sea.

In the corner of my eye I see a figure. I shoot from the hip, and am
knocked off-balance by the recoil, but I keep on shooting (like blood
gushing from an aorta).
It's a plastic bag, caught by the wind. It is being blown about and rises
on a gust of warm air. Over the sea. Ever higher, and quicker.

The overwhelming desire to feel a warm body against mine.

I lie down by the lighthouse. It is getting dark and the light skims across the sea and the grasses.
To give whoever is on the water the feeling that someone is waiting for them, and to make whoever is
on the shore believe there is a place where things are better.

I would have liked to see the stars one more time, but the glare of the lighthouse is too bright:
my eyes can't adapt to the darkness quickly enough.

Our residue will be remembered by the remarkable presence of carbon particles that will amaze
future colonists (why did Homo sapiens like plastic so much? Was it for religious reasons?).

Plastic and radioactive radiation.

The sound, each time the light beam swoops over me: like the sail of a windmill.

The proof that I am human? I saved the last bullet.

I can barely keep my eyes open; I hear her first, and then I see her.
She is standing close, looking at me. Bending the front legs.
A warm, soft mouth. Now and then a shudder passes over her back.
The horse jerks its head back and scrapes its right hoof in the grass.

Barking.

The horse shakes its mane and begins to move. The flickering eye.
The beauty of a white horse fading into the dark.

Barking. Panting. In the lighthouse's beam they look like wolves.

INDEX

C O L O P H O N

www.henkvanrensbergen.com

Concept and photography
Henk van Rensbergen

Foreword
Desmond Morris

Epilogue
Peter Verhelst

Translation
Kate Mayne

Copy-editing
First Editions Translations

Book design
Jelle Maréchal

Many thanks to the Royal Belgian Institute of
Natural Sciences (Brussels)

**This book is
MARKED**

MARKED is an initiative by Lannoo Publishers.
www.marked-books.com

 @booksbymarked

Sign up for our MARKED newsletter with news about new and
forthcoming publications on art, interior design, photography
and fashion as well as exclusive offers and MARKED events on
www.marked-books.com

If you have any questions or comments about the material in
this book, please do not hesitate to contact our editorial team:
markedteam@lannoo.com

© Uitgeverij Lannoo nv, Tielt, 2017
D/2017/45/246 – NUR 653
ISBN: 9789401443869
www.lannoo.com

#AREYOUMARKED